The ULTIMATE DRAWING AND PAINTING
TECHNIQUE BIBLE

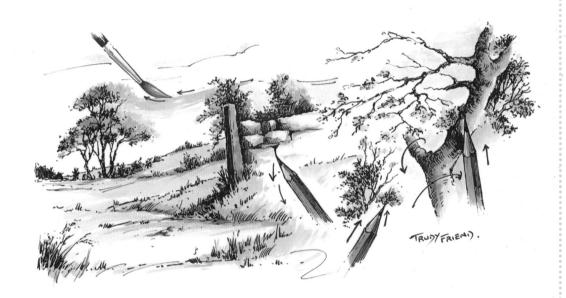

TRUDY FRIEND.

The ULTIMATE DRAWING AND PAINTING TECHNIQUE BIBLE

Trudy Friend

David and Charles

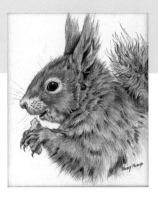

In memory of Promise

A DAVID & CHARLES BOOK

Copyright © David & Charles
Limited 2009

David & Charles is an F+W Media Inc. company
4700 East Galbraith Road, Cincinnati, OH 45236

First published in the UK in 2009
Reprinted in 2009

Text and illustrations copyright © Trudy Friend 2009
Design copyright © David & Charles 2009

A catalogue record for this book is available from the British Library.

ISBN-13: 978-0-7153-3044-9 paperback
ISBN-10: 0-7153-3044-6 paperback

Printed in China by RR Donnelley
for David & Charles
Brunel House Newton Abbot Devon

Senior Commissioning Editor: Freya Dangerfield
Editor: Bethany Dymond
Assistant Editor: Kate Nicholson
Art Editors: Sarah Clark and Martin Smith
Project Editor: Diana Vowles
Designer: Sue Cleave
Production Controller: Kelly Smith

Visit our website at www.davidandcharles.co.uk

David & Charles books are available from all good bookshops;
alternatively you can contact our Orderline on 0870 9908222
or write to us at FREEPOST EX2 110, D&C Direct, Newton Abbot,
TQ12 4ZZ (no stamp required UK only); US customers call
800-289-0963 and Canadian customers call 800-840-5220.

TRUDY FRIEND.

Contents

Introduction

With this book I will be helping you
To love your art
To live your art
And see the world go by
As colour, texture, line and form
And with an 'artist's eye'.

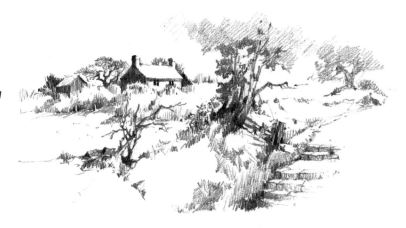

The aim of this book is to equip you first with the basic skills to represent the texture, tone and form of any subject you choose and then to offer exercises and demonstrations that will encourage your creativity and confidence in your abilities. By the time you reach the end, you should have gained enough experience to be able to produce drawings and paintings that are both believable and full of interest for the viewer.

Basic Mark-making

In the first section, you will discover a series of eight basic stroke applications that can be used alone or combined in various ways. They are the means by which I produce all my own work, and you will find that you can employ them to suit any subject you wish to draw, or to paint, for these techniques may be applied to any dry or wet media with very similar methods of execution.

Many artists, in particular beginners, find it daunting to make the first marks on a fresh piece of paper, but by using these stroke applications you will find it easier to make a plan first of just how you will proceed, choosing the marks that will fit your purpose. With a clear idea of what you aim to do, you will be able to make a more confident start that will form the basis of the rest of the work.

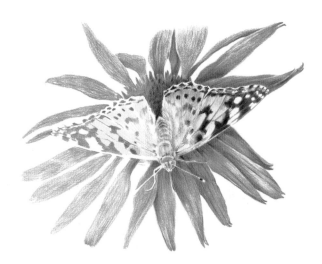

The delicacy of the application, using coloured pencils, is enhanced by overlaying colours to increase their intensity in gradual stages rather than a direct application of strong colour.

Developing Your Skills

With the eight basic strokes mastered, you will be ready to move on to experiment with different subjects and media. In this section, I have demonstrated vibrant colours with the use of Derwent Inktense watersoluble coloured pencils and more muted hues from the Graphitint range. Watercolour, gouache and acrylic are shown both as a limited palette choice and in bold bright colours, with subtle neutrals used as a contrast in some illustrations.

Texture in any form adds interest to drawings and paintings, and this may come from the surface texture of the support (paper,

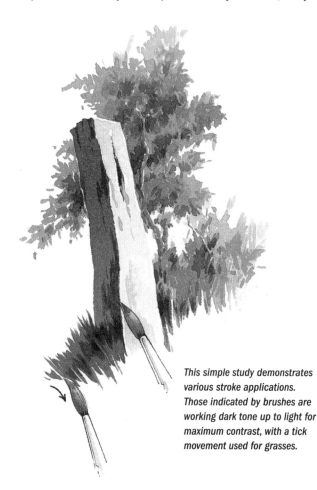

This simple study demonstrates various stroke applications. Those indicated by brushes are working dark tone up to light for maximum contrast, with a tick movement used for grasses.

card and so forth), from the addition of certain mediums to your paints (see page 10) and from your handling of your drawing or painting medium. For example, if you draw with a soft charcoal pencil upon a rough surface such as Bockingford paper you will immediately create a strong-textured impression, while a soft graphite pencil upon smooth Bristol board will give you an effect suitable for suggesting a surface such as silk. Either will be affected by the nature of the stroke application you use.

In this section, learning about line, tone and texture and how to handle them in different media will set you on the path to making further experiments on your own to explore your developing skills.

Problems and Solutions

While you will learn from your own mistakes, learning from someone else's will help you to avoid making many yourself. This chapter looks at common errors, and you will see that many of them arise from a lack of faithful observation of the subject. This is the result

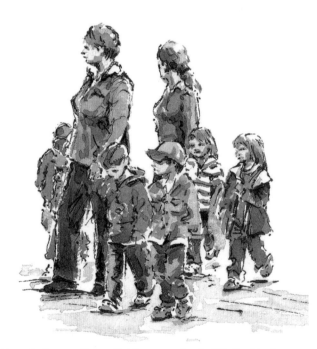

In this study, the use of interesting lines around and within the figures and the loose application of watercolour washes help to create a sense of movement throughout the group.

of two main errors: drawing your preconceptions of the subject rather than considering it carefully as an arrangement of shapes, colours, tones and textures, and rushing ahead without doing any preparatory work first.

From this section, you will see how vital it is to make sketches first, studying the subject from different viewpoints until you truly understand how to portray it. Once you have mastered its form, proportion and scale, you will be able to make a completed drawing or painting with confident use of the pencil or brush rather

than spoiling the work with anxious fiddling to get it right and overworking it because you are not sure when to stop.

Composition

No matter how faithfully you represent a subject, for a whole picture to work successfully you need to create a strong composition, or design. This may be built on certain shapes, such as an 'S' or an 'L', or on strong diagonals for dynamic effect; alternatively, you may choose calming horizontals. Whatever your overall emphasis, your aim is always to create a point of main focus which the viewer's eye is led to, via an interesting journey created by your use of shape, line and tone.

To create added interest within a composition it is helpful to overlap suitable foreground shapes. These can also be very effective in guiding the viewer's eye into the composition.

Again, preliminary sketches will set you up for a good result. Rather than just looking at a scene and deciding to paint it from your first impression, make sketches of it from different angles and eye levels, trying horizontal and vertical formats. Tonal sketches will show you whether you have interesting contrasts and balances, and if not you can use artist's licence to improve them. In this section you will also learn how to work with guidelines to help you to place the elements of your picture successfully and how to use the 'rule of thirds' (see page 175) to position your point of focus in the most pleasing area compositionally.

As an artist, your composition is in your own hands; you can leave out something that is spoiling the view in a landscape, decide where to crop the picture for the best effect, or add a building to a fold of land that will draw the eye to that area. As you reach this stage of the book, you will be eager to begin upon your own pictures and confident in your ability to make a success of them.

Drawing and Painting Media

Exploring a range of media will give you the chance to discover the effects each can give and which you most enjoy using, singly or in combination. Some people are naturally drawn to the vibrant colours of acrylic, for example, while others respond to the delicacy of watercolours in subtle tones; sometimes it all comes down to the mood you are in and the subject you wish to draw or paint.

Pencil

We all feel comfortable using a pencil, since that was probably the first tool we began to write and draw with. We make marks with a pencil unselfconsciously, doodling away or scribbling lists of things we need to do. This familiarity means that we find it much less of a challenge when we are asked to use pencils more formally than when we are presented with paints and brushes.

There are many varieties and grades of pencil, from a humble HB at the local newsagent to the finest Conté that you may have seen used in Renaissance drawings. Try as many as you can before deciding which ones best suit your style of working and the subjects you wish to represent.

Graphite Drawing Pencils

These pencils have a core of powdered graphite fired with clay. They range in hardness from 9H to 9B, with HB as the medium grade. While you can buy them cheaply, the poorer quality ones may vary in tone or scratch the paper; it is best to pay extra for high-quality artist's pencils such as Derwent Graphic, which will produce an even tone. The soft grades 6B to 9B are excellent for practising the eight basic stroke applications shown on pages 16–35. They are also ideal for practising tonal variations when used upon a smooth cartridge paper.

Watersoluble Graphite Drawing Pencils (top right)

Watersolubility combines the versatility of graphite pencils with the ability to add water and introduce brushwork. Derwent's watersoluble sketching pencils are available in light wash (HB), medium wash (4B) and dark wash (8B), while their Graphitint range gives you the chance to use colour, both wet and dry.

Conté Pencils (right)

These pencils are made of graphite or charcoal mixed with wax or clay and natural pigments such as black, brown and grey. If you wish to create rich, dark images a Conté extra-fine drawing pencil upon Bockingford paper will produce intense darks and may also be enhanced by the addition of water.

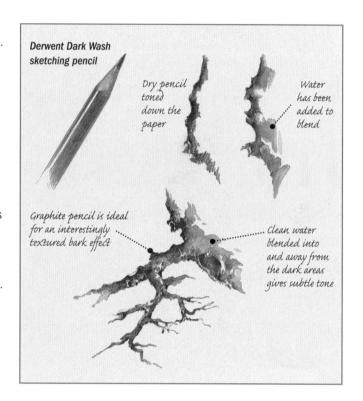

Derwent Dark Wash sketching pencil

Dry pencil toned down the paper

Water has been added to blend

Graphite pencil is ideal for an interestingly textured bark effect

Clean water blended into and away from the dark areas gives subtle tone

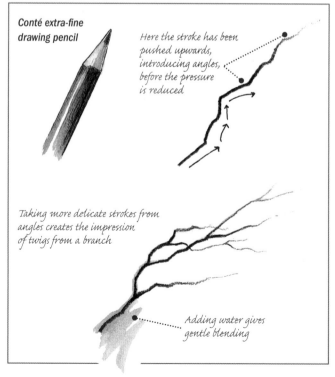

Conté extra-fine drawing pencil

Here the stroke has been pushed upwards, introducing angles, before the pressure is reduced

Taking more delicate strokes from angles creates the impression of twigs from a branch

Adding water gives gentle blending

Charcoal Pencils

You can buy charcoal, made by carbonizing wood, in several forms. Willow sticks come in a variety of widths and hardnesses, giving rich blacks that smudge very easily. In the case of charcoal pencils, the core is made of compressed charcoal powder which is less crumbly and soft. Adding water allows you to blend it into smooth tone.

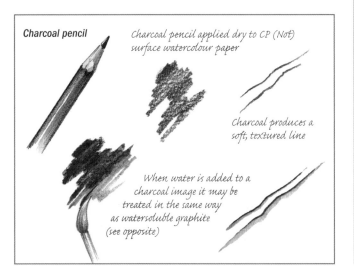

Charcoal pencil

Charcoal pencil applied dry to CP (Not) surface watercolour paper

Charcoal produces a soft, textured line

When water is added to a charcoal image it may be treated in the same way as watersoluble graphite (see opposite)

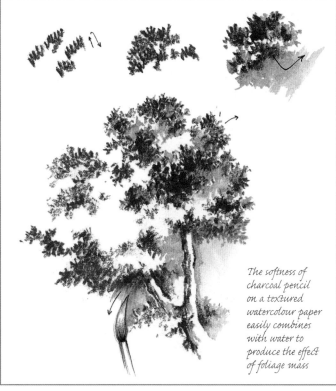

The softness of charcoal pencil on a textured watercolour paper easily combines with water to produce the effect of foliage mass

Watersoluble Pencils and Crayons

These versatile tools allow you to draw and then add water to give washes of vibrant colour. There are several brands, varying in the exact quality of texture, so it's worth experimenting to see which you prefer. Demonstrated in this book are Derwent Inktense, which give vivid, translucent colours, with a non-soluble outliner in the range with which you can draw permanent lines, and Derwent Aquatone sticks of watersoluble colour, which have a removable wrapper rather than wood casing.

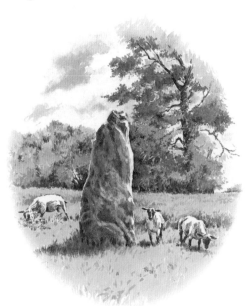

The little study of a standing stone with sheep shows an example of watersoluble pencil drawing with a watercolour overlay and a glaze of Inktense pencil hues used with a watercolour technique application.

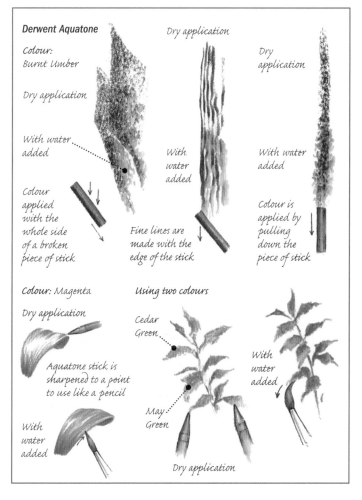

Derwent Aquatone

Colour: Burnt Umber

Dry application

With water added

Colour applied with the whole side of a broken piece of stick

Dry application

With water added

Fine lines are made with the edge of the stick

Dry application

Dry application

With water added

Colour is applied by pulling down the piece of stick

Colour: Magenta

Dry application

Aquatone stick is sharpened to a point to use like a pencil

With water added

Using two colours

Cedar Green

May Green

With water added

Dry application

Paints

In this book you will find demonstrations of watercolour, acrylic and gouache paints, all of which can be diluted with water and used with watercolour techniques. While watercolour and gouache have a long history, acrylics arrived in the mid 20th century, consisting of pigment suspended in acrylic polymer emulsion. They offer brilliant colour and are fast-drying, after which they are water-resistant. Retarders are available to slow drying time where needed.

Gouache paints have a larger ratio of pigment to water than watercolour, with the addition of a white pigment such as chalk. This makes them more opaque, and therefore ideal for adding highlights to watercolour paintings where needed – though one of the defining characteristics of true watercolour technique is that generally highlights come from leaving untouched white paper.

Mediums

When you are working in watercolour you may find some of the Winsor & Newton mediums will enhance your paintings. Lifting Preparation Medium is especially useful for beginners as it allows dry washes to be lifted from the paper with a wet brush or sponge. Blending Medium slows the drying process and will give you more time in which to blend the colours, while Texture Medium contains fine particles and will help you to achieve an impression of depth and structure in your paintings.

Watercolour paints vary in their granulating quality, which affects the texture of the wash. French Ultramarine, for example, has natural granulation. However, Granulation Medium can be used to add a granular effect to colours that usually give a smooth wash. The effect may be further enhanced with textured brushwork.

Ox Gall

Ox gall liquid is a translucent wetting agent that may be used to improve the flow of watercolour and its absorption by the paper. Obtained from the gall bladder of cows, it is often replaced today by modern synthetic wetting agents.

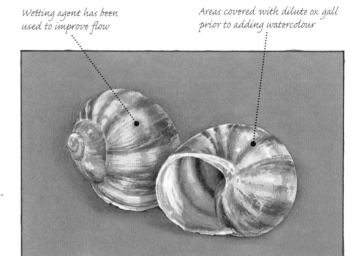

Wetting agent has been used to improve flow

Areas covered with dilute ox gall prior to adding watercolour

Gum Arabic

A natural gum made from the sap of trees from the *Acacia* genus, gum arabic is used as a binder for watercolour paints, slowing down the drying time and increasing gloss. It will give you more time to manipulate your paint and is particularly useful on hot days.

Granulation Medium

Granulation effect

Granulation can be enhanced with textured brushwork

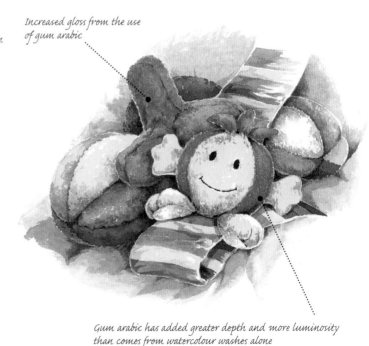

Increased gloss from the use of gum arabic

Gum arabic has added greater depth and more luminosity than comes from watercolour washes alone

Masking Fluid

For retaining light areas in watercolour painting, masking fluid is a great help. Apply it with an old brush (you will not be able to use it for paint again) and allow to dry, after which you can lay watercolour over it without any pigment reaching the paper. Once you have finished the painting and it is dry, remove the masking fluid with an eraser – it is advisable not to leave it on the surface of the paper any longer than is necessary. You can also apply masking fluid over colour where you wish to protect it from further washes.

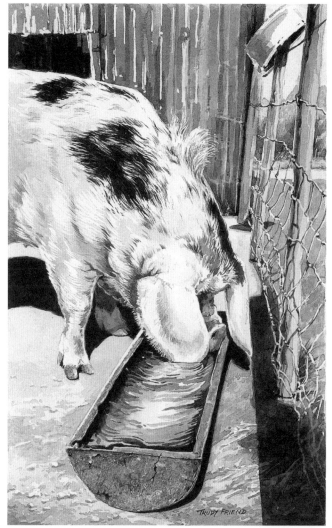

For this study of a pig drinking, masking fluid was applied with a small brush to the light strips on the corrugated iron, the tuft of hair rising from the pig's neck and the wire fence on the right. When the painting was complete (and thoroughly dry) the masking fluid was immediately removed.

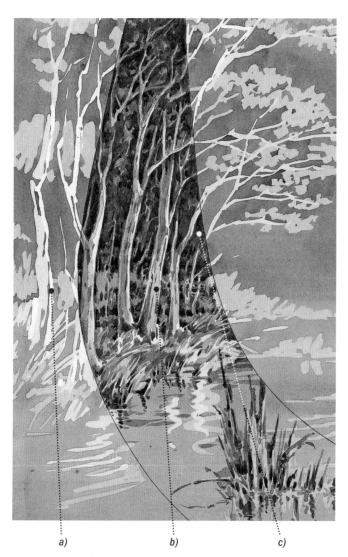

a) b) c)

Masking fluid may be applied to previously coloured areas as well as untouched white paper. In this little exercise where I have loosely applied the fluid in the forms of trees, I have indicated where a) areas of paper untouched by paint have been protected by the fluid, b) after the pigment wash had dried more fluid was placed, and c) the third wash overlay.

For slender lines, use a very fine brush with a good point

This image demonstrates the first washes over masking fluid and the way you can continue to work into the shapes, retaining the initial white paper protected by the mask.

Paper and Other Materials

While art supplies shops are packed with tempting items, in reality you do not need to buy a lot to get started as an artist. It's best to start small and acquire equipment only as you discover you really need it, spending your money instead on the best quality media and surfaces you can afford.

It is important to consider the support upon which you will draw or paint; you must choose a surface that will work with your choice of media, not against it. There is a wide range of paper available, from inexpensive cartridge paper for drawing and basic painting to top-quality handmade cotton rag watercolour paper. Cartridge paper is not acid-free, which means that, like newsprint, it will discolour when exposed to light, so use it only in pads or for temporary work.

Paper is supplied in different weights, described as gsm (grams per square metre) or as lb (imperial weight per ream, usually 500 sheets). Watercolour paper also has a choice of three surfaces: hot-pressed (HP), which is smooth; Rough, which is self-explanatory; and cold-pressed (CP, or Not), which is in between. You can buy it as single sheets, in pads, or mounted on to boards.

Pastel papers are textured so that the chalky pigment will adhere to the surface. They are available in a wide range of tones and colours, and many artists choose to work on midtoned paper so that their marks contribute the light and dark tones. You can buy pastel paper in blocks, interleaved with wax paper to stop your drawings impressing on the back of the sheet above.

Bristol board is a heavyweight paper with a working surface both front and back, available in a range of textures from rough to smooth. Use the former for crayons, charcoal and pastel and the latter for paint and inks.

Tone and Texture

Some papers are ideal for both drawing and painting and this illustration (right) shows a series of tonal exercises in pencil upon Saunders Waterford HP watercolour paper. Below are similar stroke applications with a brush, using watercolour. These demonstrate the versatility of this surface.

A Bockingford surface is also useful for pencilwork, especially charcoal and carbon pencils. In the exercises shown opposite I have used a Bockingford 300gsm (140lb) HP paper to show you how to instantly create exciting textures in a neutral hue.

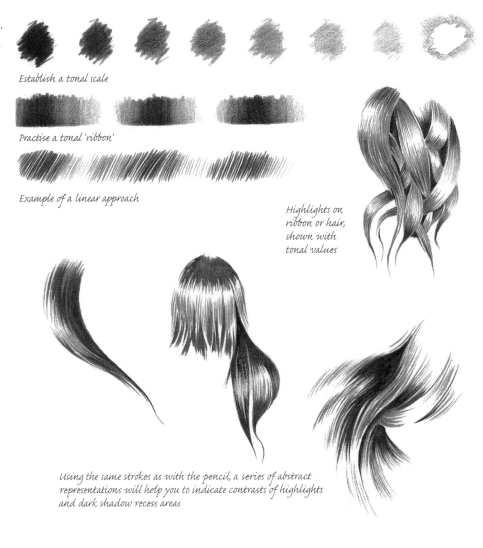

Establish a tonal scale

Practise a tonal 'ribbon'

Example of a linear approach

Highlights on ribbon or hair, shown with tonal values

Using the same strokes as with the pencil, a series of abstract representations will help you to indicate contrasts of highlights and dark shadow recess areas

tip

When you are painting in watercolour, if you are using lightweight paper or very wet washes on heavier paper you will need to stretch the paper first to avoid it cockling. To do this, soak it thoroughly with clean water then attach it firmly to a drawing board with gummed tape to stop it shrinking while it dries.

Texture Effects

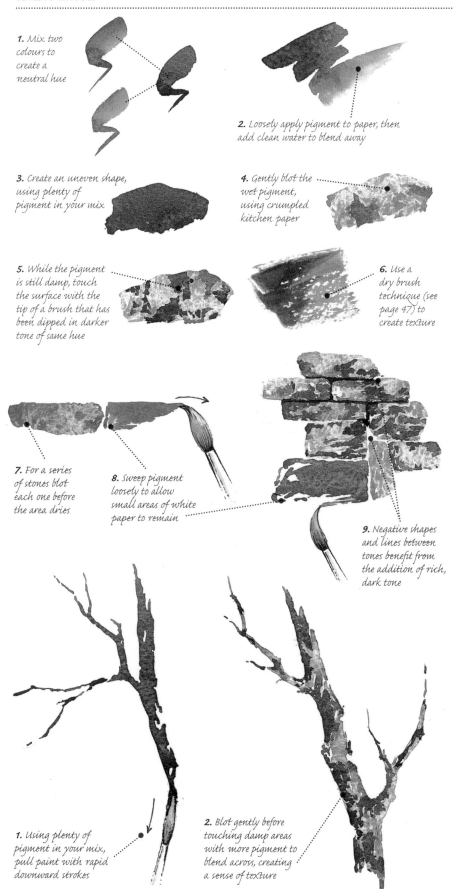

1. Mix two colours to create a neutral hue

2. Loosely apply pigment to paper, then add clean water to blend away

3. Create an uneven shape, using plenty of pigment in your mix

4. Gently blot the wet pigment, using crumpled kitchen paper

5. While the pigment is still damp, touch the surface with the tip of a brush that has been dipped in darker tone of same hue

6. Use a dry brush technique (see page 47) to create texture

7. For a series of stones blot each one before the area dries

8. Sweep pigment loosely to allow small areas of white paper to remain

9. Negative shapes and lines between tones benefit from the addition of rich, dark tone

1. Using plenty of pigment in your mix, pull paint with rapid downward strokes

2. Blot gently before touching damp areas with more pigment to blend across, creating a sense of texture

OTHER MATERIALS

You will need a drawing board to rest your paper on, but you do not have to pay art shop prices – a piece of hardboard from a DIY shop will suffice. You can also make do without an easel on which to tilt your board by using an ordinary table and finding something to put under the top end of the board such as a cardboard box, weighted down with a bag of sand or grit. If you want to go out on location without carrying too much weight, foamboard will stand in for a drawing board.

A plastic eraser, which will not damage the surface of the paper, is essential, and so is a utility knife for sharpening your pencils. You will also need gummed tape for stretching paper, while masking tape is useful for attaching your paper to your board, especially on windy locations.

Plastic eraser

Utility knife

Watercolour pan sets come with a palette built in, but you can buy extras. For acrylic paints, you will need a stay-wet palette to prevent the paint from drying out while you work. Paper towels and cotton buds have a variety of uses for cleaning up and blending colour and, of course, you will need jars for holding water. You will also find a pipette handy when you want to transfer a volume of water to your palette for a large wash.

Pipette

Basic Mark-making

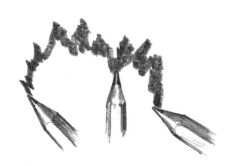

 The basis of all drawing and painting is, clearly, making marks on a surface. However, faced with pristine white paper, it is often very daunting for a beginner to make any initial marks at all, especially with paint or ink that cannot be erased. The next problem is: what sort of mark?

Analysing the strokes I use in my own artwork, I have compiled a list of eight basic stroke applications that may be adapted in various ways for all subjects and textures and used in all pencil, ink and water-based media. They may be employed individually, as part of a combination with another stroke, and with various adaptations.

The illustration opposite, executed in charcoal pencil, demonstrates these applications, giving the page numbers where you will find the strokes fully described. On these pages there are pencil exercises for you to practise in order to relate them to your own interpretations. These are followed by watercolour brushstrokes that emphasize the similarities of application between the different media.

Once you have become practised in understanding and using these strokes you will be able to look at a subject you want to depict and start to formulate ideas about how you will tackle the technical aspects of showing its form and texture before you ever commit yourself to paper, allowing you to make a confident and informed start on your pictures.

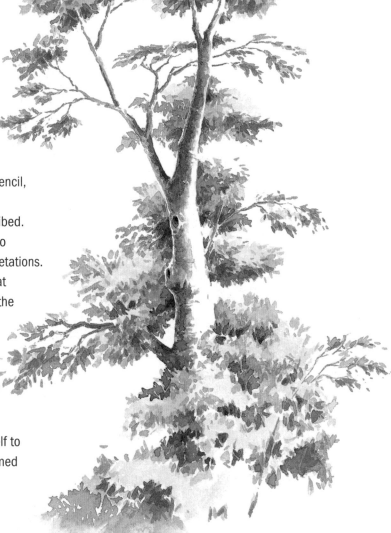

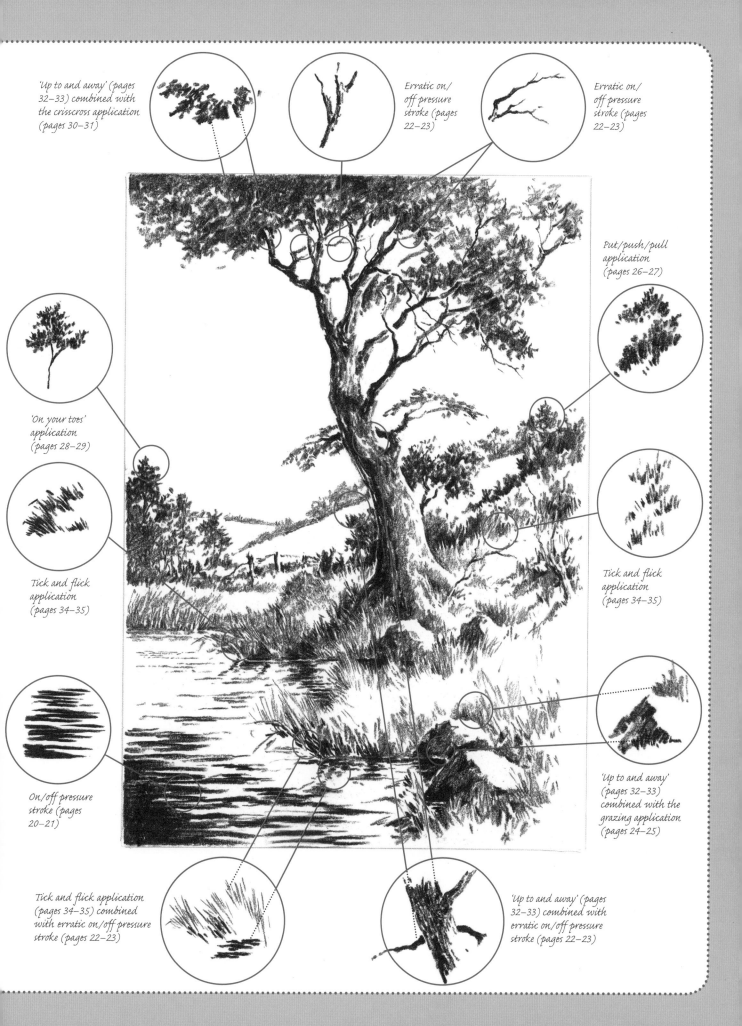

'Up to and away' (pages 32–33) combined with the crisscross application (pages 30–31)

Erratic on/off pressure stroke (pages 22–23)

Erratic on/off pressure stroke (pages 22–23)

Put/push/pull application (pages 26–27)

'On your toes' application (pages 28–29)

Tick and flick application (pages 34–35)

Tick and flick application (pages 34–35)

On/off pressure stroke (pages 20–21)

'Up to and away' (pages 32–33) combined with the grazing application (pages 24–25)

Tick and flick application (pages 34–35) combined with erratic on/off pressure stroke (pages 22–23)

'Up to and away' (pages 32–33) combined with erratic on/off pressure stroke (pages 22–23)

Introducing the Eight Basic Strokes

All the artwork in this book, no matter how complicated it may look, has been created with just eight basic strokes. They are my repertoire of applications with pencil or watercolour brush for all my images and I will be repeating them in different contexts throughout the book to help you to understand the importance of the pressure and direction of strokes in relation to the subject matter.

For example, on pages 36–39 I have used the image of a fabric doll to demonstrate how the eight basic strokes may be used to represent a soft toy and folds of cloth. The same eight applications are used to depict different textures on the post with foliage and grass on pages 58–63.

These strokes will give you the techniques to describe any surface in line, tone and texture, which means you will be equipped to tackle any drawing or painting you wish to. I have used a smooth-surfaced drawing paper and a 9B Derwent Graphic pencil to demonstrate these stroke applications (see the illustration on the page opposite), and it is the variety of pressure and directional application that produces the different effects. Before you begin the exercises, make a tonal block to prepare your pencil (see Artist's Technique panel).

ARTIST'S TECHNIQUE

The best tool for sharpening pencils is a utility knife rather than a pencil sharpener or craft knife. The aim is to create a good point by angling the blade to such an extent that it glides over the wood, removing slivers rather than chips.

Turn the pencil as it is being sharpened to ensure evenness

Pull the pencil towards the blade

Keep the hand holding the knife still, moving only the hand holding the pencil

Making a tonal block using the edge of the pencil strip allows you to see the texture you can achieve on your paper surface and also produces a chisel edge to the strip.

This study illustrates combinations of the stroke applications shown opposite, emphasizing tonal values and the effective use of strong contrasts.

Eight Basic Strokes

1. *On/Off Pressure Stroke* (pages 20–21)

Start by gently applying pressure on the pencil, holding it in the normal writing position. As the pencil travels, put firmer pressure on it to widen the stroke.

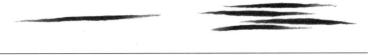

2. *Erratic On/Off Pressure Stroke* (pages 22–23)

Squeeze the pencil tightly so that your hand shakes, making an irregular line **(a)**. Twisting the pencil as you work gives you less control and therefore more interest of line **(b)**. Zigzagging the pencil produces blocked (wider) areas.

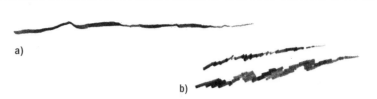

a)

b)

3. *Grazing Stroke* (pages 24–25)

Skim the pencil over the surface of the paper, using the wide chisel edge for broad areas **(a)** and the fine point for clarity of detail **(b)**.

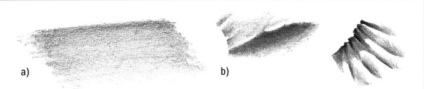

a)

b)

4. *Put/Push/Pull Application* (pages 26–27)

Start with a single push up stroke then change the angle of the pencil to a vertical position and pull down **(a)**. The stroke can be used for overlaying tones as a solid block **(b)** or for individual strokes **(c)**.

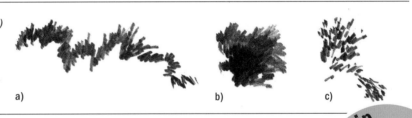

a)

b)

c)

5. *'On Your Toes' Application* (pages 28–29)

Hold the pencil vertically to the paper as you work. Use it for stippling outlines **(a)**, for linear applications and for building up tone by stippling **(b)**.

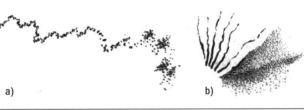

a)

b)

> **tip**
>
> The 'dancing on your toes' application is also useful for creating individual leaf shapes (see page 28).

6. *Crisscross Application* (pages 30–31)

Make a basic cross to start, maintaining contact with the surface of paper throughout. Overlap the strokes to build up tone **(a)** or use more delicately for a fine crisscross application **(b)**.

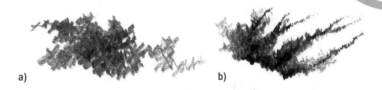

a)

b)

7. *'Up to and Away' Application* (pages 32–33)

This allows you to bring tone up to a light shape without encroaching upon it. Zigzag tone up to and away from the light side of the object, then clarify the edge of the object and continue to tone away from it.

8. *'Tick and Flick' Application* (pages 34–35)

Make a brief downward stroke followed by a firm upward flick **(a)**. Good for grass and hair, it is also useful for a variety of gentle grazing tones **(b)**.

a)

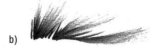

b)

Paper Comparisons

It is important to be aware of how your chosen pencil will react upon different paper surfaces. A hard pencil grade, when used with heavy pressure, may make unwanted indentations in the paper. A soft grade of pencil may smudge too easily or produce strokes that are too wide for the delicacy you want in some detailed drawing.

On textured paper surfaces, soft grades produce instant textured effects. If this isn't what you want you will need to experiment with different grades until you find the one that suits your purpose.

Practising Linear and Tonal Applications

Here I have chosen Derwent graphic pencils, ranging from HB to 9B, to demonstrate how you can practise **(a)** linear application, **(b)** tonal application and **(c)** a mix of both to see how these grades react upon your chosen paper surface. I have used ordinary copier paper.

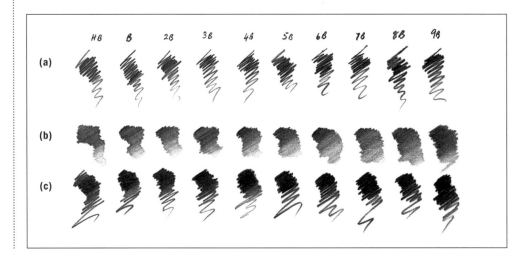

Using White Drawing Cartridge Paper

Here I have used 110gsm (51lb) white drawing cartridge paper on which to make a series of marks taken from an extension of the basic tonal block, using a very soft grade pencil. Practise these marks until you feel confident in your handling of the pencil.

The solid tonal block gradates into texture and lighter tonal value and progresses to a wide linear stroke of medium tonal value. The very soft pencil used has produced a textured impression

The medium tonal value of (a) may be intensified (b) by turning the pencil slightly during application. A return stroke (c) may be used to widen the image

(a) **(b)** **(c)**

By using the alternate side of the strip, which is narrow, you can achieve a fine line

You can produce a downwards zigzag without turning the pencil within your fingers, pressing and lifting pressure alternately as you work. You will find the strip of a soft pencil automatically widens

Re-establish the chisel and fine sides of the pencil strip by producing another tonal block and work from the pale tone into a wide stroke. Twist the pencil for irregular effect

Make a series of on/off pressure strokes, twisting the pencil in a continuous movement

Using a Dual-purpose Paper

A Bockingford 190gsm (90lb) paper is suitable for drawing as well as watercolour. Again, practise upon this surface with different pencil grades until you find the one that suits your purpose. If you want your pencil marks to have a more textured appearance this paper is ideal. Shown here is exactly the same series of strokes as on the opposite page, using the same soft grade drawing pencil, only this time made on the textured surface of the Bockingford paper.

　　After you have practised the strokes on this paper it is a good idea to obtain a variety of paper samples upon which to try exactly the same application of strokes so you can see the different effects that may be achieved using the same grade of pencil. An HP watercolour paper is also suitable for pencil work and the Saunders Waterford slightly off-white surface is ideal for delicate interpretations. The next step is to try other pencil grades in the same way to familiarize yourself with the materials you intend to use for your drawings.

tip

Practise pressing and lifting a series of randomly placed lines to help you appreciate how easily different effects may be achieved. Try varying the direction to achieve versatility of application.

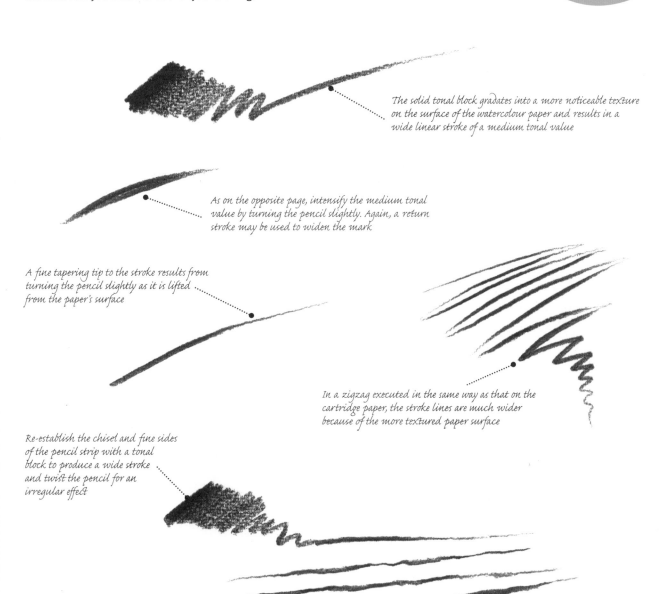

The solid tonal block gradates into a more noticeable texture on the surface of the watercolour paper and results in a wide linear stroke of a medium tonal value

As on the opposite page, intensify the medium tonal value by turning the pencil slightly. Again, a return stroke may be used to widen the mark

A fine tapering tip to the stroke results from turning the pencil slightly as it is lifted from the paper's surface

In a zigzag executed in the same way as that on the cartridge paper, the stroke lines are much wider because of the more textured paper surface

Re-establish the chisel and fine sides of the pencil strip with a tonal block to produce a wide stroke and twist the pencil for an irregular effect

Subsequent strokes are given interest by twisting or rocking the pencil as it travels, using the on/off pressure stroke

The On/Off Pressure Stroke

MEDIA: VERY SOFT GRADE PENCIL ON 110GSM (51lb) CARTRIDGE DRAWING PAPER

The on/off pressure stroke is useful for a wide range of effects, especially for hair and water ripples as the regular application of pressure and lift from the paper surface gives the impression of a surface sheen. The widening of the strokes that occurs as you work downwards is also helpful in lending a three-dimensional effect to an expanse of water. A very soft grade pencil is used in order to achieve the necessary width of stroke when pressure is applied.

Apparently simple and straightforward, the on/off pressure stroke is invaluable in developing your control of the pencil as you practise it.

How to Execute the On/Off Pressure Stroke

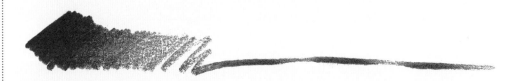

1. Start by making a tonal block, trying to achieve the darkest dark possible by exerting heavy pressure upon the paper. Lift the pressure as the pencil travels and you will see a textured appearance in the lighter tone. Then proceed into an on/off pressure line; you have now created a chisel and fine side to your pencil strip.

2. Hold the pencil in the normal writing position. Using the chisel side of the strip to obtain maximum width, start the stroke by gently applying pressure to the paper. As the pencil travels from immediately in front out towards the side, the angle at which you are holding the pencil will change. To obtain maximum width of stroke, place firmer pressure upon the pencil at this angle before easing pressure again as you end the stroke.

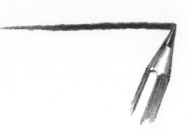

ARTIST'S TECHNIQUE

The on/off pressure stroke is useful for drawing people, both for showing lines and wrinkles and for describing patterns on fabric (see page 91).

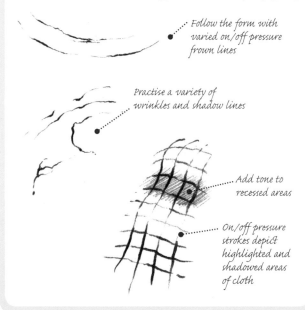

Follow the form with varied on/off pressure frown lines

Practise a variety of wrinkles and shadow lines

Add tone to recessed areas

On/off pressure strokes depict highlighted and shadowed areas of cloth

Creating a Sheen Effect

For this, use the fine tip of the pencil strip to give you a finer line. Draw a single sequence of on/off pressure strokes and then align further strokes beneath them, working down the paper towards you. However fine your first strokes are you will notice that the strokes will widen as the tip loses its fine point; eventually they will be as wide as those made by the chisel side.

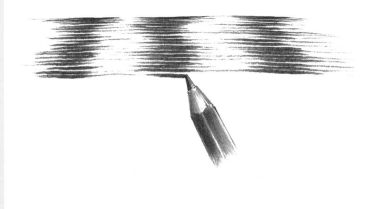

Using a Contour

Experiment with stroke application at different angles, putting various pressure strokes together to make a pattern. Here I have changed from the diagonally drawn basic stroke application to various contoured interpretations that work together and make an interesting exercise to practise.

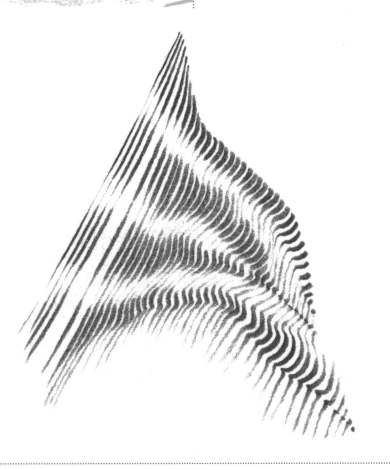

Using the On/Off Pressure Stroke Application in your Sketching

This example demonstrates how the smooth on/off pressure stroke may be used for the depiction of water ripples. For the representation of wire or twine from the post and to show its texture, use the twist and zigzag applications described on pages 22–23.

tip

It is the fluidity of movement that creates highlight effects successfully in this stroke application. Practising these strokes will help you to achieve pencil control that will be of benefit for all your strokes.

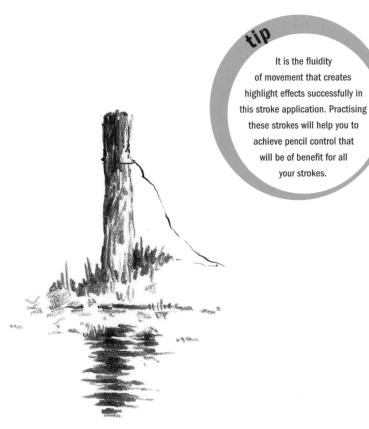

Try placing basic on/off pressure strokes close together to realistically represent water reflections. Here, each stroke illustrates a ripple in the water

The Erratic Pressure Stroke

MEDIA: VERY SOFT GRADE PENCIL ON 110GSM (51LB) CARTRIDGE DRAWING PAPER

Carried out with a very soft grade pencil, this basic stroke application is similar to the on/off pressure stroke on pages 20–21, but differs in that it is applied with erratic, or uneven, pressure upon the pencil. With its variations, it has a wide range of uses, not only in creating the impression of textured surfaces in your drawings but also as a way of introducing the interest of 'edge' lines in your linear representations. The latter prevents a hard, diagrammatic outline around images, which tends to flatten the form.

How to Execute the Erratic Pressure Stroke

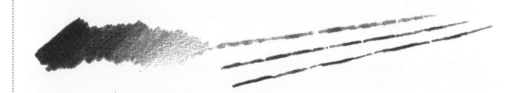

1. Make a gradated tonal block as before to create a chisel side to your pencil strip. Notice how a textured effect is produced when you use a lighter pressure on the pencil.

2. Using erratic pressure upon the pencil strip, create a series of on/off pressure strokes. To create this type of stroke it may help to hold the pencil tightly and allow your hand to shake a little as you make the stroke, using slightly jerky movements as the pencil travels so that it skims the surface unevenly.

The Directional Erratic Stroke

By holding the pencil at the angle shown throughout the stroke, you will achieve a 'directional' feel to the application that can describe form or help to lead the viewer's eye where you wish it to go.

Gently allow your pencil to travel along at an angle with slightly jerky on/off pressure application

The Erratic Zigzag Stroke

This stroke is achieved by irregular zigzag application, producing some blocked areas in contrast to the line of single width. It may vary in width according to the width of the pencil's chisel-shaped strip.

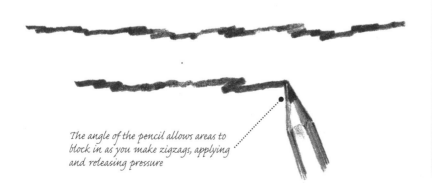

The angle of the pencil allows areas to block in as you make zigzags, applying and releasing pressure

ARTIST'S TECHNIQUES

Making a series of erratic pressure strokes is an excellent way of creating the impression of a tiled roof.

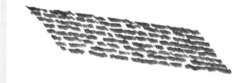

Applied vertically, the erratic zigzag stroke is useful for depicting the textured bark of a tree trunk.

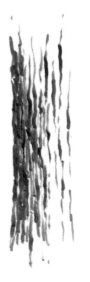

The Twist or Rock Stroke

By twisting or rocking the pencil at the same time as you apply and lift pressure, you will achieve the impression of contrasting wide and narrow lines.

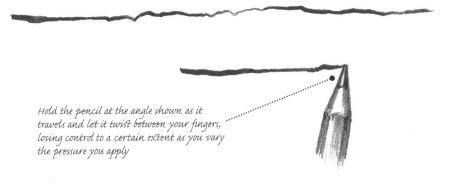

Hold the pencil at the angle shown as it travels and let it twist between your fingers, losing control to a certain extent as you vary the pressure you apply

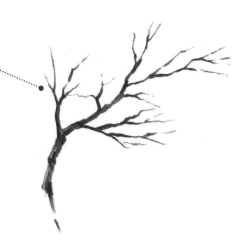

Twisting or rocking the pencil is ideal for the depiction of twigs and small branches on trees as well as for showing small shadowed cracks in walls

Using the Erratic Pressure Stroke to Represent a Well

This rough sketch of a well clearly illustrates how the erratic pressure stroke can be used to effectively depict a number of different textures.

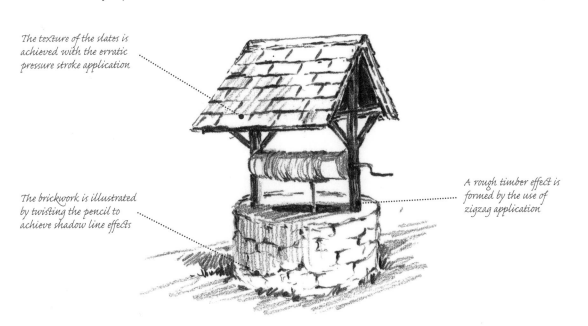

The texture of the slates is achieved with the erratic pressure stroke application

The brickwork is illustrated by twisting the pencil to achieve shadow line effects

A rough timber effect is formed by the use of zigzag application

The Grazing Application

MEDIA: VERY SOFT GRADE PENCIL ON 110GSM (51LB) CARTRIDGE DRAWING PAPER

Executed with a well-established chisel side to the pencil strip, a grazing application of wide strokes placed directly against each other forms areas of tonal values that combine to create interesting contrasts against the white paper. These strokes may be swept directionally into representing large forms, for example hills and mountains, and are also useful for building tone.

By grazing the fine point of the pencil strip directionally over the paper surface – especially if you lift the pencil from the paper completely in mid-stroke – you can achieve effective contrasts of highlight and dark tone.

There are two methods of applying the grazing stroke: continuous application and individual application. As usual, make a tonal block first to establish a chisel side to your pencil strip (see page 16).

How to Execute the Grazing Stroke

1. For continuous application, use the chisel side of the pencil strip and create a solid tonal area with horizontal strokes back and forth, just maintaining contact with the paper surface throughout.

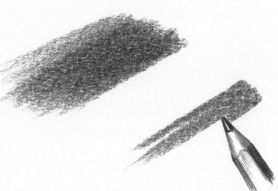

2. For individual application, place the strokes alongside each other to form a tonal area or shape, lifting the pencil between each stroke. Hold the pencil at a shallower angle (with the wooden casing nearer to the paper) to make maximum use of the chisel side.

Using High Contrast

Even though you are not exerting pressure on the paper, you can create dark tones by overlaying strokes. Setting the darkest tones directly against the lightest gives high contrast to add drama.

Practise taking the grazing strokes into recognizable tonal shapes, setting crisp dark edges against the lightest tones

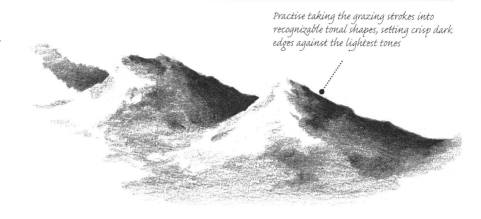

Enhancing Texture

Grazing strokes across the surface emphasizes the surface of textured paper, especially where you are applying lighter tones.

Practise applying grazing strokes in gradated tones from dark to light on a textured paper to see how you might describe light and shade on the roughcast wall of a building, for example

Describing Form

On a rounded form, the light will reflect more strongly on areas directly facing it, while areas curving away will be darker in tone. The grazing stroke is ideal for laying down areas of varying tone. Using the fine side of the pencil strip rather than the chisel side will give a smoother effect, even on the same paper surface.

To show a cylindrical form, make continuous grazing strokes to build up dark tone and midtone areas, leaving white paper between to indicate where the light strikes the object

Cast Shadows

You can use either continuous or individual grazing strokes to show cast shadows. Remember that a shadow thrown upon an object will follow its form.

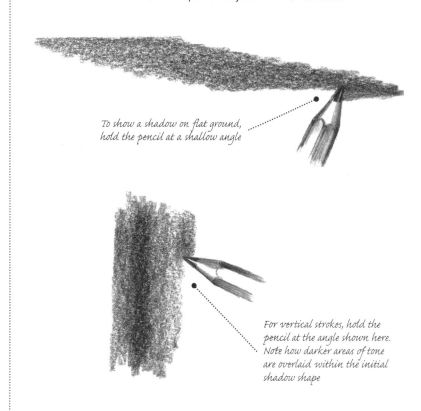

To show a shadow on flat ground, hold the pencil at a shallow angle

For vertical strokes, hold the pencil at the angle shown here. Note how darker areas of tone are overlaid within the initial shadow shape

Using Contoured Strokes

A smooth rounded object will have more shine on the surface than a rough-textured one. To practise this, make a tonal block of fine strokes side by side, then progress to contoured strokes.

tip

When applying the grazing strokes against each other to depict highlights in hair, press firmly to start the stroke, lift pressure as the pencil travels and flick off swiftly to create tapers to your strokes.

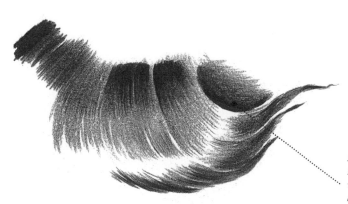

Start the stroke, then lift the pencil strip from paper mid-stroke before reapplying pressure to complete it, leaving white paper to depict highlighted areas. Intensify the dark areas for maximum contrast

The Put/Push/Pull Application

MEDIA: VERY SOFT GRAPHITE PENCIL ON 110GSM (51LB) CARTRIDGE DRAWING PAPER

The combination of push and pull that defines this application lends itself naturally to the depiction of foliage masses, so here I am demonstrating three examples of its use for this. By retaining contact with the paper as much as possible, you can swiftly achieve a silhouette shape of the upwards and outwards growth of foliage masses. Alternatively, you can apply directional strokes individually, pulling them down for trailing foliage.

The sequence of the three components of this stroke application is important – and for foliage representation, they need to be applied in the direction of growth.

How to Execute the Put/Push/Pull Stroke

1. First make a tonal block (see page 20), then put the pencil strip, chisel side, against the paper.

2. Then push upwards to make the first mark. Following this, maintain constant contact with the paper surface.

3. Pull down, moving into the body of the foliage mass, before moving upwards again. This achieves short directional movements, close together, to mass the strokes.

Constant Contact

When you are using this application to give the impression of foliage mass, try to fan out the way the strokes are placed in relation to the particular tree species you are depicting.

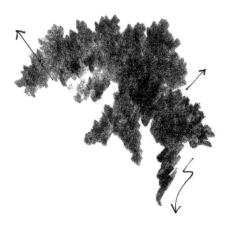

This effect is achieved by keeping the pencil strip in constant contact with the paper's surface, giving the impression of dense foliage. The arrows show the direction of the pencil strokes.

Massed Put and Push Strokes

Making a series of massed individually placed put and push strokes, with the pencil strip losing contact with paper after each stroke, gives a different foliage effect.

Taking the pencil off the paper leaves flecks of white space showing, suggesting sparser, airy foliage

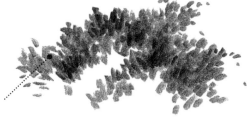

Using Pull Down Strokes

Many plants have trailing foliage, and for these you will need to use mostly pull down strokes to follow the direction of growth.

To show a spray of trailing foliage, fan out individual strokes in varying directions of growth, reducing their number towards the ends of each branch

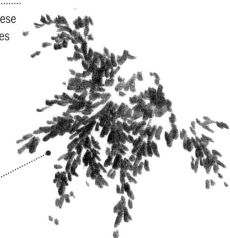

Using the Put/Push/Pull Stroke to Build up Foliage

Fanning out the put/push/pull stroke is ideal for leaving areas of white paper to suggest light branches against a darker background or, conversely, sky seen through open spaces in the foliage. Silhouette shapes are useful for the depiction of distant trees, while if you want to present a tree in the foreground, with expanses of highlighted and shadowed areas, the same stroke application will serve you well.

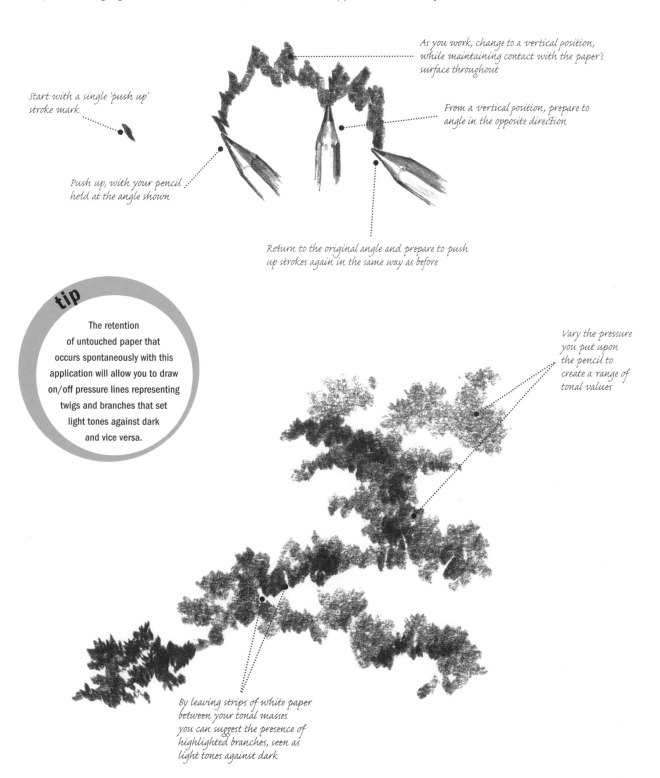

As you work, change to a vertical position, while maintaining contact with the paper's surface throughout

Start with a single 'push up' stroke mark

From a vertical position, prepare to angle in the opposite direction

Push up, with your pencil held at the angle shown

Return to the original angle and prepare to push up strokes again in the same way as before

tip

The retention of untouched paper that occurs spontaneously with this application will allow you to draw on/off pressure lines representing twigs and branches that set light tones against dark and vice versa.

Vary the pressure you put upon the pencil to create a range of tonal values

By leaving strips of white paper between your tonal masses you can suggest the presence of highlighted branches, seen as light tones against dark

The Eight Basic Strokes: PUT/PUSH/PULL in Pencil

The 'On Your Toes' Application

MEDIA: VERY SOFT GRADE PENCIL ON 110GSM (51lb) CARTRIDGE DRAWING PAPER

Cartridge drawing paper allows for fine-detailed representations using the 'on your toes' method. In order to achieve delicate detail you need to sharpen the pencil strip to a fine point and hold it vertical to the paper's surface. Here I am demonstrating further ways of describing trees as well as showing how this technique is capable of rendering fine detail.

You may choose to sharpen your pencil with either a knife or pencil sharpener – the latter may make it easier to achieve the finest tip possible to the pencil strip. You will need to resharpen the strip more frequently for this stroke application than for others. Alternatively, make a tonal block to establish a chisel side to the pencil strip (see right).

How to Execute the 'On Your Toes' Application

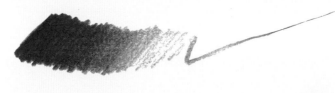

1. If you want to make a chisel edge on your pencil, make a tonal block then take the wide chisel line into a narrow line by turning the pencil.

2. The term 'on your toes' refers to the position in which the pencil is held in relation to the paper surface. Place it vertical to the paper so that you can use the fine tip of the strip to create delicate marks. A chisel edge allows you to make broader marks.

Combining Applications

As the 'on your toes' application is a way of holding the pencil rather than a stroke in itself, you can combine it with other applications such as the on/off pressure stroke to suit the subject you are drawing.

Here the 'on your toes' position is used as in the put/push/pull application (see pages 26–27) to draw foliage

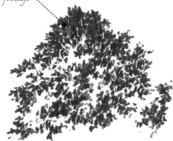

Interesting contour lines may be achieved in the 'on your toes' position with on/off pressure application

Here a hard (HB) pencil is used to increase the preciseness of the line

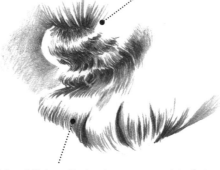

Using a very soft (9B) pencil gives a more diffuse, textured quality to the mark-making

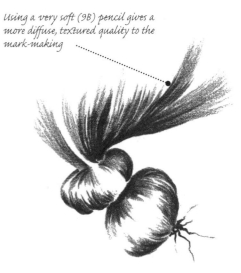

Tick and flick application (see pages 34–35) in the 'on your toes' position produces delicacy of line

ARTIST'S TECHNIQUE

Holding the pencil vertically to the paper allows you to draw delicate edges to your images.

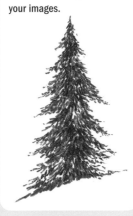

Stippling

In the stippling technique, tone is built up by applying masses of tiny dots or dashes. This is done by swiftly placing firm pressure down on to the paper surface as individual movements, using a sharp point or the fine side of the chisel strip.

ARTIST'S TECHNIQUE

When you are depicting delicate silhouette shapes – for example, distant trees in a landscape – the 'on your toes' method of application will enable you to achieve fine edges to your images. It is a very versatile way of working as you can create delicate twig and branch effects or, at the opposite extreme, solid tonal shapes.

Working with the pencil held vertically to the paper, you will be able to achieve delicacy of line

Massed dots form areas of tone and, when closely massed, the tone will appear darker. For lighter areas of tone the dots are more widely spaced

Stippling may also be in the form of dashes. For these you may find the chisel side of the strip more useful

The 'on your toes' application is helpful when you are cutting in behind a light form with darker tones as it gives you very precise control of the pencil

Using the chisel edge helps you to achieve solid tonal shapes while holding the pencil vertically

By stippling you can put in tone with only a vague suggestion of form, leaving more defined edges to attract the viewer's eye to where you wish it to go

Use 'on your toes' for delicate twigs and branches, where you need to create fine lines to show their form

The Crisscross Stroke Application

MEDIA: VERY SOFT GRADE PENCIL ON 110GSM (51lb) CARTRIDGE DRAWING PAPER

You can use the crisscross stroke for many subjects, but you will probably find it most useful for trees and foliage masses of shrubs or pot plants. You will see from my demonstrations that it's an excellent way to work if you are looking for a looser application in comparison to the precision of the 'on your toes' way of working.

You will need a sound understanding of your subject in order to define the shapes you are creating with your massed crosses. In the case of foliage masses, you will have to differentiate between the dark-shadowed recessive shapes within lighter tonal areas and the interesting overall silhouette shapes they make.

The crisscross application is easier to master if you start by maintaining constant contact with the paper's surface, but once you feel confident also try lifting the pencil from the paper to produce a looser effect.

How to Execute the Crisscross Stroke

1. First make a tonal block to create the chisel side of the pencil strip, then, using the wide side, make a simple cross.

2. You may find that one side of the cross is wider than the other, depending upon how you hold your pencil.

3. Next, make a cross without allowing your pencil to leave the paper.

4. Make a second cross, but this time place less pressure on one arm of the cross. Practise these basic strokes until you feel confident that you can place them accurately.

Maintaining Contact

Keeping contact with the paper throughout, create crosses to form a tonal shape, applying and releasing pressure to avoid uniformity.

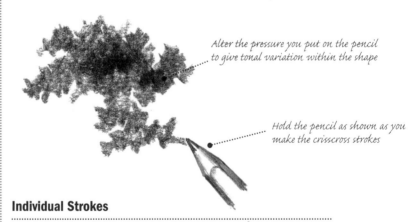

Alter the pressure you put on the pencil to give tonal variation within the shape

Hold the pencil as shown as you make the crisscross strokes

Individual Strokes

Taking the pencil off the paper between the strokes gives a looser effect with more feeling of movement in the image, especially if they are applied unevenly, with less pressure.

Here tone is built up with unevenly applied individual strokes based upon the crisscross application

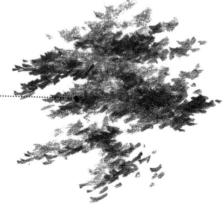

The Crisscross Stroke in the Landscape

You will find this application very useful for drawing landscapes, where it is excellent for trees, hedges and water. Remember to leave plenty of white paper showing to take full advantage of the characteristics of the stroke.

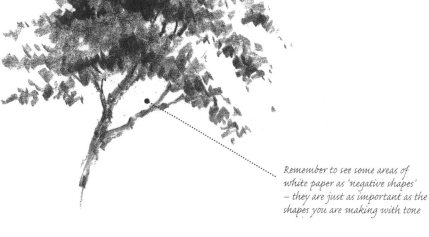

By leaving untouched paper in areas that you wish to appear as the lightest lights you will be able to suggest a three-dimensional feel to massed foliage on a tree

Here the crisscross movement produces interesting silhouette edges to the image

Remember to see some areas of white paper as 'negative shapes' – they are just as important as the shapes you are making with tone

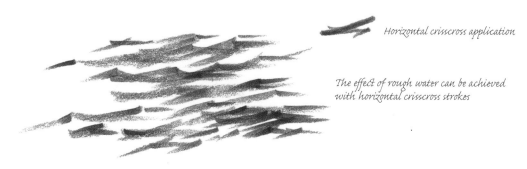

Horizontal crisscross application

The effect of rough water can be achieved with horizontal crisscross strokes

Light-pressure crisscross application for texture on stone

Heavy-pressure crisscross application for shadow within foliage

Crisscross away out into the paper to diffuse tone to its faintest

For those effects a basic cross keeping contact with the paper has been used

The 'Up to and Away' Application

MEDIA: VERY SOFT GRAPHITE PENCIL ON 110GSM (51lb) CARTRIDGE DRAWING PAPER

When you are defining the edges of forms that are lighter in tone than the background area it is important to avoid any background toning overlapping. 'Up to and away' provides an effective way of preventing this from happening. You can use any stroke application for this, but zigzagging is the easiest method.

Unless your aim is to achieve fine detail, make sure you have created a very wide chisel side to your pencil strip, for you will be almost painting with the pencil when you are putting in these expanses of tone to indicate dark areas behind light shapes. If you experience difficulty with cutting in crisply against the edge of the light shape, just turn your pencil slightly to give you a more defined edge.

How to Execute the 'Up to and Away' Application

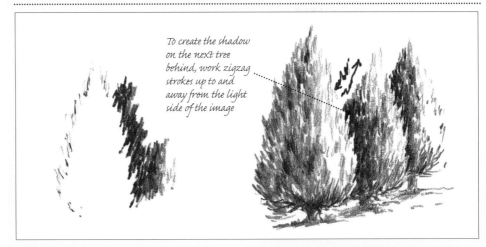

To create the shadow on the next tree behind, work zigzag strokes up to and away from the light side of the image

1. After making a tonal block to create the chisel side of the pencil strip (see page 20), take closely worked zigzag strokes up to and away from the light tone that you want to preserve.

2. Define the light edge of the form by clarifying the shape, working the dark area of the adjoining tree using vertical strokes, then tone away from the edge. In some areas the pencil is removed completely to represent the light side of the tree.

Practising with Tone

'Up to and away' requires some practise before you will feel confident at achieving clean edges. The best way is to begin with irregular edges before you progress to trying for a smoother line.

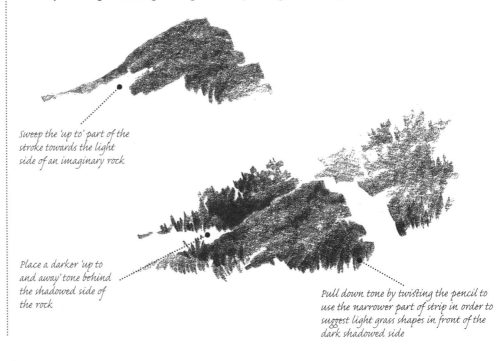

Sweep the 'up to' part of the stroke towards the light side of an imaginary rock

Place a darker 'up to and away' tone behind the shadowed side of the rock

Pull down tone by twisting the pencil to use the narrower part of strip in order to suggest light grass shapes in front of the dark shadowed side

Toning Up to a Light Form

Toning up to a light form has the effect of pushing it forward, leaving the dark tone to form a background. There is no need to firmly establish the overall edge – the viewer's eye will fill in 'lost lines'. Allowing the viewer's imagination to do some of the work gives more interest to your drawings and avoids a diagrammatic effect.

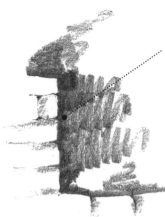

In this study of a stone wall, the edge is uneven to give the idea of the rough masonry. Toning up to the wall, establishing the contrast and then working away from the light edge has given the effect of the wall being in front of the background tone

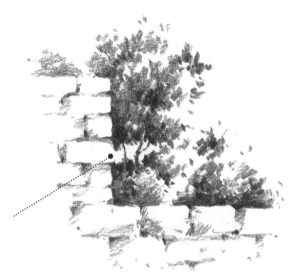

Notice how some areas may appear 'lost', where the tone is the same on the wall as in the background area. Your eye will still recognize the edge, even if there is no contrasting tone behind

Toning Shadows and Dark Backgrounds

If you are toning a dark background up to the shadowed side of an object you will need to solve the problem of the whole merging into an indistinguishable mass. The way to achieve this is to leave a very slim line of white paper to define the edge of the object.

The righthand side of the trunk is highlighted, contrasting with the dark foliage. Where there is a gap in the foliage the line is 'lost'

Increasing the depth of tone up to the edge of the trunk has made it stand forward from the foliage

Leaving a slender line of white paper showing on the edge of the tree trunk has separated it from the background foliage

The Tick and Flick Application

MEDIA: VERY SOFT GRAPHITE PENCIL ON 110GSM (51lb) CARTRIDGE DRAWING PAPER

This useful stroke, when applied en masse, swiftly creates the effect of long grasses, hair, rope strands and many similar subjects. The first part of the tick impression – down into the base of the stroke – acts only as a 'lead in' to the main upward stroke, so it requires less pressure and need only be a very short mark.

It is not necessary to make a tonal block to prepare your pencil for this application if you prefer to use a pencil sharpener or knife to obtain a very fine point. Much also depends upon the grade of pencil you choose. The rapid stroke movement may blunt a soft grade pencil quite quickly, in which case you will need to keep turning it within your fingers as you work in order to use the finest edge. You may find a harder grade pencil easier to use for these strokes.

How to Execute the Tick and Flick Application

2. Tick upwards and outwards, with the pencil leaving the paper at a shallower angle to finalize the stroke and create a tapering tip.

1. Sharpen your pencil to a good point, then make the downstroke, holding the pencil in the 'on your toes' position. The downstroke is short and is only included to provide a launch into the upward flick.

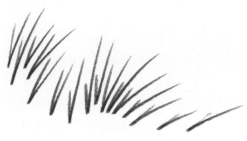

3. If the downward part of the stroke is too long it is incorrect – it should be only a brief initial mark (left to right).

Different Effects

Practise making the the ticks with different pencil grades to see the effects you can achieve with this application, and try altering the direction of the stroke and the pressure you put on the pencil.

Make a series of closely placed strokes using a very soft pencil grade

Repeat the same strokes but this time using a harder grade pencil to compare the different effects

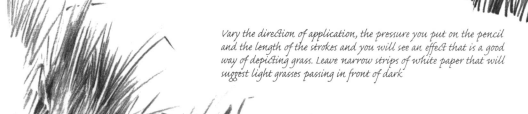

Vary the direction of application, the pressure you put on the pencil and the length of the strokes and you will see an effect that is a good way of depicting grass. Leave narrow strips of white paper that will suggest light grasses passing in front of dark

Contours and Highlights

Contouring your strokes and leaving white paper for highlights allows you to use this application for many subjects, including hair coiled into elaborate shapes, for example. As in all techniques, this will take some practise to get right but by making the same small marks over and over again you will develop your skill. The first step is to master making a smooth contour line before developing a drawing.

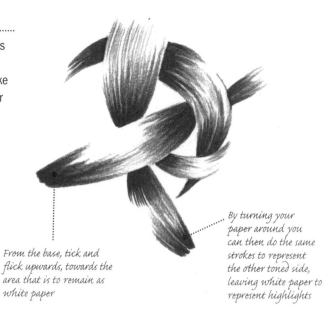

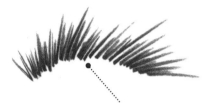

Practise tick and flick strokes from an imaginary (or lightly drawn) contour line until you can align them evenly

From the base, tick and flick upwards, towards the area that is to remain as white paper

By turning your paper around you can then do the same strokes to represent the other toned side, leaving white paper to represent highlights

To draw a feather, place a fine, contoured line and tick from it as in the exercise above, reducing the length of the strokes to taper towards the tip

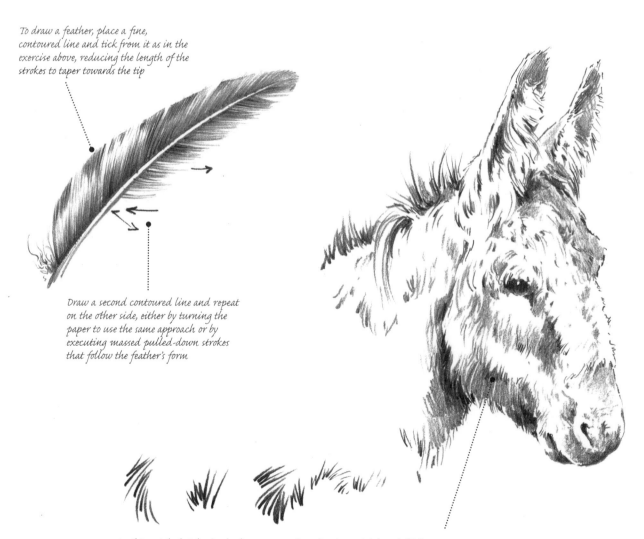

Draw a second contoured line and repeat on the other side, either by turning the paper to use the same approach or by executing massed pulled-down strokes that follow the feather's form

In this quick sketch of a donkey, contoured applications of tick and flick are cut in to allow light hair to fall over the dark shape beneath

Case Study: Fabric Doll

MEDIA: DERWENT GRAPHIC 9B PENCIL ON 190gsm (90lb) SAUNDERS WATERFORD HP PAPER

If you have practised the eight basic strokes you will be able to understand how they are used in my drawing of a fabric doll. As soft toys are ideal for use as models they also appear elsewhere within the book to help you get to grip with the strokes and use them to create a feeling of character.

A fabric doll such as this gives you an opportunity to practise the textures of wool (the doll's hair), smooth fabric (the face), gathered fabric (the sleeves of the dress), folded cloth (the skirt), delicate line work (the lace), solid tonal shape (the bodice), and pattern (the fabric of the apron).

The First Stages

The delicate linear drawing is placed first to create edges from which to tone 'up to and away' and create a three-dimensional impression. This stroke application is useful both within the image and for creating a toned supporting background contrast.

While they are still visible in the early stages of toning shown below, the initial carefully drawn on/off pressure lines will mainly be absorbed by the subsequent building up of tone so that the light forms stand forward from the dark tones behind them.

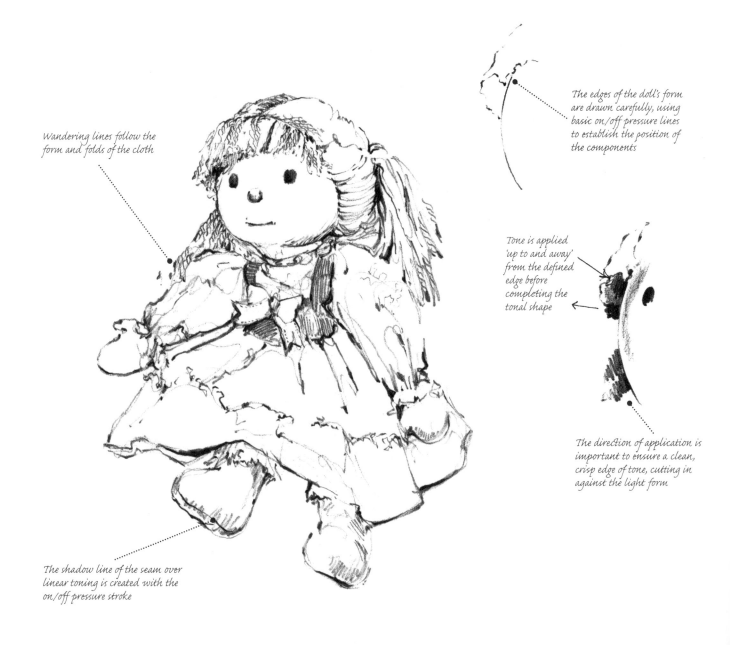

Wandering lines follow the form and folds of the cloth

The edges of the doll's form are drawn carefully, using basic on/off pressure lines to establish the position of the components

Tone is applied 'up to and away' from the defined edge before completing the tonal shape

The direction of application is important to ensure a clean, crisp edge of tone, cutting in against the light form

The shadow line of the seam over linear toning is created with the on/off pressure stroke

The Finished Tonal Study

Using a soft grade pencil has given texture within the tonal areas of the drawing. Notice where 'lost' lines have been introduced so that hard, diagrammatic outlining is avoided and where minimal pencil work has suggested a highlighted area.

tip

Before embarking on an image such as this, spend some time executing the eight basic stroke applications in relation to the various areas so that you discover how to render all the different textures and tones.

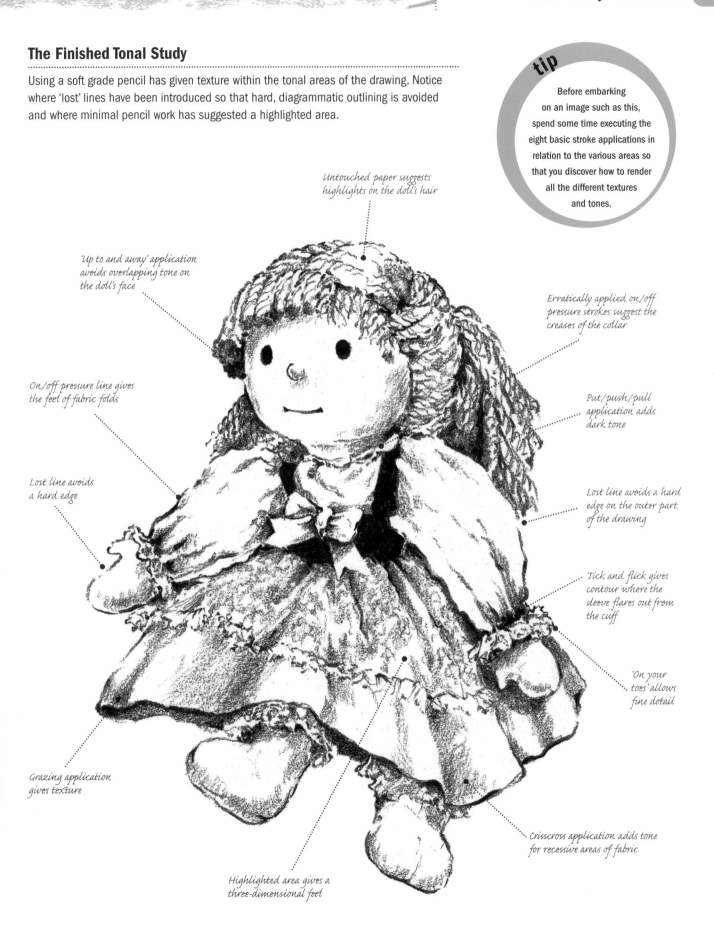

Untouched paper suggests highlights on the doll's hair

'Up to and away' application avoids overlapping tone on the doll's face

Erratically applied on/off pressure strokes suggest the creases of the collar

On/off pressure line gives the feel of fabric folds

Put/push/pull application adds dark tone

Lost line avoids a hard edge

Lost line avoids a hard edge on the outer part of the drawing

Tick and flick gives contour where the sleeve flares out from the cuff

'On your toes' allows fine detail

Grazing application gives texture

Crisscross application adds tone for recessive areas of fabric

Highlighted area gives a three-dimensional feel

Use of Tone

MEDIA: 9B PENCIL ON 190gsm (90lb) SAUNDERS WATERFORD HP PAPER

Even when we are drawing in a linear way we are able to create a variety of tones as a result of the pressure we place upon the pencil, whether heavy or light. This gives interest of line and avoids a wire-like appearance that can flatten the form.

Jagged, zigzagging strokes, made with the chisel edge of the pencil, will give wider lines that progress into tonal shapes. These may be shadowed, recessive areas or negative shapes and are very important within a drawing, adding interesting contrasts. In other areas, recessive dark tones that gradate out into lighter tones (and eventually white paper) may be required. The latter may then need a dark tone placed against them in order to establish the form in front of its background tone.

Setting the darkest dark against the lightest light is essential in areas that require strong contrasts. Directional application around forms is the starting point for building the supporting background, which may then gradate out into the light tone of the paper surface.

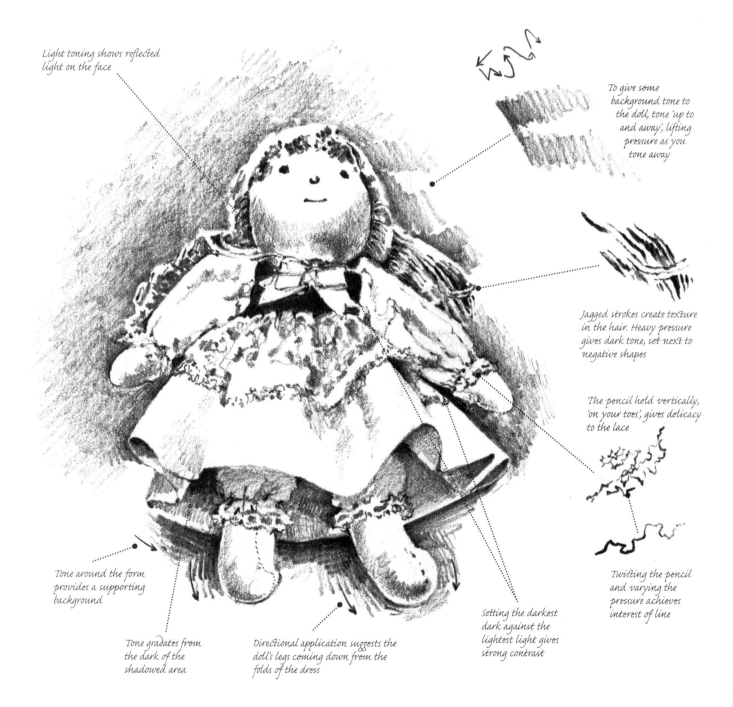

Light toning shows reflected light on the face

To give some background tone to the doll, tone 'up to and away', lifting pressure as you tone away

Jagged strokes create texture in the hair. Heavy pressure gives dark tone, set next to negative shapes

The pencil held vertically, 'on your toes', gives delicacy to the lace

Twisting the pencil and varying the pressure achieves interest of line

Tone around the form provides a supporting background

Tone gradates from the dark of the shadowed area

Directional application suggests the doll's legs coming down from the folds of the dress

Setting the darkest dark against the lightest light gives strong contrast

Drawing Detail

MEDIA: 2B or 3B PENCIL ON 190gsm (90lb) SAUNDERS WATERFORD HP PAPER

Once you start looking closely into the construction of intricate elements in your subject you will probably want to try some finely detailed pencil work. For this you will require a harder grade pencil – 2B or 3B – upon a paper with a smooth surface.

Practise little exercises relating to the textures you wish to depict, for example strands of wool, lace and ribbon.

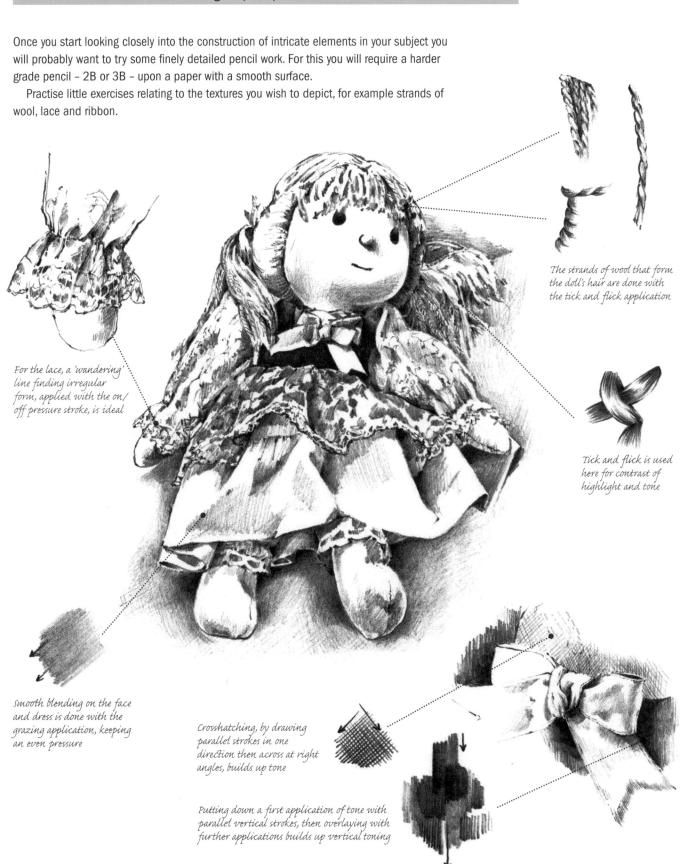

The strands of wool that form the doll's hair are done with the tick and flick application

For the lace, a 'wandering' line finding irregular form, applied with the on/off pressure stroke, is ideal

Tick and flick is used here for contrast of highlight and tone

Smooth blending on the face and dress is done with the grazing application, keeping an even pressure

Crosshatching, by drawing parallel strokes in one direction then across at right angles, builds up tone

Putting down a first application of tone with parallel vertical strokes, then overlaying with further applications builds up vertical toning

Basic Mark-making with the Brush: Watercolour

Loading your brush with a mix of pigment and water in order to make a mark upon the paper requires some thought. The method of lifting the mix from palette to paper – whether you dab the brush into the well of your palette, drag it through the mix or place it deep into the mix and turn it – will influence the shapes of the marks. The angle and direction of the application and the pressure upon the brush will also have an effect.

In addition to this, the shape and type of brush and the material of which it is made will play an important part in the making of marks. The choice is extensive – round, flat, chisel-shaped, fan, rigger and many others. Shown here is a small selection of characteristic marks.

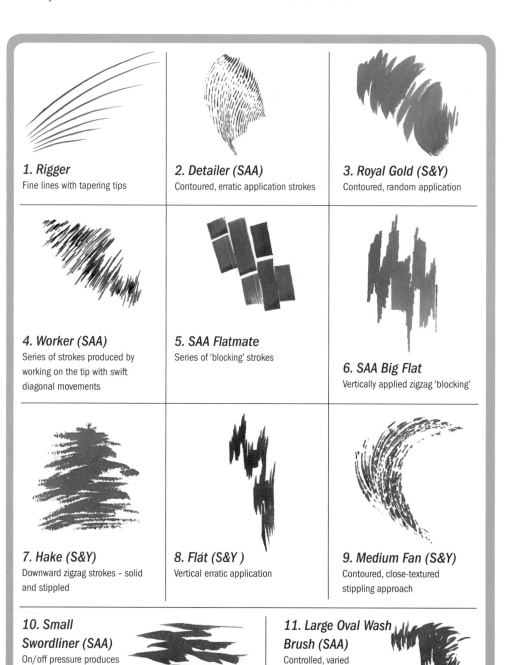

1. Rigger
Fine lines with tapering tips

2. Detailer (SAA)
Contoured, erratic application strokes

3. Royal Gold (S&Y)
Contoured, random application

4. Worker (SAA)
Series of strokes produced by working on the tip with swift diagonal movements

5. SAA Flatmate
Series of 'blocking' strokes

6. SAA Big Flat
Vertically applied zigzag 'blocking'

7. Hake (S&Y)
Downward zigzag strokes – solid and stippled

8. Flat (S&Y)
Vertical erratic application

9. Medium Fan (S&Y)
Contoured, close-textured stippling approach

10. Small Swordliner (SAA)
On/off pressure produces shapes of varying width

11. Large Oval Wash Brush (SAA)
Controlled, varied application strokes

The Effects of Different Paper Surfaces

The five warm-up swirls featured below have been executed on different paper surfaces.

Bockingford 300gsm (140lb) CP (Not)

Bockingford 300gsm (140lb) Rough

Saunders Waterford 638gsm (300lb) Rough

Saunders Waterford 190gsm (90lb) HP

Saunders Waterford 300gsm (140lb) CP (Not)

** S&Y: Stratford and York brushes, available through the SAA*

The Eight Basic Brush Stroke Applications

From watercolour brush mark-making we can move into creating the eight basic stroke applications, this time using paint. The hand movement and application is very similar to that used in pencil work, but here you will have an extra element – water – to diffuse and soften the images where required.

The brush is held in the same way as for pencil application, with varying pressure placed upon it. Firm pressure will spread the hairs, producing a wider stroke (the equivalent of the chisel side of the pencil) and lifting pressure will produce finer lines (as with the fine side of the pencil strip). You will find details on how to execute the individual strokes on pages 42–57.

The strokes demonstrated on this page were executed upon 90lb Saunders Waterford CP (Not) paper.

Eight Basic Brush Stroke Applications

1. On/Off Pressure Application (pages 42–43)

2. Erratic On/Off Pressure Application (pages 44–45)

Twisting

Zigzag

3. Grazing Application (pages 46–47)

solid tone dry brush texture

4. Put/Push/Pull Application (pages 48–49)

5. 'On Your Toes' Application (pages 50–51)

6. Crisscross Application (pages 52–53)

7. 'Up to and Away' Application (pages 54–55)

8. Tick and Flick Application (pages 56–57)

ARTIST'S TECHNIQUE

Making a preliminary swirl of paint gives you the chance to practise your brushstrokes with the particular brush and surface you are using, and to see the different effects you can achieve by holding the brush at different angles. It also loosens your hand and gets you ready for the real thing. Follow these steps to execute the warm-up swirl:

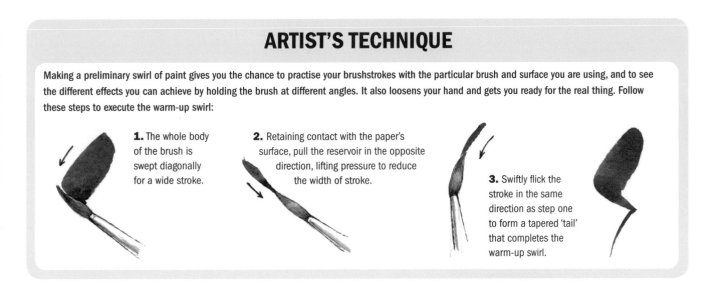

1. The whole body of the brush is swept diagonally for a wide stroke.

2. Retaining contact with the paper's surface, pull the reservoir in the opposite direction, lifting pressure to reduce the width of stroke.

3. Swiftly flick the stroke in the same direction as step one to form a tapered 'tail' that completes the warm-up swirl.

The On/Off Pressure Stroke

MEDIA: WORKER BRUSH ON 190gsm (90lb) SAUNDERS WATERFORD CP (NOT) PAPER

The on/off pressure stroke has a variety of uses and I am demonstrating two quite different ones here, concentrating mainly upon the horizontal application of the stroke. This is particularly useful for the representation of ripples upon the surface of water.

It is essential to choose a brush that possesses a fine point and good holding capacity in order to achieve tapering tips at either end of the stroke and width in the centre. Make a warm-up swirl (see page 41) before you start practising the stroke.

How to Execute the On/Off Pressure Stroke

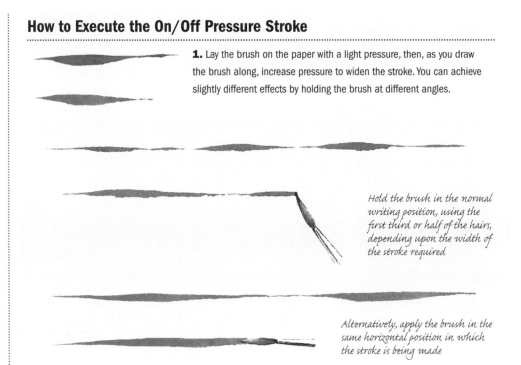

1. Lay the brush on the paper with a light pressure, then, as you draw the brush along, increase pressure to widen the stroke. You can achieve slightly different effects by holding the brush at different angles.

Hold the brush in the normal writing position, using the first third or half of the hairs, depending upon the width of the stroke required

Alternatively, apply the brush in the same horizontal position in which the stroke is being made

Painting Water

When you are painting water, establish a feeling of three dimensions by reducing the width of the ripples as they recede from you and use darker tones in the foreground.

Using both methods of holding the brush, practise laying broader strokes in the foreground and narrower, even broken, strokes towards the horizon

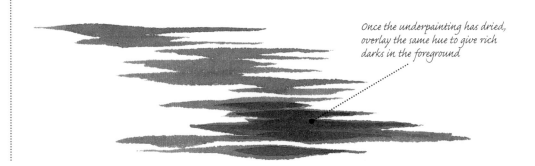

Once the underpainting has dried, overlay the same hue to give rich darks in the foreground

One-stroke Leaf Images

You will find one-stroke leaves simple to execute with the on/off pressure stroke. This versatile shape recurs on other pages of the book, so spend a little while practising it now until you feel confident about handling the brush to give exactly the shape you want.

tip

To train your eye, practise starting some leaf strokes at their outer point and work back towards a predetermined mark on the stem, twisting the brush towards the point of contact as you go.

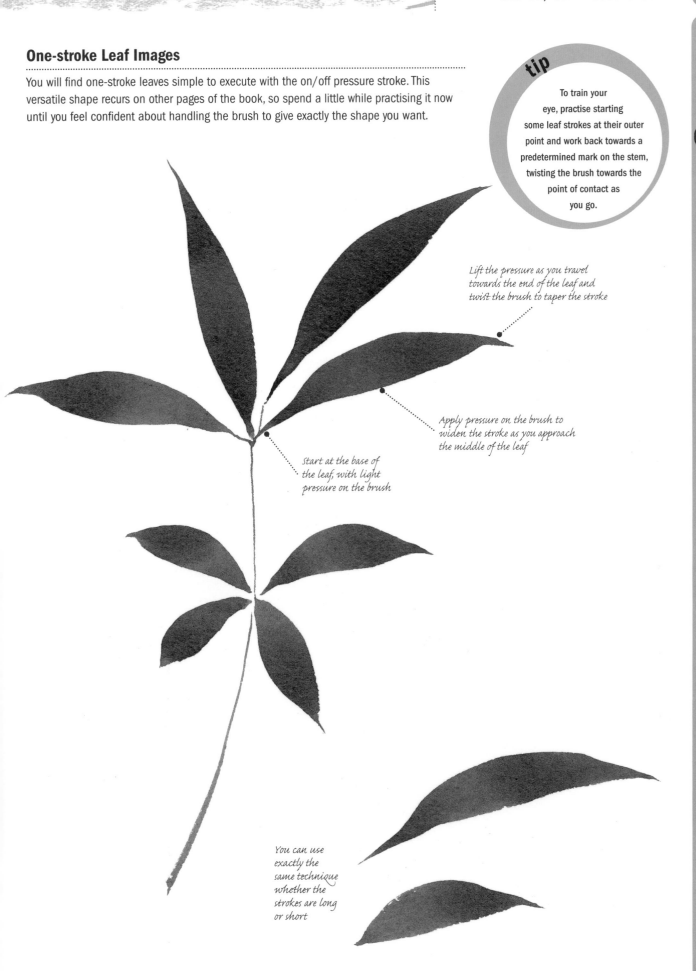

Lift the pressure as you travel towards the end of the leaf and twist the brush to taper the stroke

Apply pressure on the brush to widen the stroke as you approach the middle of the leaf

Start at the base of the leaf, with light pressure on the brush

You can use exactly the same technique whether the strokes are long or short

The Erratic Pressure Stroke

MEDIA: WORKER BRUSH ON 190gsm (90lb) BOCKINGFORD PAPER

The erratic pressure stroke and its variations are useful for suggesting texture and interest of line. As with so many of these strokes, it is the angle at which they are applied, related to the subject they are depicting, that is so important. So too is how much of the brush is in contact with the paper – the tip, one half or one third of it, or the whole length.

This stroke is particularly useful for showing tiled roofs, linear shadows, angular tree branches and twigs and texture for a range of surfaces.

How to Execute the Erratic Pressure Stroke

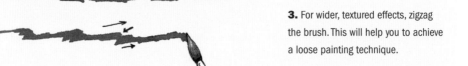

1. After making a warm-up swirl to establish how your brush and paper work together, lay an erratic line, lifting and exerting pressure. In places, lift the brush from the paper altogether. The line will vary in thickness according to the size of the brush and the pressure you place upon it.

2. Twist the brush or rock it from side to side to produce interesting variations of wide and narrow pressure lines.

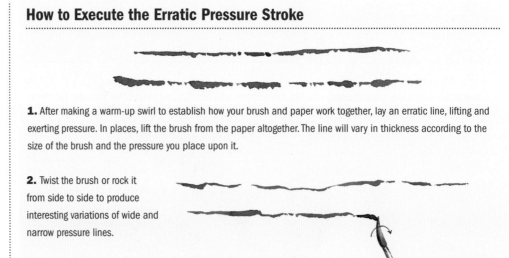

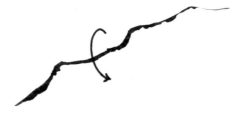

3. For wider, textured effects, zigzag the brush. This will help you to achieve a loose painting technique.

Trees and Branches

As an exercise, try twisting the brush as you work and then follow through the lines you produce to make a representation of tree branches.

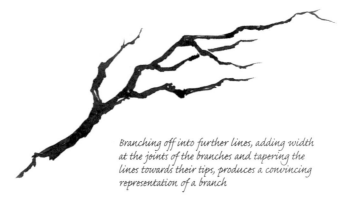

This random line already resembles a single branch of a gnarled, leafless tree

Branching off into further lines, adding width at the joints of the branches and tapering the lines towards their tips, produces a convincing representation of a branch

Vertically applied, the zigzag application is useful for the shadowed sides of objects and for background tone

Showing Expanses of Water

The varying width of the erratic pressure stroke makes it ideal for describing water. By leaving a greater or smaller proportion of untouched paper and varying the strokes, it is possible to suggest the ruffled surface of the water and the light upon it.

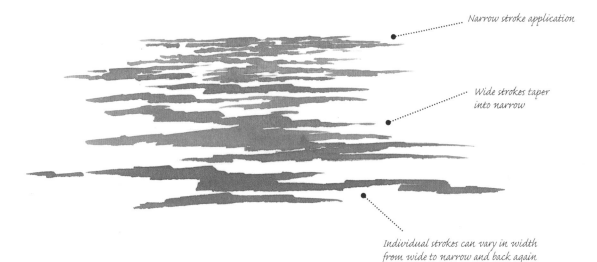

Narrow stroke application

Wide strokes taper into narrow

Individual strokes can vary in width from wide to narrow and back again

Texture, Tone and Profile

The erratic pressure stroke has a wide variety of uses, especially in representing tone on textured surfaces and uneven edges.

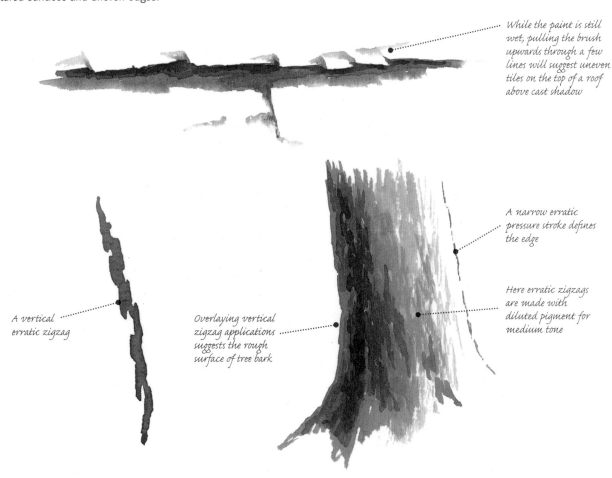

While the paint is still wet, pulling the brush upwards through a few lines will suggest uneven tiles on the top of a roof above cast shadow

A narrow erratic pressure stroke defines the edge

Here erratic zigzags are made with diluted pigment for medium tone

A vertical erratic zigzag

Overlaying vertical zigzag applications suggests the rough surface of tree bark

The Grazing Application

MEDIA: WORKER BRUSH ON 190GSM (90LB) BOCKINGFORD PAPER

Grazing, translated from drawing into painting, is simply the application of washes in watercolour. Overlaying washes, wet on dry, allows you to control the effects you achieve and will help you build your confidence.

When pigment is very diluted, should an area not look as you would wish, you can quickly blot off the paper with kitchen paper or a tissue. This will leave a slight stain that, when dry, may be overpainted and will hardly show in some instances. On other occasions a blotted-off area may actually enhance the overall appearance of your painting.

How to Execute the Grazing Application

2. After making a warm-up swirl, sweep the pigment swiftly across paper, just grazing the surface to produce a textured effect.

1. For the laying of flat washes and grazing techniques, use more of the body of the brush to take advantage of its full holding capacity.

3. Adding more pigment and water will give a solid tonal area until it is used up and texture reappears.

Building Up Tone

The grazing application is an excellent way of building up areas of dark tone in your paintings, overlaying fresh applications of paint once the previous one has dried.

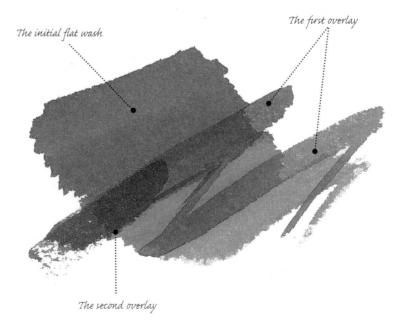

The initial flat wash

The first overlay

The second overlay

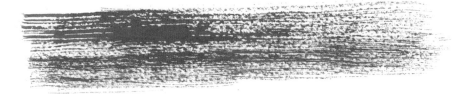

Dry Brush Technique

As the name suggests, in this technique you load minimum diluted pigment on to your brush. It is most effective on Rough surface paper, where the brush skips across the tooth of the paper leaving flecks of white paper showing – ideal for depicting subjects such as roughcast walls or, especially, light on water.

Dry brush effects can often add interest to your paintings when they are used intentionally, but they can spoil the effect when they are a result of miscalculation about the amount of pigment on your brush or are not suited to your subject, so take care how you use them.

tip

Although a round brush is capable of creating many exciting dry brush effects, you may find it easier to use a flat brush where you are trying to represent the effect of a flat surface.

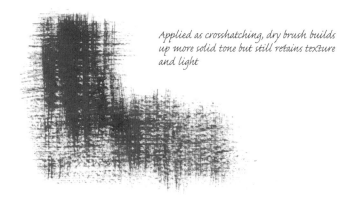

For basic horizontal dry brush grazing, load your brush very sparsely with pigment and drag it across the surface of the paper

Applied as crosshatching, dry brush builds up more solid tone but still retains texture and light

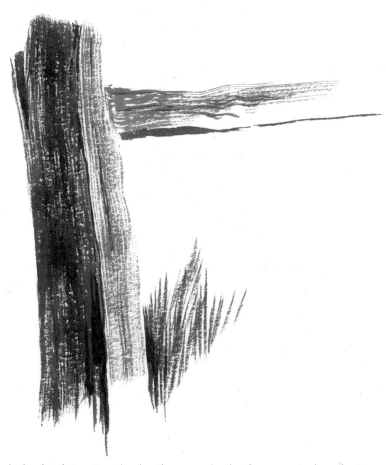

Here dry brush technique is used to describe a post and rail with grass growing beneath. The texture of the wood is summed up in a few grazing strokes, with overlaid tone on the shadowed side of the post

The Eight Basic Strokes: GRAZING in Watercolour

The Put/Push/Pull Application

MEDIA: WORKER BRUSH ON 190GSM (90LB) BOCKINGFORD PAPER

The 'put/push/pull' stroke application is particularly useful for the representation of foliage mass shapes, which can often present problems for beginners. The pushing and pulling of the brush effectively represents the mass of leaf shapes, and by overpainting with this style you can easily create hue and tone for a three-dimensional effect.

Before you start any exercises with your brush, begin with the warm-up swirl as explained on page 41, which tests for hue, tone and reaction to the paper surface. Follow the steps (right) as a basis for doing this and see below for the two variations of this stroke: constant contact and using individual 'put' strokes.

How to Execute the Put/Push/Pull application

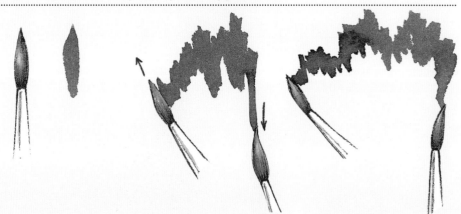

1. This is the basic 'put' position that your loaded brush should be in when it is placed on to the paper, alongside the resulting mark that is formed.

2. From the basic 'put' position, push upwards and pull downwards. The downward 'pull' stroke not only widens the initial shape of the pigment mark but also travels into the resulting image.

3. Push up into the delicate silhouette edges and downwards to achieve tonal mass. Work across from side to side, travelling downwards at the same time.

Constant Contact

Work the put/push/pull stroke application as explained above, making sure you keep your brush in constant contact with the paper for most of the execution to keep the pigment fluid. This is useful for creating hue and tone to give depth to foliage.

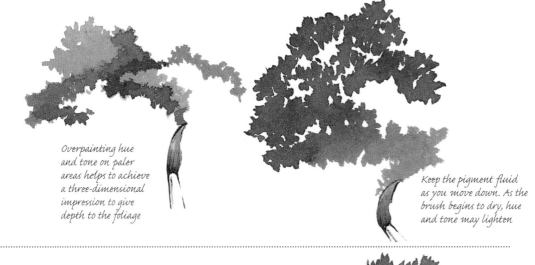

Overpainting hue and tone on paler areas helps to achieve a three-dimensional impression to give depth to the foliage

Keep the pigment fluid as you move down. As the brush begins to dry, hue and tone may lighten

Individual 'Put' Strokes

Adapt the main put/push/pull technique by lifting your brush after each stroke. The individually placed strokes will merge together to create an impression of mass foliage.

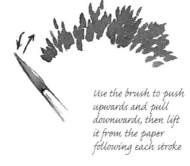

Use the brush to push upwards and pull downwards, then lift it from the paper following each stroke

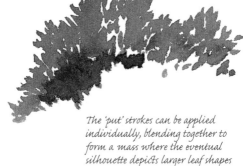

The 'put' strokes can be applied individually, blending together to form a mass where the eventual silhouette depicts larger leaf shapes

Using the Put/Push/Pull Application for Tree Representations

The put/push/pull technique is ideal for creating foliage, as the movement of the brushstrokes creates realistic leaf shapes that combine together perfectly for an effective tree representation, as shown below.

tip

The 'dancing on your toes' application is also useful for creating individual leaf shapes (see page 50).

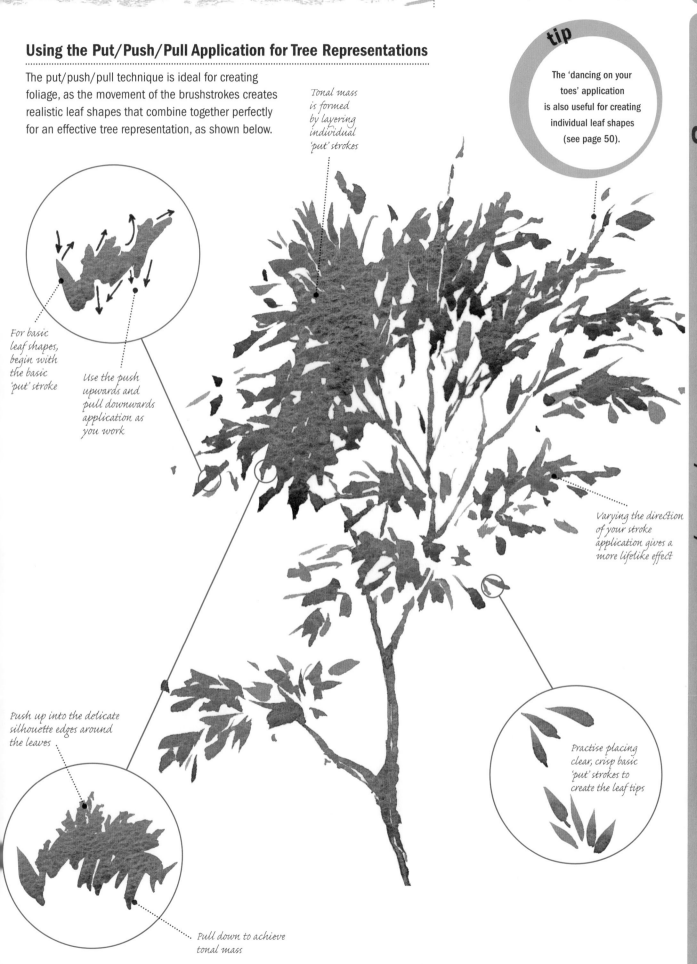

Tonal mass is formed by layering individual 'put' strokes

For basic leaf shapes, begin with the basic 'put' stroke

Use the push upwards and pull downwards application as you work

Varying the direction of your stroke application gives a more lifelike effect

Push up into the delicate silhouette edges around the leaves

Practise placing clear, crisp basic 'put' strokes to create the leaf tips

Pull down to achieve tonal mass

The Eight Basic Strokes: PUT/PUSH/PULL in Watercolour

The 'On Your Toes' Application

MEDIA: WORKER BRUSH ON 190GSM (90LB) BOCKINGFORD PAPER

Working 'on your toes' – on the very tip of the brush hairs – will enable you to achieve the most delicate of brush strokes. However, for this method, a brush that tapers to a very fine point is essential.

Contact with the paper is minimal, with the brush hairs barely touching it at all; it is often just the pigment/water mix on the tip of the brush that makes the mark on the surface. Whether you are stippling or using tiny individual strokes, think of your brush as dancing lightly over the paper.

How to Execute the 'On Your Toes' Application

 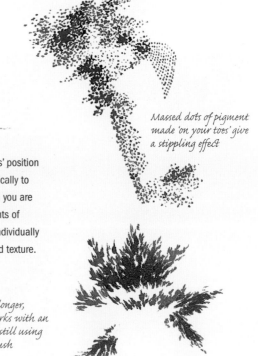

Massed dots of pigment made 'on your toes' give a stippling effect

1. First make a warm-up swirl, finishing with a fine line to learn the amount of pressure you need to make a mark with the tip of the brush.

2. In the 'on your toes' position the brush is held vertically to the paper upon which you are working. Small amounts of pigment are placed individually to achieve pattern and texture.

Alternatively, place longer, directional brushmarks with an equally light touch, still using just the tip of the brush

Painting Trees and Foliage

The 'on your toes' application is suitable for a variety of foliage and tree subjects, since the very controlled use of the brush tip allows you to describe fine edges and slender lines.

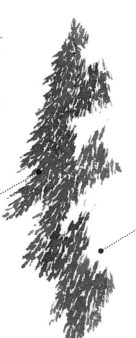

This method of application is useful to achieve the delicate edges of silhouetted tree shapes

Any untouched paper shapes that remain have plenty of interest in their edges

Combining the 'on your toes' position with a 'twist' application produces delicacy of line for twigs, cracks in plaster and so forth

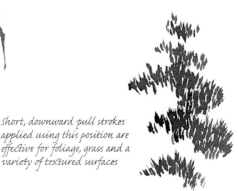

Short, downward pull strokes applied using this position are effective for foliage, grass and a variety of textured surfaces

Painting a Tree Canopy 'On Your Toes'

You will find it easy to build foliage masses using this application, and its very nature suggests plenty of air and white space left in the canopy. Start with a small area and work on outwards until you have achieved a recognizable tree shape.

Start with a blob of pigment diluted with plenty of water, using the body of the brush to apply it

Next, lift the brush until you are using only the very tip

Working outwards from the blob 'on your toes', travel out in different directions

Be aware of the edges of your tree canopy and give them an interesting silhouetted shape

If strips of white inadvertently appear, use them to suggest light branches against dark foliage masses

The Crisscross Application

MEDIA: WORKER BRUSH ON 190GSM (90LB) BOCKINGFORD PAPER

This is a useful method of brushwork for diffusing tone from behind an image out into background areas, as well as for painting images themselves. In my demonstrations on this spread the strokes are shown in relation to foliage masses. However, used in a more horizontal direction they can suggest a variety of other subjects, including disturbed water.

Although this stroke application is based upon a cross shape, try to ensure your cross marks are not apparent in your final image. They are only your means to an end and it should not be obvious how you achieved that result. The purpose of working in this way is to achieve lively brushstrokes that give interesting edges as well as shapes within forms and to encourage a loose approach to painting.

How to Execute the Crisscross Application

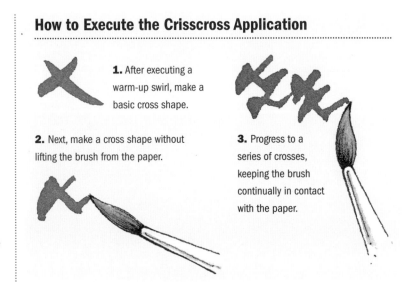

1. After executing a warm-up swirl, make a basic cross shape.

2. Next, make a cross shape without lifting the brush from the paper.

3. Progress to a series of crosses, keeping the brush continually in contact with the paper.

Exploring Texture

The textural nature of the crisscross application makes it suitable for foliage in general but particularly apt for gorse, holly and other plants with tough, spiky leaves. Nevertheless, it is capable of conveying delicacy too.

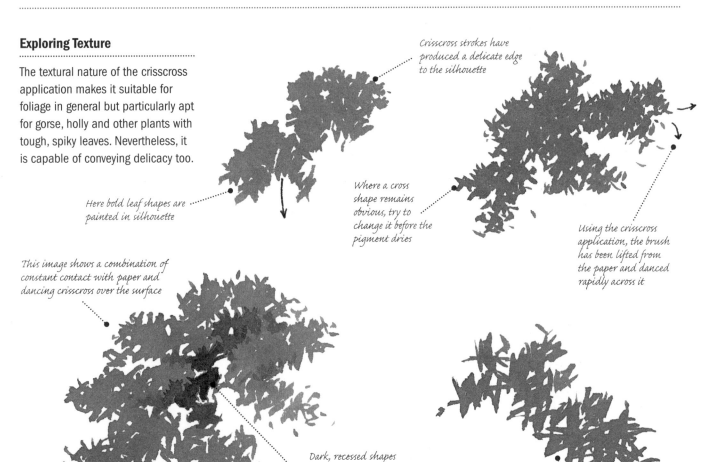

Crisscross strokes have produced a delicate edge to the silhouette

Here bold leaf shapes are painted in silhouette

Where a cross shape remains obvious, try to change it before the pigment dries

Using the crisscross application, the brush has been lifted from the paper and danced rapidly across it

This image shows a combination of constant contact with paper and dancing crisscross over the surface

Dark, recessed shapes can be shown by overlaying further applications of crisscross strokes

From the basic crisscross application you can develop other variations, such as a few downward zigzags preceding the second side of the cross

Painting Foliage Mass with the Crisscross Application

Here the crisscross brushwork suggests a tree or shrub with large, robust leaves. Remember to use plenty of water with your pigment and to mix enough for the whole image.

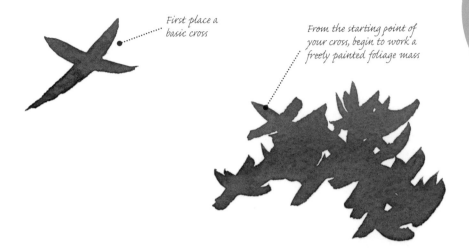

First place a basic cross

From the starting point of your cross, begin to work a freely painted foliage mass

tip

When crisscross strokes are made horizontally they can suggest the surface of rough water. Crisscross is also useful for blending out into the surface of Rough paper to diffuse the edges of the image.

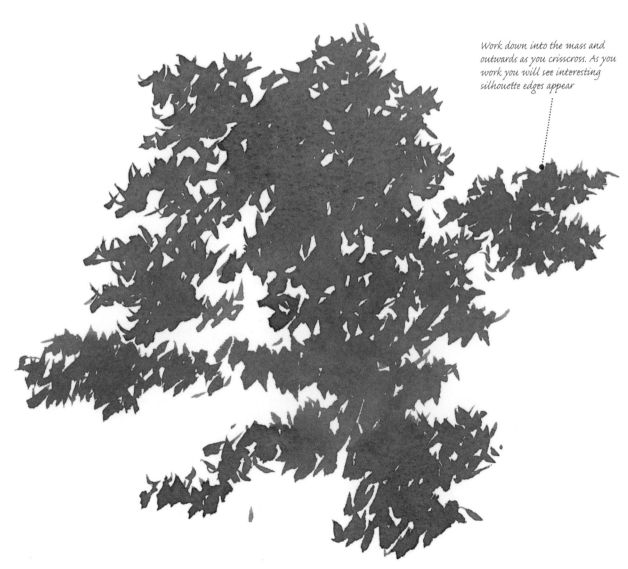

Work down into the mass and outwards as you crisscross. As you work you will see interesting silhouette edges appear

The Eight Basic Strokes: CRISSCROSS in Watercolour

The 'Up to and Away' Application

MEDIA: WORKER BRUSH ON 190GSM (90LB) BOCKINGFORD PAPER

To avoid any treatment of your background areas trespassing into the light forms in front, work up to the edge of the light form from a starting point a little way from the image. After cutting in crisply against the light edge in order to define the form, you can immediately take the pigment out and away into other images or a background treatment.

The background area may be clearly defined as recognizable shapes or diffused, ready to be clarified at a later stage. I refer to this as 'putting it on hold', meaning I shall return to the area later in order to define images more clearly. When I am putting an area of background on hold I often crisscross away, skimming the surface of the Rough paper, in order to diffuse the marks and leave no clear edges that might restrict future developments.

How to Execute the 'Up to and Away' Application

1. After making a warm-up swirl, draw a guideline with a pencil to give you an edge to practise with. Using a loaded brush, work away from the edge. Next, use an interesting stroke application up to the edge. Clarify the edge before working away and out into the background area.

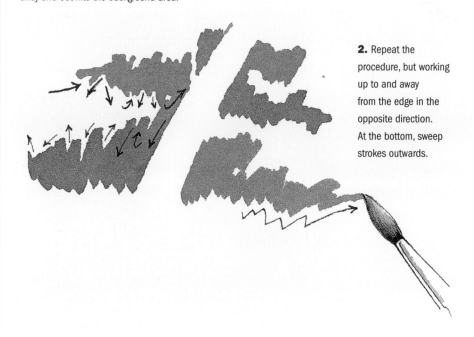

2. Repeat the procedure, but working up to and away from the edge in the opposite direction. At the bottom, sweep strokes outwards.

Trying Different Strokes

You can use a variety of strokes to perform the 'up to and away' technique, according to what most suits the subject you are drawing. Practise the technique using several different strokes until you feel confident in your ability to take tone up to a clean edge without encroaching upon it.

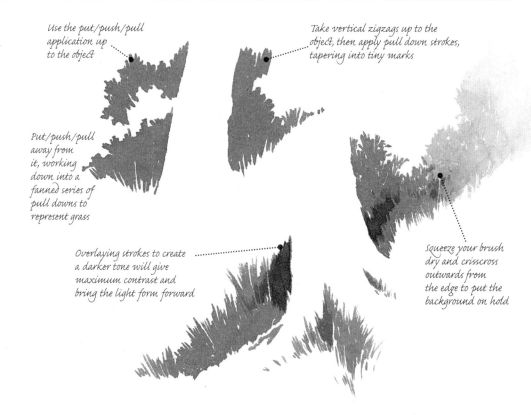

Use the put/push/pull application up to the object

Take vertical zigzags up to the object, then apply pull down strokes, tapering into tiny marks

Put/push/pull away from it, working down into a fanned series of pull downs to represent grass

Overlaying strokes to create a darker tone will give maximum contrast and bring the light form forward

Squeeze your brush dry and crisscross outwards from the edge to put the background on hold

Using the 'Up to and Away' Application

This application is invaluable where you want to show manmade forms such as posts, chimney pots, cars and so forth outlined against a background mass of more diffuse foliage. On forms where one plane is highlighted and another is in shadow you will need to use it on the form itself as well as differentiating it from the background.

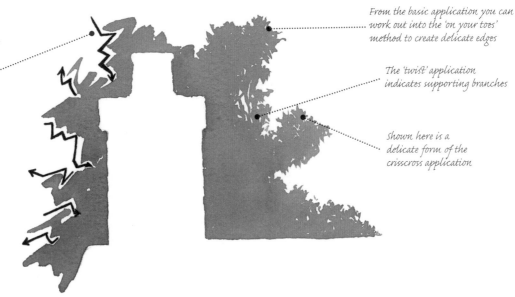

The arrows indicate the direction of the movement of your brush as the wash is applied up towards the image and then away into silhouette underpainting of background foliage

From the basic application you can work out into the 'on your toes' method to create delicate edges

The 'twist' application indicates supporting branches

Shown here is a delicate form of the crisscross application

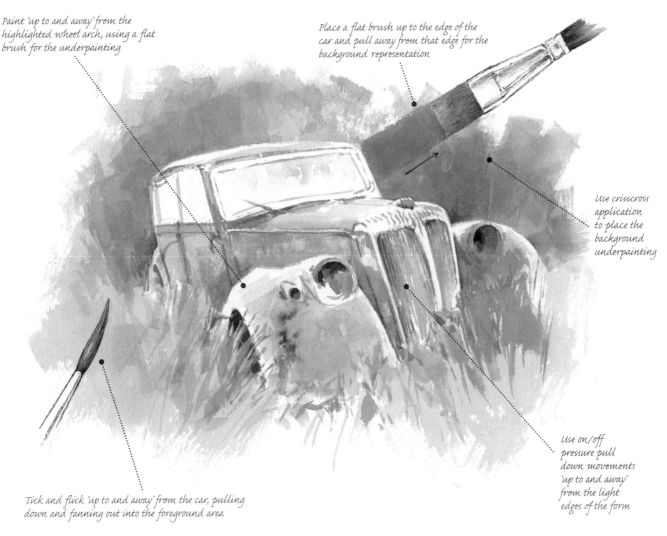

Paint 'up to and away' from the highlighted wheel arch, using a flat brush for the underpainting

Place a flat brush up to the edge of the car and pull away from that edge for the background representation

Use crisscross application to place the background underpainting

Tick and flick 'up to and away' from the car, pulling down and fanning out into the foreground area

Use on/off pressure pull down movements 'up to and away' from the light edges of the form

The Eight Basic Strokes: 'UP TO AND AWAY' in Watercolour

The Tick and Flick Application

MEDIA: WORKER BRUSH ON 190GSM (90LB) BOCKINGFORD PAPER

In this application the first part of the stroke – the downward movement – is only a lead-in to the execution of the important upwards and outwards directional stroke. It is by massing these strokes that the overall impression is achieved, and to make sure they mass effectively you will need to mix plenty of water with your pigment. This technique is excellent for depicting grass, hair, strands of rope and similar subject matter.

A brush with a fine point is useful, but if you have one that can be flattened into a chisel shape by pressing it against the base of your palette well, the slim edge of the chisel will enable you to achieve the same results.

How to Execute the Tick and Flick Application

1. After practising a warm-up swirl, start to make a tick by taking the first movement down into the base of the stroke. Flick upwards and outwards to complete the stroke.

2. Practise a series of randomly placed basic strokes, making sure that the downward strokes are minimal compared to the upward and outward ones.

Execute the strokes close together to form a mass, using plenty of fluid pigment so that the strokes will blend together

ARTIST'S TECHNIQUE

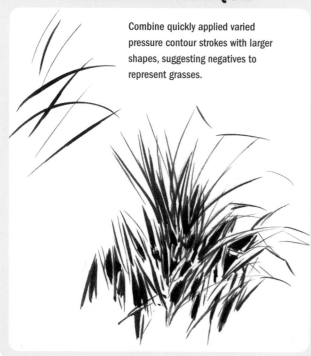

Combine quickly applied varied pressure contour strokes with larger shapes, suggesting negatives to represent grasses.

Painting Grass

The nature of the tick and flick application makes it ideal for showing grass. Overlaying extra strokes will allow you to show darker tones, which are especially important in depicting long, wind-ruffled grass convincingly.

To represent the light grasses in front you will need to pull down strokes. Dark, shadowed shapes may then be added as an overlay

Painting Hair

When you are painting hair or fur, use tonal overlays with plenty of fluidity, wet on dry, and a directional tick and flick application to indicate how the hair growth follows the form.

On the painting of a lion's head (right), the strokes of this application fan outwards in areas around the ear and across the mane on top. This fanning is demonstrated in the exercise below. To practise the application, draw a faint contour line in pencil and tick and flick away from the line.

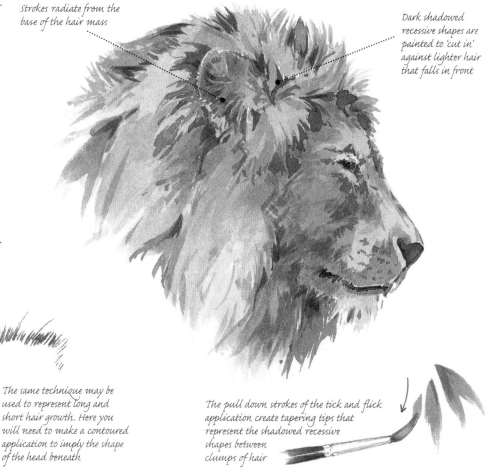

Strokes radiate from the base of the hair mass

Dark shadowed recessive shapes are painted to 'cut in' against lighter hair that falls in front

The same technique may be used to represent long and short hair growth. Here you will need to make a contoured application to imply the shape of the head beneath

The pull down strokes of the tick and flick application create tapering tips that represent the shadowed recessive shapes between clumps of hair

Painting Feathers

This stroke application can be used effectively for various other subjects, including feathers. Although it is applied in a similar way for these, the effects may vary according to the paper worked upon, the brushes used and the way the paint is applied.

Delicate feather interpretations require the use of a brush that tapers to a fine point.

The strokes used are similar to those for shadowed recessive shapes in hair (see lion painting above)

Tick and flick is used for long black feathers

Upward ticks and pull down strokes bring colour into the foreground

Case Study: A Post with Foliage

Taking the simple image of a post set against foliage, on this and the following spread I am demonstrating the use of the eight basic stroke applications in pencil, monochrome brushwork, watercolour and watercolour pencil.

However, stroke applications are not the only consideration when you are creating drawings and watercolours. Including lost lines and tonal contrast, in particular counterchange where light is set against dark and vice versa, will bring interest and drama to your work.

Drawing in a Painterly Way

MEDIA: SOFT GRADE PENCIL ON 110GSM (51LB) CARTRIDGE DRAWING PAPER

As usual, I made a tonal block to prepare a chisel edge and fine point on my pencil before I began to work. Never try to skip this step as it also accustoms you to the particular texture of the pencil and paper combination and loosens your hand before you start drawing in earnest.

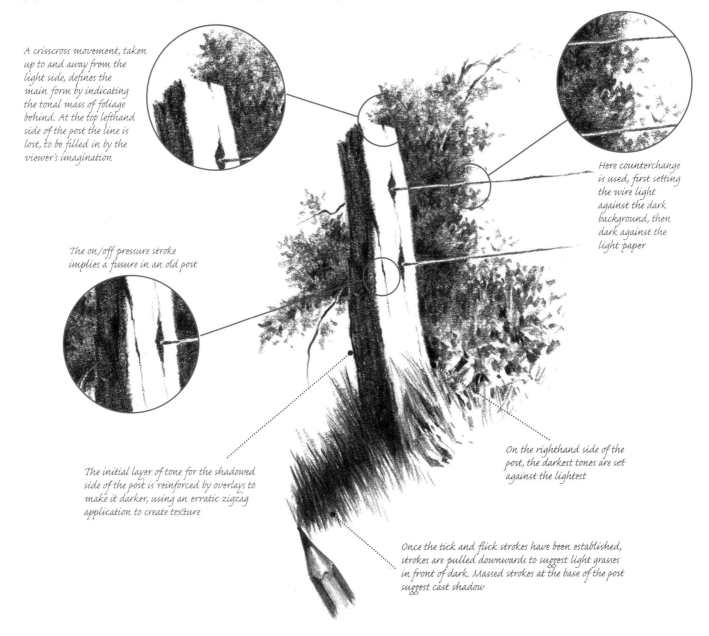

A crisscross movement, taken up to and away from the light side, defines the main form by indicating the tonal mass of foliage behind. At the top lefthand side of the post the line is lost, to be filled in by the viewer's imagination

Here counterchange is used, first setting the wire light against the dark background, then dark against the light paper

The on/off pressure stroke implies a fissure in an old post

The initial layer of tone for the shadowed side of the post is reinforced by overlays to make it darker, using an erratic zigzag application to create texture

On the righthand side of the post, the darkest tones are set against the lightest

Once the tick and flick strokes have been established, strokes are pulled downwards to suggest light grasses in front of dark. Massed strokes at the base of the post suggest cast shadow

Study in Monochrome

MEDIA: WORKER BRUSH AND WATERCOLOUR ON 190GSM (90LB) BOCKINGFORD PAPER

Here I am demonstrating the eight basic stroke applications in a similar study to that shown on the opposite page, working in monochrome so that you are able to make tonal comparisons. Note that all the stroke applications in pencil and watercolour brushwork are very similar in the way they are executed – the only difference being that, by using water to blend the latter, you have the contrast of fluidity with watercolour against the stability of pencilwork.

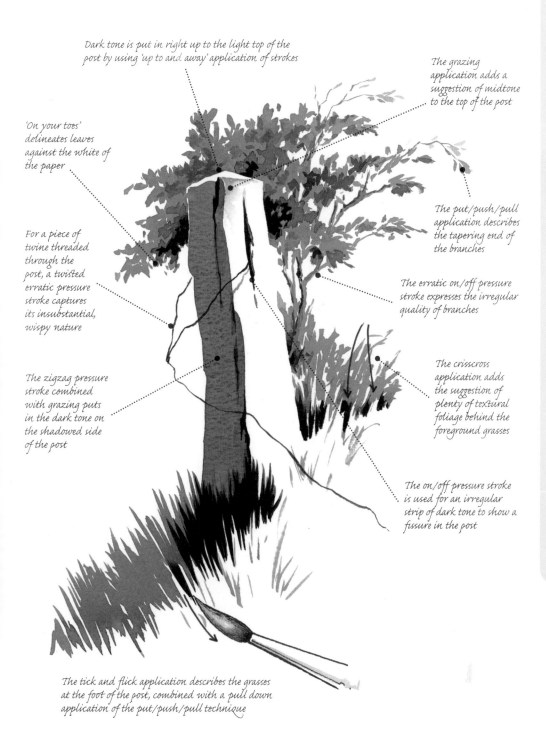

Dark tone is put in right up to the light top of the post by using 'up to and away' application of strokes

The grazing application adds a suggestion of midtone to the top of the post

'On your toes' delineates leaves against the white of the paper

The put/push/pull application describes the tapering end of the branches

For a piece of twine threaded through the post, a twisted erratic pressure stroke captures its insubstantial, wispy nature

The erratic on/off pressure stroke expresses the irregular quality of branches

The zigzag pressure stroke combined with grazing puts in the dark tone on the shadowed side of the post

The crisscross application adds the suggestion of plenty of textural foliage behind the foreground grasses

The on/off pressure stroke is used for an irregular strip of dark tone to show a fissure in the post

The tick and flick application describes the grasses at the foot of the post, combined with a pull down application of the put/push/pull technique

ARTIST'S TECHNIQUE

These two strips, each representing eight tonal values from darkest tone to white paper, demonstrate the contrast achieved between working in a dry and a wet medium upon the same Bockingford paper surface. The dry medium (in this instance charcoal pencil) shows an obvious texture as a result of the pencil grazing the surface and leaving the indentations as white paper. Tonal values painted in watercolour upon the same surface appear as flat washes.

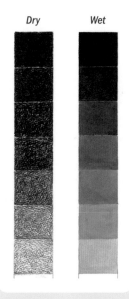

Dry *Wet*

Using Watercolour

MEDIA: WORKER BRUSH AND WATERCOLOUR ON 190GSM (90LB) BOCKINGFORD PAPER

Using just three primary colours, I am showing you here a few of the many variations you will be able to achieve by adding a tiny amount of the pure hues to your mixes. For example, neutrals resulting from mixing all three primaries can be changed by adding a little more blue, yellow or red and so forth. A basic green resulting from a blue and yellow mix will become a more subtle hue with the addition of red and then a little extra blue, whereas lemon yellow will add a sunnier effect. Lemon yellow is also an ideal hue for glazing, where a very dilute translucent wash is applied to certain areas over the first underlay washes once they have dried.

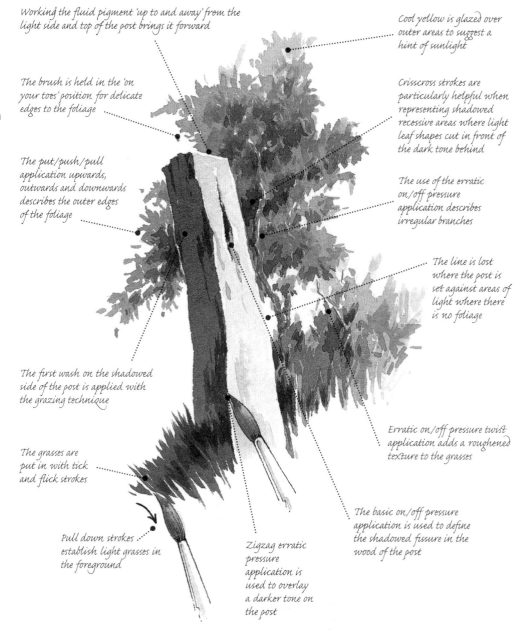

Working the fluid pigment 'up to and away' from the light side and top of the post brings it forward

The brush is held in the 'on your toes' position for delicate edges to the foliage

The put/push/pull application upwards, outwards and downwards describes the outer edges of the foliage

Cool yellow is glazed over outer areas to suggest a hint of sunlight

Crisscross strokes are particularly helpful when representing shadowed recessive areas where light leaf shapes cut in front of the dark tone behind

The use of the erratic on/off pressure application describes irregular branches

The line is lost where the post is set against areas of light where there is no foliage

The first wash on the shadowed side of the post is applied with the grazing technique

Erratic on/off pressure twist application adds a roughened texture to the grasses

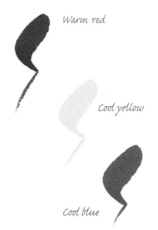

Warm red

Cool yellow

Cool blue

The grasses are put in with tick and flick strokes

Pull down strokes establish light grasses in the foreground

Zigzag erratic pressure application is used to overlay a darker tone on the post

The basic on/off pressure application is used to define the shadowed fissure in the wood of the post

Colour Mixes

1. Three primaries mix

2. With a little blue added

3. With a little more yellow

4. With a little more red

5. Blue and yellow mix

6. With a little red added

7. With a little blue added

8. With a little more blue added

9. With more yellow added

Working with Watercolour Pencils

MEDIA: INKTENSE PENCILS ON SAUNDERS WATERFORD CP (NOT) PAPER

This image of a post has been executed in Derwent Inktense watercolour pencils, with a limited palette of seven colours. You will be able to match these hues from another manufacturer's range of watercolour pencils if you wish to.

The main method of application is dry pencil drawing upon a dry paper surface (remember that different papers will produce different effects). Here and there a delicate wash is achieved by 'lifting' pigment from the paper using a wet brush.

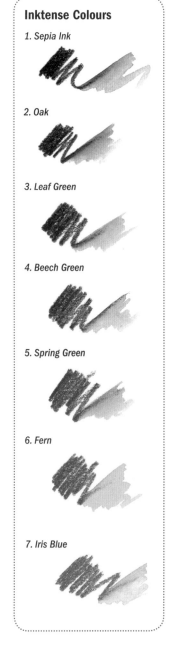

Inktense Colours

1. Sepia Ink
2. Oak
3. Leaf Green
4. Beech Green
5. Spring Green
6. Fern
7. Iris Blue

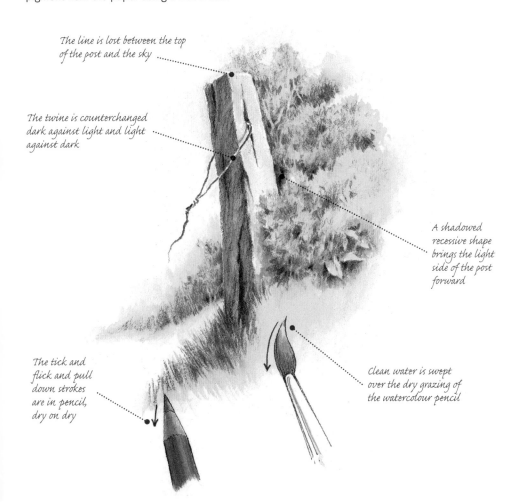

The line is lost between the top of the post and the sky

The twine is counterchanged dark against light and light against dark

A shadowed recessive shape brings the light side of the post forward

The tick and flick and pull down strokes are in pencil, dry on dry

Clean water is swept over the dry grazing of the watercolour pencil

ARTIST'S TECHNIQUE

In these illustrations the initial drawing is made in coloured pencil, using directional strokes as shown by the arrows to give the texture of rough wood and foliage mass. Clean water is then swept over the drawing to blend the pigments.

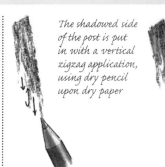

The shadowed side of the post is put in with a vertical zigzag application, using dry pencil upon dry paper

Clean water wash is put over the dry pencil drawing to blend the pigment

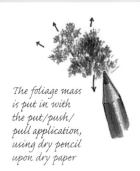

The foliage mass is put in with the put/push/pull application, using dry pencil upon dry paper

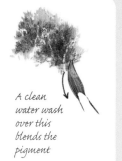

A clean water wash over this blends the pigment

Try It Yourself: Pencil

MEDIA: SOFT GRADE PENCIL ON 110GSM (51LB) CARTRIDGE DRAWING PAPER

This step-by-step approach, incorporating all eight stroke applications, will help you to familiarize yourself with their use. The first important shape of the foliage background against the light side of the post may be applied with relatively firm pressure as a starting point. However, it is advisable to apply subsequent background strokes with less pressure initially so that you may build tonal overlays. These allow you to consider contrasts which will result in a three-dimensional impression. Remember to retain white paper in areas where you wish to indicate the lightest lights.

ARTIST'S TECHNIQUE

Try to incorporate a variety of tonal values, noting the texture that you gain from using a soft grade pencil.

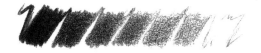

Drawing the Post

After making a tonal block to prepare your pencil with a chisel edge, begin to draw the post. The first step is to put in the shadowed side; the light side is described by the foliage behind it.

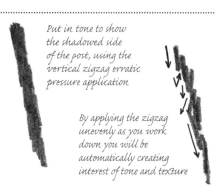

Put in tone to show the shadowed side of the post, using the vertical zigzag erratic pressure application

By applying the zigzag unevenly as you work down you will be automatically creating interest of tone and texture

Beginning the Foliage

The next step is to begin putting in the foliage, starting at the upper right-hand side of the post in order to establish its shape. You will need to take great care not to encroach upon the white paper which represents the light side of the post and to work accurately around the top. Once you have established the shapes of the foliage masses, you can begin to add more definition to the post and put in the first grasses.

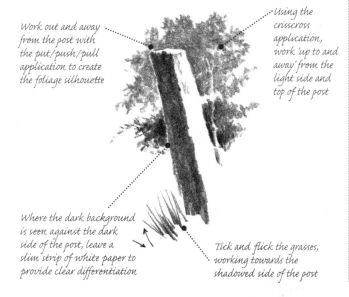

Work out and away from the post with the put/push/pull application to create the foliage silhouette

Using the crisscross application, work 'up to and away' from the light side and top of the post

Where the dark background is seen against the dark side of the post, leave a slim strip of white paper to provide clear differentiation

Tick and flick the grasses, working towards the shadowed side of the post

Building Up Tone and Detail

You now have all the basic elements of your picture laid in and your next task is to extend the foliage and to add more information on texture and tone, looking to set dark shapes against light to give interesting contrast.

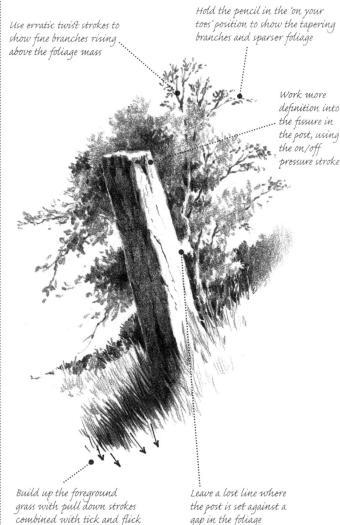

Use erratic twist strokes to show fine branches rising above the foliage mass

Hold the pencil in the 'on your toes' position to show the tapering branches and sparser foliage

Work more definition into the fissure in the post, using the on/off pressure stroke

Build up the foreground grass with pull down strokes combined with tick and flick

Leave a lost line where the post is set against a gap in the foliage

Try It Yourself: Watercolour

MEDIA: INKTENSE PENCILS ON 190GSM (90LB) BOCKINGFORD PAPER

For this exercise, try using watercolour pencils applied as washes. Coloured pencils from the Derwent Inktense range, sharpened into individual palette wells and mixed with water, can be used in just the same way as watercolour pans.

On this page I have demonstrated overlaying as a method of building hue and tone, applied in the form of glazing. Follow the same order of development as you did using your pencil and apply all the eight stroke applications in the same way. The only difference is that, when working with fluid pigment, blending will automatically occur.

tip

Depicting the post tilted to one side rather than standing totally erect makes for a more interesting study. Build texture on the shadowed side with monochrome only, working wet on dry.

The First Washes

As before, begin by putting in the shadowed side of the post in dark tone to give you a starting point from which to place your foliage in relation to the lighter side. Remember that you are aiming for a good contrast of tone to hold the viewer's interest.

Execute the shadowed side of the post with the same up and down zigzag movement as in pencil, but here the strokes will blend to form solid tonal shape. The zigzag application ensures interest in the silhouetted edge

Working 'up to and away' from the post with crisscross movements will place the first pale washes. Diffuse the edges to put them on hold

Set the darkest dark against the lightest light to heighten contrast to the maximum

Building Up the Washes

With your basic shapes in place, as with pencil, you now need to work over them, adding definition and detail and strengthening your areas of dark tone. Using colour, you will need to add some pale washes to the light side of the post rather than leaving it as mainly white paper as you did with your monochrome pencil study.

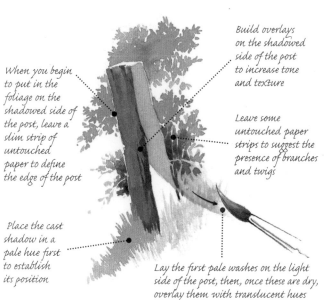

When you begin to put in the foliage on the shadowed side of the post, leave a slim strip of untouched paper to define the edge of the post

Place the cast shadow in a pale hue first to establish its position

Build overlays on the shadowed side of the post to increase tone and texture

Leave some untouched paper strips to suggest the presence of branches and twigs

Lay the first pale washes on the light side of the post, then, once these are dry, overlay them with translucent hues

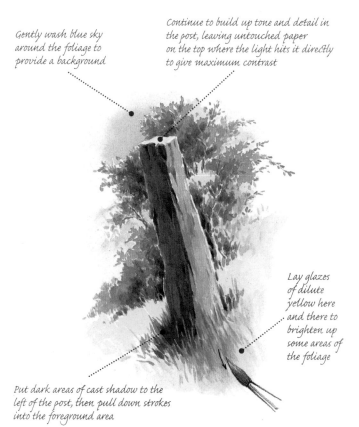

Gently wash blue sky around the foliage to provide a background

Continue to build up tone and detail in the post, leaving untouched paper on the top where the light hits it directly to give maximum contrast

Lay glazes of dilute yellow here and there to brighten up some areas of the foliage

Put dark areas of cast shadow to the left of the post, then pull down strokes into the foreground area

Working from Memory or Imagination

For the images of different posts and their backgrounds I worked from memory and used my imagination in order to place the components comfortably in relation to each other. On this spread I have done the same with the image of a tree. The way in which the areas of trunk, branches, twigs and foliage are shown is a combination of my artist's eye for a visually pleasing arrangement and the use of the eight basic stroke applications.

 In places where there is no need to fill in detail I have left untouched paper to enhance the all-important tonal contrasts.

ARTIST'S TECHNIQUE

Parallel grazing lines are often used for sketching as they give texture and the ability to quickly overlay darker tones where needed.

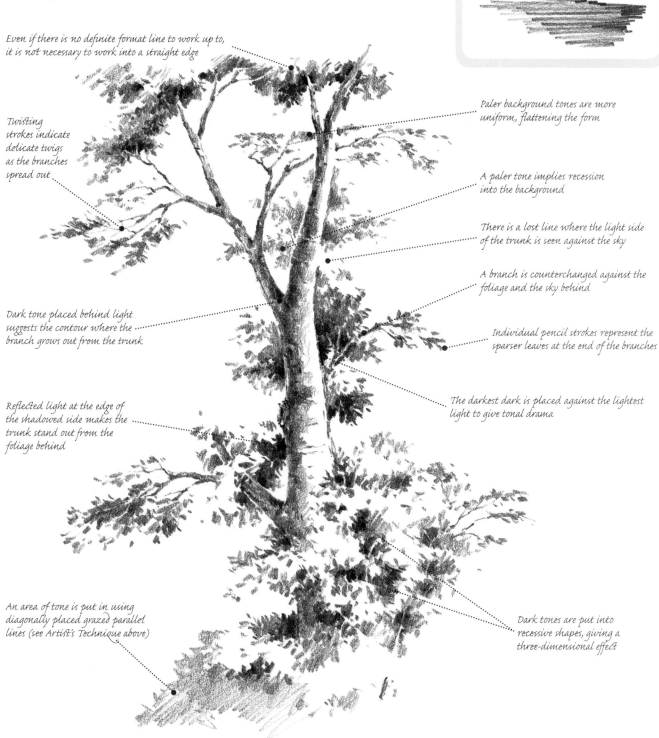

Even if there is no definite format line to work up to, it is not necessary to work into a straight edge

Twisting strokes indicate delicate twigs as the branches spread out

Dark tone placed behind light suggests the contour where the branch grows out from the trunk

Reflected light at the edge of the shadowed side makes the trunk stand out from the foliage behind

An area of tone is put in using diagonally placed grazed parallel lines (see Artist's Technique above)

Paler background tones are more uniform, flattening the form

A paler tone implies recession into the background

There is a lost line where the light side of the trunk is seen against the sky

A branch is counterchanged against the foliage and the sky behind

Individual pencil strokes represent the sparser leaves at the end of the branches

The darkest dark is placed against the lightest light to give tonal drama

Dark tones are put into recessive shapes, giving a three-dimensional effect

Colour from Memory and Imagination

Neutral hues are an excellent support for colour and many tree trunks are basically neutral, with just a suggestion of warm or cool colour. In this image I have taken the green of the foliage slightly into the neutrals of trunk and branch areas. However, in order to achieve strong contrasts, white paper continues to play an important part. The stroke applications of the brush are the same as those executed in pencil.

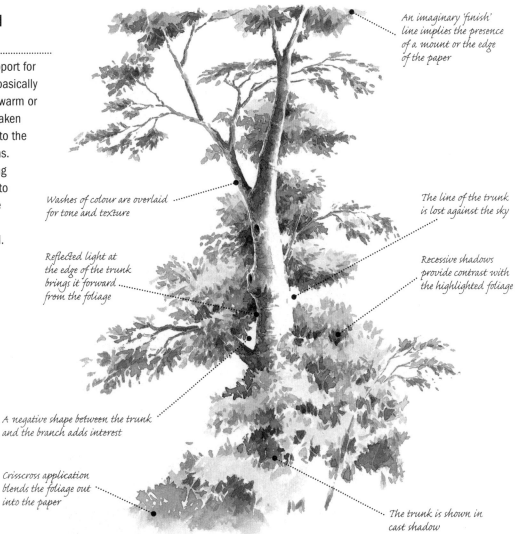

An imaginary 'finish' line implies the presence of a mount or the edge of the paper

Washes of colour are overlaid for tone and texture

The line of the trunk is lost against the sky

Reflected light at the edge of the trunk brings it forward from the foliage

Recessive shadows provide contrast with the highlighted foliage

A negative shape between the trunk and the branch adds interest

Crisscross application blends the foliage out into the paper

The trunk is shown in cast shadow

Trying Out Colours

When you are using colours without visual reference to guide you, experimenting with glazes of watercolour until you reach the colour you want is an excellent way of clarifying your decisions.

Bright green

Sepia

Mix of green and sepia

Glazing hues

Various hues from the mix

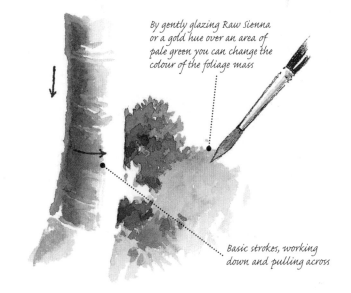

By gently glazing Raw Sienna or a gold hue over an area of pale green you can change the colour of the foliage mass

Basic strokes, working down and pulling across

Using Your Sketchbook

A sketchbook is invaluable to you as an artist; it is where you can put down ideas for future finished drawings or paintings, make sketches of people and scenes for reference later and, most of all, practise your drawing without any of the inhibition that can come when you start upon what you hope will be a finished work to be put on display. You will find it useful to have one pocket-sized sketchbook that you can take out and about with you and a larger one for working out your sketches at home.

Whether you are working in a dry medium or with swiftly applied monochrome brushstroke washes, quick sketches rely upon simplicity for a fresh, immediate feel that captures the essence of your subject. If you want to swiftly place an area of tone just to indicate tonal differences rather than looking for a three-dimensional effect, use either flat or contoured directional grazing strokes. In my pencil sketches you will see many of my tonal areas are achieved by the placing of parallel lines. I think of these as 'open' strokes and the grazing strokes placed close together as 'closed'.

> **tip**
>
> When you are working in monochrome, it is important to try to incorporate a variety of tonal values and set the very lightest areas against the very darkest to give a full tonal range and interesting contrast.

Country Cottage

A tonal sketch made in pencil on location gave me sufficient information for a more finished study of the cottage back in the studio, using monochrome brushwork (see page 6).

A dark tree mass brings the light side of the cottage forward

A swift vertical application of the brush places the elements in the picture tonally

Tree Study

This A5 sketchbook pencil study was enlarged to approximately
23 x 15cm (9 x 6in) for representation in monochrome brushwork,
using a sepia mix of watercolour. It demonstrates that it is not necessary
to cover all the paper up to the edges to create an interesting picture.

The sunlit lower half of the tree is seen against dark foliage and
therefore no outline is required to define the form. However, where
white paper has been left to represent both the sunlit side of the tree
and the area of sky, a means of defining the division between them is
necessary. This has been achieved with an erratically applied edge line
that avoids a hard diagrammatic outline.

*Negative shapes are as
important in the picture
as positive ones*

*Here the eye is led into the picture
by what is left out*

*Simple silhouette shapes give
interest to the background without
distracting the eye from the main
focal point of the tree*

*Delicate 'on your toes'
representation using
a fine brush describes
leafless tree branches*

*Brush strokes are applied
horizontally to indicate the
rounded form of the post*

*Alternating dark shapes and
untouched paper guide the eye
into the picture*

*The variety of tonal values and simplicity of
shapes provide a visually satisfying foreground*

Using Reference Material at Home

If you want to depict the natural world but feel inhibited about sketching outdoors where people may want to look at and comment upon your work, bring some material indoors instead so that you can work there in privacy. This is an obvious solution with fruit, vegetables, flowers and so forth, but it can also be done with the wider landscape. A single rock can represent a mountain, for example, and a few sprigs of plant material can give you the reference you need for a forest.

Stone Wall

In my photograph you will see how, by putting a sheet of plain paper behind and below my little 'wall', I have created the essence of what may be seen outdoors in the garden or countryside. A sprig of heather was used to represent some form of foliage mass behind.

I have made my drawing from a different angle to that in the photograph. You may like to draw the 'wall' yourself using the photograph as reference and my pencil drawing to help you with the stroke application.

Where the stones are juxtaposed interesting negative shapes are made

The heather sprigs offer delicate structure

Shadowed recessive shapes appear within the foliage mass

Areas of cast shadow appear where one stone juts forward over another

Strong contrasts of light against dark provide tonal drama

Where the stones lie on the 'ground' there is an opportunity to depict an interesting shadow line with the on/off pressure stroke

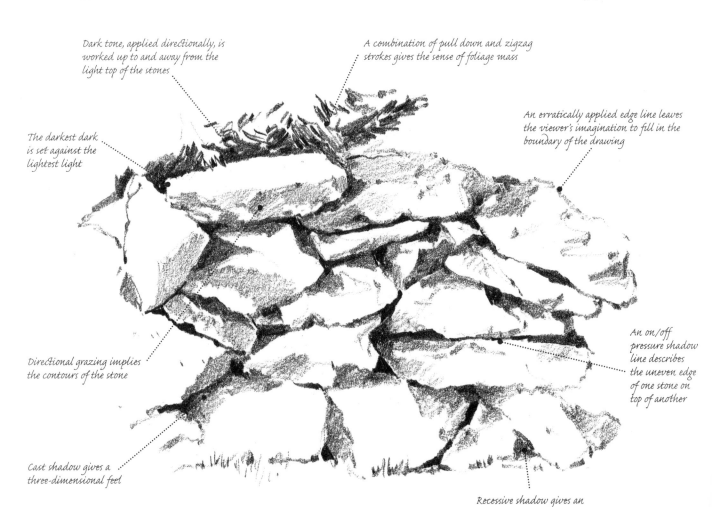

Dark tone, applied directionally, is worked up to and away from the light top of the stones

A combination of pull down and zigzag strokes gives the sense of foliage mass

An erratically applied edge line leaves the viewer's imagination to fill in the boundary of the drawing

The darkest dark is set against the lightest light

An on/off pressure shadow line describes the uneven edge of one stone on top of another

Directional grazing implies the contours of the stone

Cast shadow gives a three-dimensional feel

Recessive shadow gives an interesting negative shape

Drawing a Single Object

On pages 74–75 I have demonstrated a step-by-step drawing of three apples as a still life group. However, before embarking upon a group it is a good idea to start with just a single fruit or vegetable on which to practise your stroke application.

Its variety of texture and shape makes a mushroom ideal for this, as you can practise wide and narrow strokes, vertical and contoured grazing, continuous zigzag strokes and varied pressure lines. Use a soft grade pencil on 110gsm (51lb) drawing paper.

1. First establish the chisel side of your pencil strip with a tonal block. Practise wide and narrow strokes, alternating between the chisel edge and the fine point.

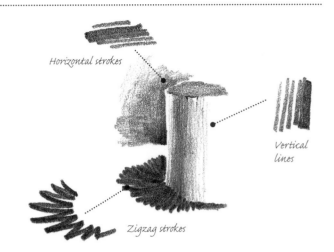

Horizontal strokes

Vertical lines

Zigzag strokes

Tonal block, using soft pencil *Wide strokes* *Narrow strokes*

2. Begin your drawing by placing a series of vertical lines to represent the shadowed side of the mushroom stalk, gradating into white paper for the light side. Place some dark tone vertically at the base of the stalk on the shadowed side at the rear, a little away from the tone to leave an area of reflected light. Working away from these first vertically placed strokes, zigzag around the base of the stalk, reducing the width of strokes in the centre.

3. Gently tone 'up to and away' from the stalk and cap, leaving white paper lower down to indicate the surface upon which the cap rests. Place an on/off pressure stroke to indicate the base of the cap and tone horizontally away from this stroke to suggest the cast shadow. Add some tone to the cut edge of the stalk with horizontal grazing. Use on/off erratic pressure lines to add interest around the rim of the cap and stalk.

Finally, graze cast shadow over the rim of the cap and the base, again leaving a lighter area of reflected light.

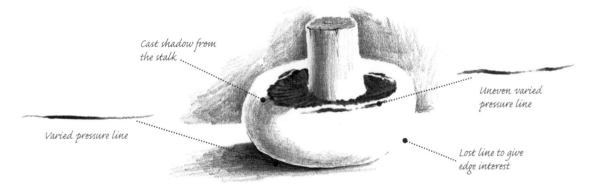

Cast shadow from the stalk

Uneven varied pressure line

Varied pressure line

Lost line to give edge interest

A Group of Mushrooms

Once you have built up your confidence by drawing a single mushroom, try a group, working along the same principles. This time, use watersoluble pencils so that you can blend in a little colour at the end.

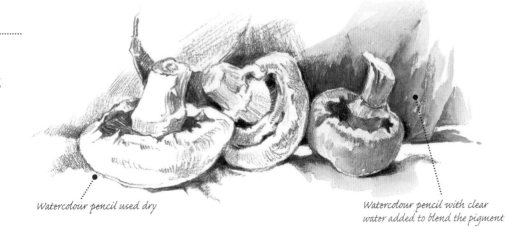

Watercolour pencil used dry

Watercolour pencil with clear water added to blend the pigment

Executing a Picture

It is only by practising the stroke applications that you will learn to understand their use in your pictures and how various pencil brands and grades react upon different paper surfaces.

The drawing on the facing page was done on the smooth white surface of ordinary copier paper with a medium soft pencil grade. To see the different effects you can obtain, try it yourself but on slightly textured paper using a very soft Derwent Graphic 9B pencil, as has been done for the stroke examples on this page. Practise the stroke applications as small exercises before putting them to the test in the complete drawing.

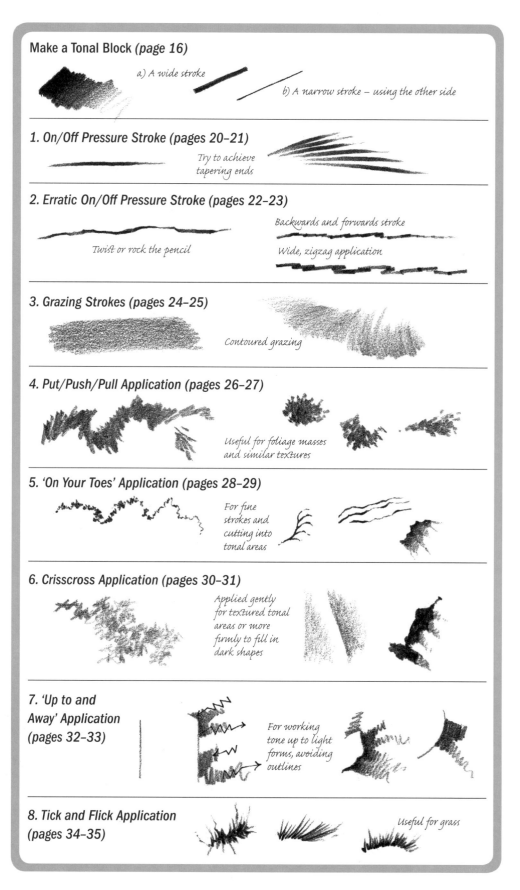

Make a Tonal Block (page 16)

a) A wide stroke

b) A narrow stroke – using the other side

1. On/Off Pressure Stroke (pages 20–21)

Try to achieve tapering ends

2. Erratic On/Off Pressure Stroke (pages 22–23)

Twist or rock the pencil

Backwards and forwards stroke

Wide, zigzag application

3. Grazing Strokes (pages 24–25)

Contoured grazing

4. Put/Push/Pull Application (pages 26–27)

Useful for foliage masses and similar textures

5. 'On Your Toes' Application (pages 28–29)

For fine strokes and cutting into tonal areas

6. Crisscross Application (pages 30–31)

Applied gently for textured tonal areas or more firmly to fill in dark shapes

7. 'Up to and Away' Application (pages 32–33)

For working tone up to light forms, avoiding outlines

8. Tick and Flick Application (pages 34–35)

Useful for grass

Cottage and Tree

Here we are looking at some typical components of a rural scene and their execution, without yet considering the theories of composition (see pages 174–187). These include a building with tiled roof, steps, a bank, shrubs and a tree, as well as a small area of water and long grasses.

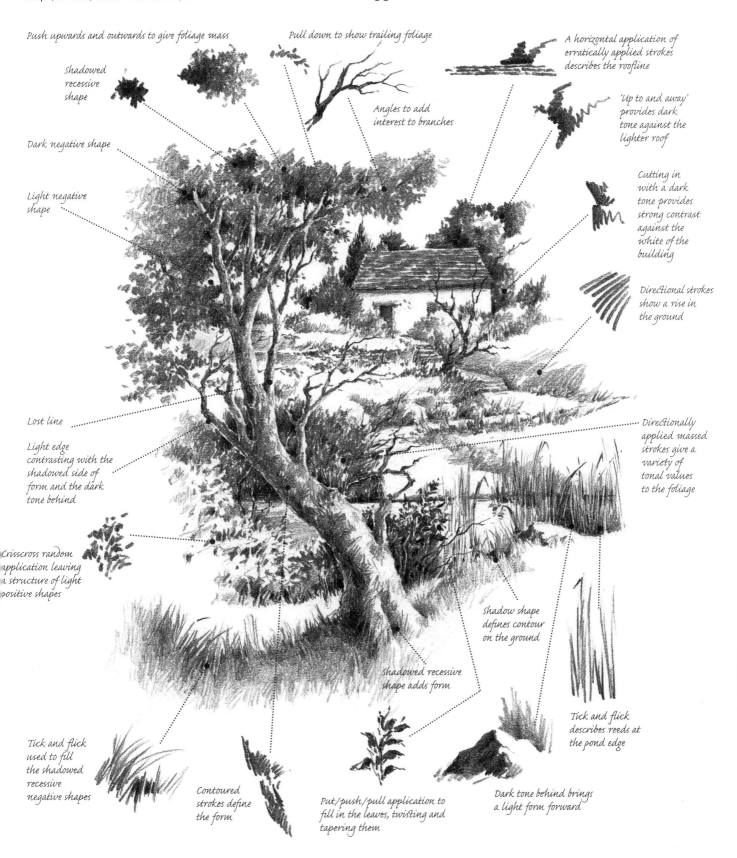

Push upwards and outwards to give foliage mass

Shadowed recessive shape

Dark negative shape

Light negative shape

Lost line

Light edge contrasting with the shadowed side of form and the dark tone behind

Crisscross random application leaving a structure of light positive shapes

Tick and flick used to fill the shadowed recessive negative shapes

Pull down to show trailing foliage

Angles to add interest to branches

Contoured strokes define the form

Put/push/pull application to fill in the leaves, twisting and tapering them

A horizontal application of erratically applied strokes describes the roofline

'Up to and away' provides dark tone against the lighter roof

Cutting in with a dark tone provides strong contrast against the white of the building

Directional strokes show a rise in the ground

Directionally applied massed strokes give a variety of tonal values to the foliage

Shadow shape defines contour on the ground

Shadowed recessive shape adds form

Tick and flick describes reeds at the pond edge

Dark tone behind brings a light form forward

Tonal Overlays

Showing a range of tonal values is crucial to the success of your drawings, both for describing form and for establishing depth in the picture. Strong contrasts of tone will also add dynamism to your work. On this and the facing page I am demonstrating a few little exercises in pencil and watercolour relating to tonal overlays to help you practise your skills at establishing tone. Both relate to the tree images on pages 64 and 65.

MEDIA: 9B PENCIL ON 110GSM (51LB) CARTRIDGE DRAWING PAPER

A soft pencil will enable you to draw in a 'painterly' way with the broad stroke application that helps you to lay in areas of tone quickly. As usual, make a tonal block first to establish a chisel edge and fine point on the pencil.

Dark Background Tone

Use up and down strokes to establish a dark mass behind the light tree form. As you reach the edges of the foliage mass, make sure they give an interesting silhouette by using massed crosses or massed push strokes.

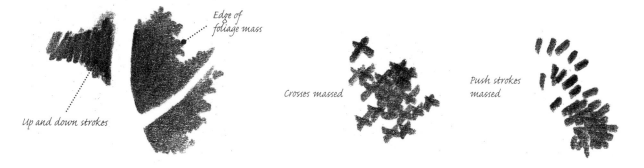

Edge of foliage mass

Up and down strokes

Crosses massed

Push strokes massed

Shadowed Recessive Shapes

Use a variety of angled strokes to achieve uneven tonal masses. Your areas of dark tone may act as strong negative shapes.

The arrows indicate the variety of angled strokes you can use to create uneven tonal masses

Introducing a Second Tone

Working into shadowed recessive shapes requires a number of different tones to build up variety and sufficient strength of tone for the darkest areas.

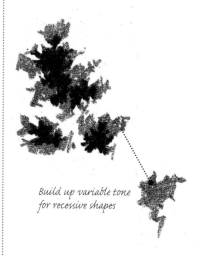

Build up variable tone for recessive shapes

Cutting in to Create Leaves

Tone away from dark recessive shapes using a variety of strokes to create the impression of a lighter leaf mass between them. White paper can be left untouched to suggest branches and twigs.

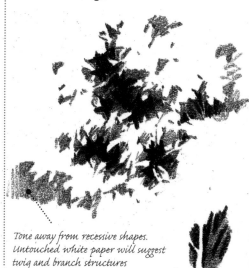

Tone away from recessive shapes. Untouched white paper will suggest twig and branch structures

MEDIA: WATERCOLOUR PENCILS ON BOCKINGFORD PAPER

Now try translating the tonal overlays into colour. A mix of Hooker's Green and Payne's Grey results in a useful green for practising monochrome foliage mass exercises. Make sure that you mix plenty of water and pigment in your palette well to achieve a rich hue and tone. Then, take a little of that strong mix into a separate well using a pipette (see page 13) and add a little more water to dilute the mix to a paler tone. Use the stronger tone for your first stroke applications and the paler one for working away from the initial shapes. Remember to make a warm-up swirl before you begin.

Hooker's Green Payne's Grey

Warm-up swirl

Putting in a Dark Background

Use a succession of up and down strokes as your brush moves away from the white paper to give a dark background behind a light image. Make sure the edge of your foliage mass provides an interesting outline, using a crisscross application or push strokes with plenty of pigment and water to encourage them to blend.

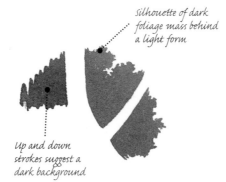

Silhouette of dark foliage mass behind a light form

Up and down strokes suggest a dark background

Blended crisscross application

Blended push strokes

Light and Shade in Foliage Masses

To create dark negative shapes within foliage masses, blend zigzag strokes together. Apply lighter tone away from the shadow shape, retaining some areas of white paper to suggest leaf masses in full sunlight. Suggest individual leaf shapes by cutting in around their form with a dark background.

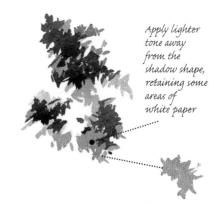

Apply lighter tone away from the shadow shape, retaining some areas of white paper

Blended zigzag strokes

Build up tone to suggest shadowed recessive shapes

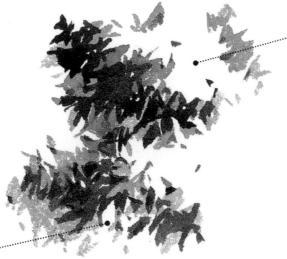

Retain areas of white paper to foliage in full sunlight

Suggest leaf shapes by cutting in around the form with dark tone

Relating Forms

MEDIA: HB, 2B AND 3B PENCILS ON COPIER PAPER

When you are drawing individual objects such as the doll and tree, one of the main considerations is the depiction of the texture of fabric, bark and foliage. With this study of three apples, the effect required is for a smoother texture with strong shadow contrasts enhancing a feeling for form. However, with multiple forms, the placing of them in relation to each other is just as important as describing their surface.

On these two pages I am demonstrating four stages of development, from the first rough sketch to a tonal three-dimensional drawing. Allow your strokes to follow the form of the objects, whether you are indicating shadows or the markings on the surface of the apples.

> **tip**
>
> You can trace your sketch on a lightbox or, if you do not have one, another method is to attach your sketch to a window, place a fresh sheet of copier paper over it, then gently trace the main shapes.

Initial Sketch

First make a rough drawing with your HB pencil to place the apples in the correct position, using sketchy strokes that follow their contours. Look for an interesting negative shape between them, and avoid aligning the foreground apples at the base – placing them on a different level will be more interesting compositionally.

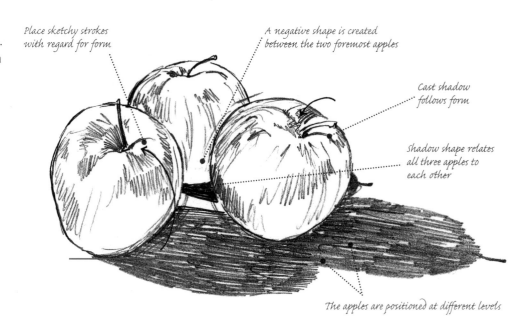

Place sketchy strokes with regard for form

A negative shape is created between the two foremost apples

Cast shadow follows form

Shadow shape relates all three apples to each other

The apples are positioned at different levels

Tracing your Image

Once your rough sketch is complete, trace it on to a fresh sheet of paper (see tip, above). By toning away from the highlight area, indicate where the white paper will remain untouched. When you are tracing shadow shapes, avoid drawing a line around them and filling in; instead, shade the edge shape and then work between this and the base of the apples. Do not forget to add the contoured cast shadows from the short stalks that fall across the tops of the apples.

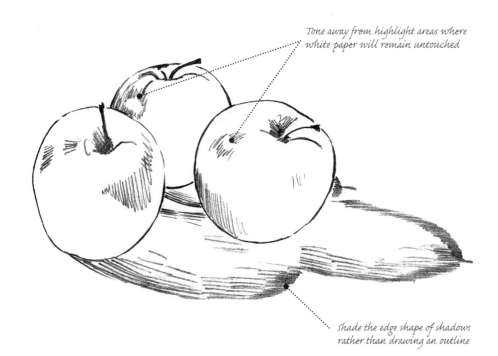

Tone away from highlight areas where white paper will remain untouched

Shade the edge shape of shadows rather than drawing an outline

Blocking in the Main Tonal Areas

After tracing your rough sketch on to a new sheet of paper, block in a first pale tonal underlay, using your 2B pencil. Look for angles and straight edges on your particular apples – always rely on observation rather than just assuming that an apple is round. Follow the contour of the apples with your placing of blocks of tone.

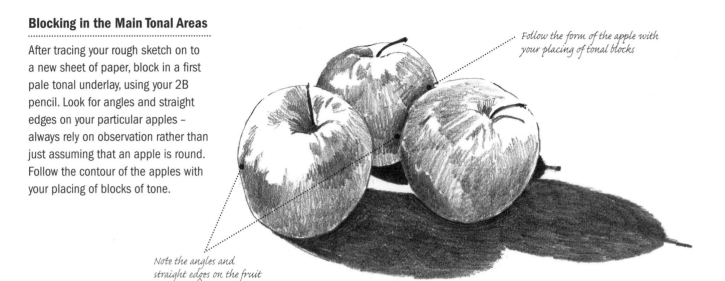

Follow the form of the apple with your placing of tonal blocks

Note the angles and straight edges on the fruit

Adding the Finishing Touches

The principal task that remains is to enrich the darks to emphasize contrasts and create a three-dimensional impression. This is achieved by overlaying tonal values, some of which indicate coloured areas, while others depict shadows. The stroke application is contoured grazing for the fruit and solid tonal shapes for the cast shadows, using a 3B pencil to enhance the darks.

 Blend tone up to and away from the light side of the left-hand apple to bring it forward from the background area. Work on tonal variations within the shadowed areas of the fruit and introduce some tonal marking on the skin. Finally, add a background cloth behind the group to give an opportunity to counterchange light against dark and vice versa.

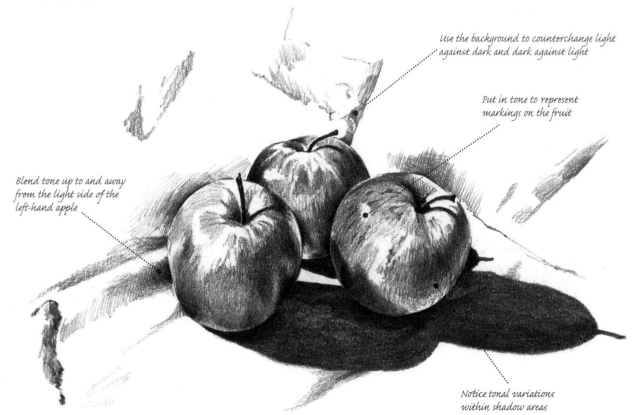

Use the background to counterchange light against dark and dark against light

Put in tone to represent markings on the fruit

Blend tone up to and away from the light side of the left-hand apple

Notice tonal variations within shadow areas

Case Study: Padlock and Chain

MEDIA: GRAPHITE PENCIL AND WATERCOLOUR ON BOCKINGFORD PAPER

The simple subject of a padlock and chain with supporting background will give you plenty of opportunity to develop your observational skills. The padlock needs to look heavy and solid, the chain strong enough to do the job required, and the wooden supporting post convincingly textured. A variety of textures and tonal shapes such as this can appear quite complex, so you need to look closely at all the components of the study and how they relate to each other.

As a contrast to these strong, solid forms a more delicate, sympathetic treatment of the distant hedge and tree will help to emphasize the light edge of the padlock and bring the form forward.

For this drawing you could use a watersoluble graphite pencil (see page 8), or an ordinary 3B graphite pencil gently overlaid by a monochrome watercolour wash to soften tonal areas. Remember to sharpen your pencil frequently while you are working in order to achieve delicacy of treatment in the 'on your toes' position while you are putting in the linear elements.

Tone and Texture

Begin by drawing the padlock and chain in watersoluble or ordinary graphite pencil. Carefully study the small intricate shapes in the padlock and the tonal contrasts these give rise to and compare its texture to that of the wooden post. Put in distant foliage with the crisscross application, working up to and away from the post above the padlock and chain. Use vertical zigzag grazing for the dark background and 'on your toes' erratic on/off pressure strokes for the grain of the wood.

Once you have finished drawing, blend the watersoluble pencil with a clear water wash or, if you have used ordinary graphite pencil, add a monochrome watercolour wash.

ARTIST'S TECHNIQUE

On a drawing with some complex areas such as this, look for even the smallest shapes and render them accurately in tone to make the object look convincing.

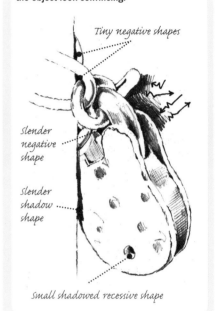

Tiny negative shapes

Slender negative shape

Slender shadow shape

Small shadowed recessive shape

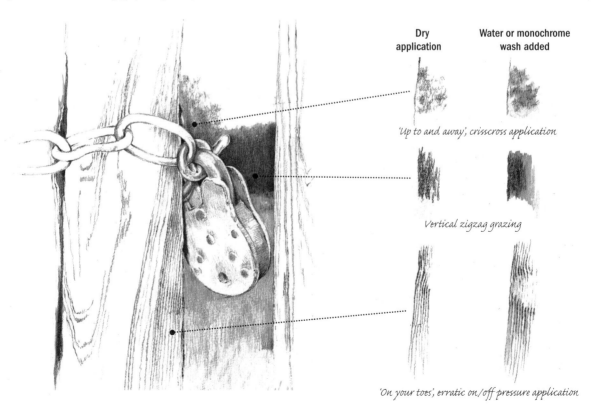

Dry application

Water or monochrome wash added

'Up to and away', crisscross application

Vertical zigzag grazing

'On your toes', erratic on/off pressure application

Adding a Coloured Overlay

For this, use an ordinary graphite pencil to do the initial drawing. If the watercolour overlay washes are dilute and translucent, the underdrawing textures will show through them. When the paint is completely dry you can work further into the drawing, enhancing the darks and adding more textured effects to emphasize contrasts.

Take advantage of the paper's surface texture as well to help create interest in the way the strokes are applied.

In the two studies the padlock is viewed from slightly different angles, which means the shadow shapes, negatives and cast shadow shapes are also slightly different.

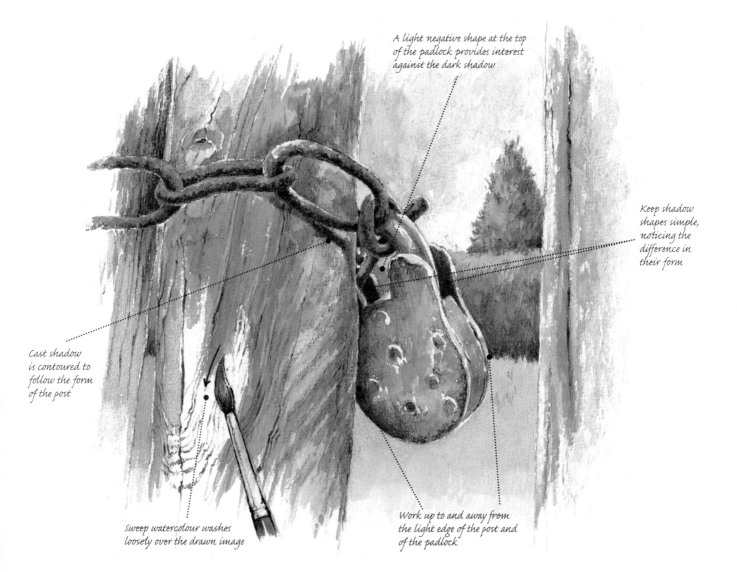

A light negative shape at the top of the padlock provides interest against the dark shadow

Keep shadow shapes simple, noticing the difference in their form

Cast shadow is contoured to follow the form of the post

Sweep watercolour washes loosely over the drawn image

Work up to and away from the light edge of the post and of the padlock

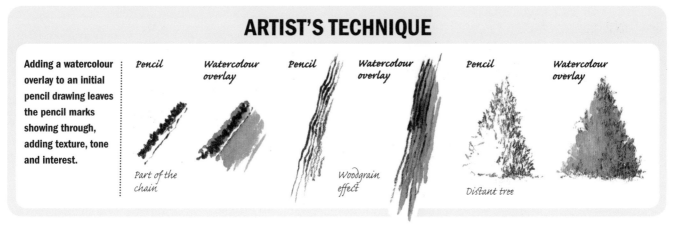

ARTIST'S TECHNIQUE

Adding a watercolour overlay to an initial pencil drawing leaves the pencil marks showing through, adding texture, tone and interest.

Pencil *Watercolour overlay* *Pencil* *Watercolour overlay* *Pencil* *Watercolour overlay*

Part of the chain

Woodgrain effect

Distant tree

Choosing Your Media

Working with one subject viewed from different angles and handled with different media will give you an opportunity to develop a deeper understanding of the relationships within the subject, the combination of paper or card and drawing or painting media and the stroke application you use with them. As an example I have chosen nursery toys and executed the studies in pencil, pen and ink with white gouache, coloured gouache over penwork and watersoluble pencils.

Working with Pencil

MEDIA: SOFT GRADE PENCIL ON 110GSM (51LB) CARTRIDGE DRAWING PAPER

A pencil study is an ideal starting point, enabling you to familiarize yourself with the subject. Look for opportunities to include lost lines, counterchange, shadow shapes, negative shapes, contrasts and dark tones behind light forms. In this illustration I show how the first placing of forms may be established with light toning, allowing subsequent overlays to build tonal values. The grazing application is very much in evidence in this study.

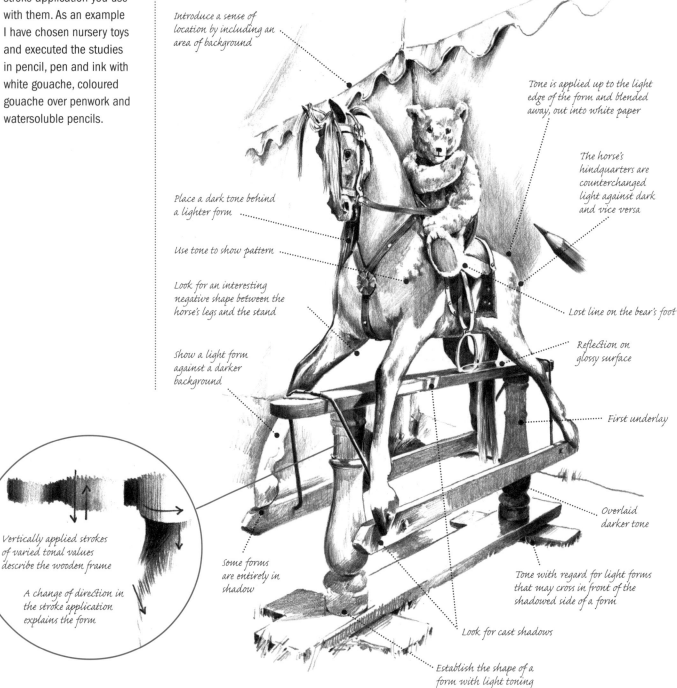

Introduce a sense of location by including an area of background

Tone is applied up to the light edge of the form and blended away, out into white paper

The horse's hindquarters are counterchanged light against dark and vice versa

Place a dark tone behind a lighter form

Use tone to show pattern

Look for an interesting negative shape between the horse's legs and the stand

Show a light form against a darker background

Lost line on the bear's foot

Reflection on glossy surface

First underlay

Overlaid darker tone

Vertically applied strokes of varied tonal values describe the wooden frame

A change of direction in the stroke application explains the form

Some forms are entirely in shadow

Tone with regard for light forms that may cross in front of the shadowed side of a form

Look for cast shadows

Establish the shape of a form with light toning

Pen, Ink and White Gouache

MEDIA: 0.1 PIGMENT LINER AND WHITE GOUACHE ON GREY BOCKINGFORD PAPER

Tinted Bockingford paper is an ideal support for pen and ink work and the use of white gouache will enhance highlights. For this study the viewing angle has been changed – the bear and horse are seen close up, enabling more observation of detail and interesting stroke application.

The main strokes to practise are those required for long hair, crosshatching pattern areas to enhance form and the short contoured strokes required for the depiction of the bear's fur.

For the fur, use short contoured strokes in varied directions

Enhance light areas with white gouache

Use short strokes to suggest hair

Crosshatch the surface of the pawpad

Depict long hair with long, flowing strokes

Build pattern with crosshatching

Build intensity of tone by overlaying

Delicately graze the surface to build intensity of tone

Start long hair with short contoured strokes

Extend into longer strokes

Add curves before tapering the strokes to complete

Contour crosshatching round the curve of the horse's chest

Paint white gouache over areas that require highlighting

Use short crosshatching strokes to create pattern, contouring them where necessary

Gouache

..

MEDIA: GOUACHE COLOURS ON DARK GREY MOUNT CARD

After the limited application of white gouache on tinted paper used in the study on the previous page, this study takes full advantage of gouache colours on darker-toned mount card. This offers the artist an opportunity to make use of light hues to full effect, with bright primary colours adding vibrancy in the form of the ribbon and rosettes.

On pages 132–139 you will discover various gouache techniques. Here I have used both a round watercolour brush for the bear's fur and a small flat synthetic bristle for dry-brush effects upon the patterned surface of the rocking horse. The initial drawing was executed in pen and ink and some of these lines have been allowed to remain visible in the completed work.

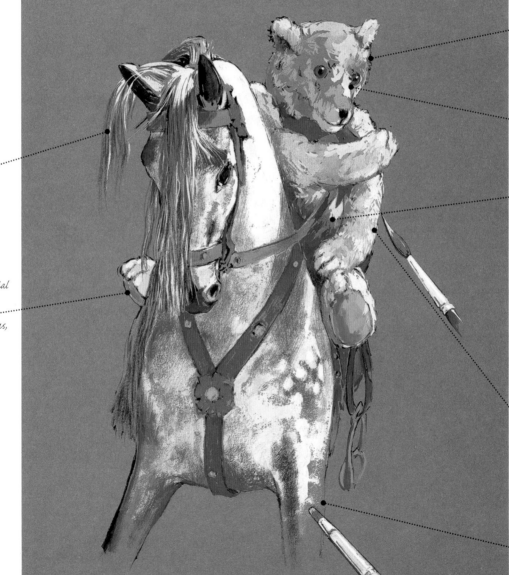

Here the initial drawing is done with a fine brush and black paint or pen and ink work

Colour is blocked in with regard for tonal areas

Overlays of hue and tone are built up

Loosely applied flowing strokes describe the long forelock and mane

Some of the initial black brush or pen and ink drawing remains, enhancing contrasts

Fine detail is added where required

A stiff, short-haired brush gives a dry-brush textured effect

Watersoluble Pencils

MEDIA: CHARCOAL AND INKTENSE PENCILS ON CREAM BOCKINGFORD PAPER

The vibrant colours of Inktense watersoluble pencils combined with dark charcoal pencil underdrawing were ideal for Bockingford paper, which has an attractive randomly textured surface. It is also excellent for its colour-lifting qualities.

For this study I have used the method of sharpening pigment strips into palette wells and adding water to mix, enabling a watercolour painting technique to be used over the charcoal underdrawing once it has been treated with fixative. As the Inktense washes are permanent when dry, subsequent wet on dry washes may be built up to increase hue and tone. Inktense Antique White pencil was used to highlight certain areas.

tip

This image was built using overlays of alternating washes and drawing. You will need to think carefully about your tones as you work in order to avoid losing the all-important highlights.

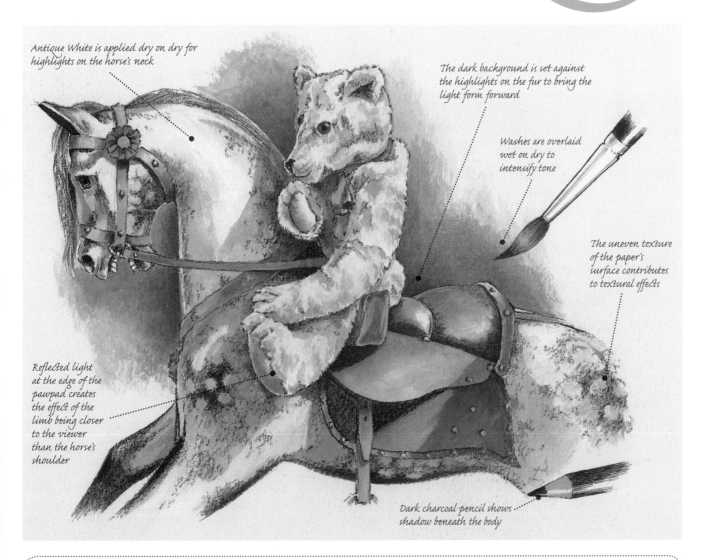

Antique White is applied dry on dry for highlights on the horse's neck

The dark background is set against the highlights on the fur to bring the light form forward

Washes are overlaid wet on dry to intensify tone

The uneven texture of the paper's surface contributes to textural effects

Reflected light at the edge of the pawpad creates the effect of the limb being closer to the viewer than the horse's shoulder

Dark charcoal pencil shows shadow beneath the body

Inktense Watersoluble Pencils

| 1. Mustard | 2. Baked Earth | 3. Willow | 4. Bark | 5. Charcoal Grey | 6. Deep Indigo | 7. Bright Blue | 8. Poppy Red | 9. Sun Yellow | 10. Antique White |

PART TWO

Developing Your Skills

 In this section of the book you will find many ways in which you can employ the eight basic stroke applications to draw and paint a variety of subjects. Drawing illustrations in pencil will encourage the development of both your observational and technical skills. Experimenting with controlled and looser approaches, you will discover the delights of working with graphite and coloured pencils, including tinted charcoal pencils (pages 84–99).

Pastel techniques (pages 100–107) lead into a more 'painterly' approach that acts as a natural progression into traditional watercolour painting techniques, either with a brush and pans or tubes of paint (pages 108–115) or with watersoluble pencils (pages 116–123).

Acrylic and gouache paints (pages 124–139) may be used with the same techniques as watercolour paint, but their opacity allows you to use white paint rather than leaving untouched paper for highlights, as is necessary with watercolour. You will also learn the possibilities that come with using pen and ink, which these days is available in a large range of colours, brushes and nib types (pages 140–147).

When you have explored all these media, the obvious temptation is to try combining two or more in one painting. This section ends with pages showing the exciting options that present themselves in the mixing of wet and dry media (pages 150–155).

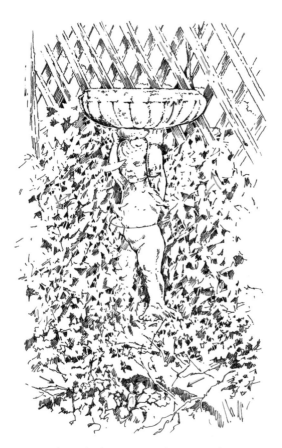

The arrows indicate the direction of strokes. Varying them is important as otherwise the foliage will look too uniform to be convincing

When you are using Inktense pencils for painting either pull pigment from the pencil strip into a palette well (left) or, when a stronger hue is required, touch the tip of the pencil with a wet brush (right).

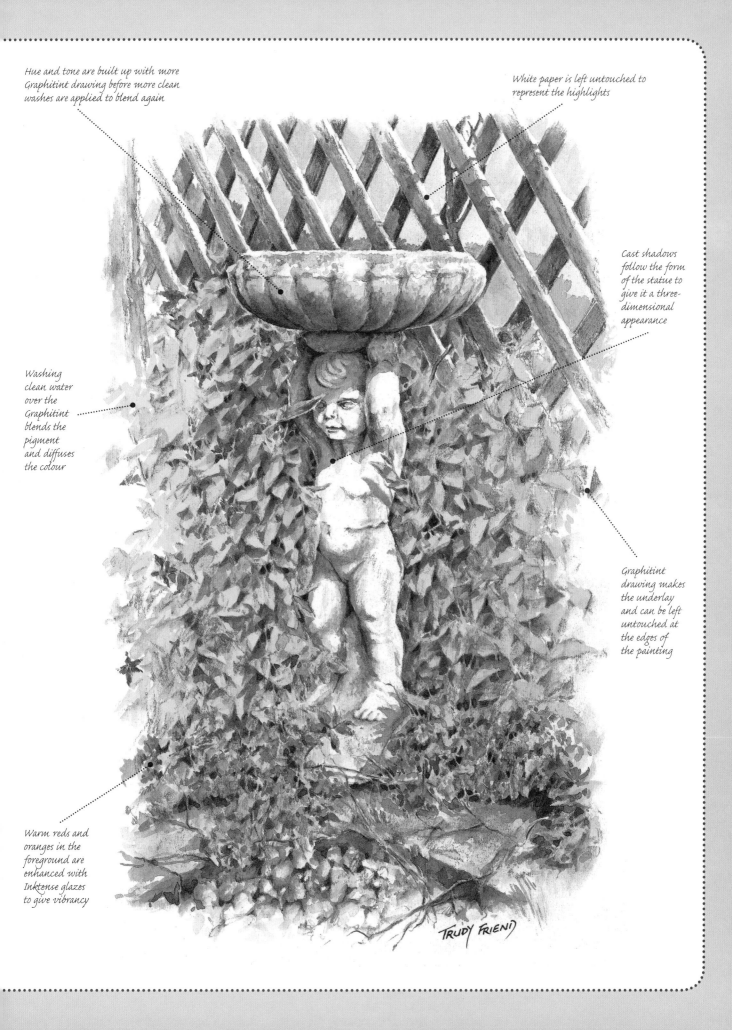

Hue and tone are built up with more Graphitint drawing before more clean washes are applied to blend again

White paper is left untouched to represent the highlights

Cast shadows follow the form of the statue to give it a three-dimensional appearance

Washing clean water over the Graphitint blends the pigment and diffuses the colour

Graphitint drawing makes the underlay and can be left untouched at the edges of the painting

Warm reds and oranges in the foreground are enhanced with Inktense glazes to give vibrancy

TRUDY FRIEND

Graphite: A Versatile Medium

Graphite comes in a range of forms for the artist. From hard 9H to soft 9B, graphite pencils are ideal for crisp, detailed line illustrations, combinations of line and tone, loosely executed drawings and soft sketches. Derwent produce sketching and watersoluble sketching pencils which have a soft, extra-wide graphite strip, making them ideal for quick, free line sketches and bold line drawings. These are available in three degrees, respectively HB, 2B and 4B and HB, 4B and 8B.

Derwent's watersoluble Graphitone is a stick of pure, artist-quality graphite that can be used wet or dry. The four wash strengths are 2B, 4B and 8B. Also available from Derwent are natural graphite blocks, which are particularly good for creating free, expressive drawings. They are slightly dusty, which makes for easy blending, and are available in soft, medium and hard grades.

tip

When you are using watersoluble graphite it is advisable to work on a watercolour paper or heavyweight cartridge paper as these are capable of accommodating washes without cockling.

Using Watersoluble Graphite Pencils

In this illustration, a watersoluble graphite pencil was used dry-on-dry on the left-hand side. In the central area, water was added to soften areas of tone and enhance the darks, while on the right-hand side I have placed an area of monochrome watercolour for comparison.

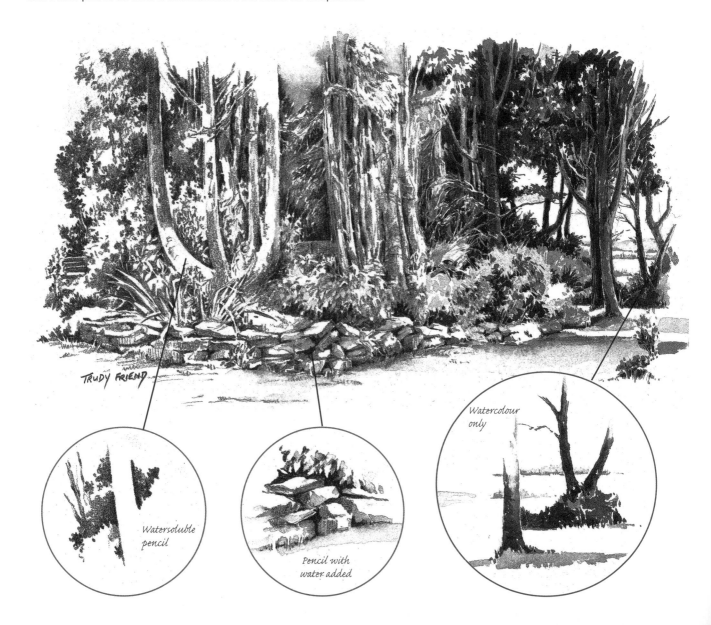

TRUDY FRIEND

Watersoluble pencil

Pencil with water added

Watercolour only

Line and Tone in Graphite

These exercises demonstrate the versatility of soft graphite pencils upon a smooth white paper surface, used here in relation to the drawing of plants. Try these exercises to accustom yourself to the quality of graphite pencils.

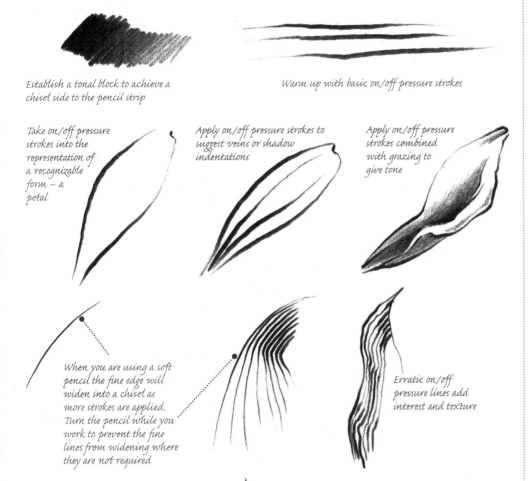

Establish a tonal block to achieve a chisel side to the pencil strip

Warm up with basic on/off pressure strokes

Take on/off pressure strokes into the representation of a recognizable form – a petal

Apply on/off pressure strokes to suggest veins or shadow indentations

Apply on/off pressure strokes combined with grazing to give tone

When you are using a soft pencil the fine edge will widen into a chisel as more strokes are applied. Turn the pencil while you work to prevent the fine lines from widening where they are not required

Erratic on/off pressure lines add interest and texture

In this image a directional application of all the strokes shown here defines the form

Practise gentle undulations of on/off pressure strokes to help you represent the graceful form of many plants

The introduction of tick and flick strokes enhances other areas

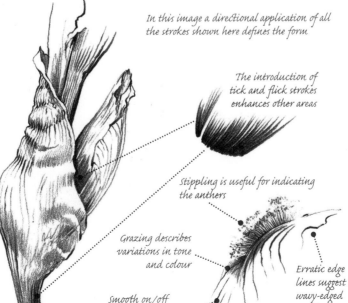

Stippling is useful for indicating the anthers

Grazing describes variations in tone and colour

Smooth on/off pressure strokes give a sinuous line

Erratic edge lines suggest wavy-edged petals

Case Study: Teddy with Boot

MEDIA: 5B GRAPHIC PENCIL ON 110GSM (51LB) DRAWING PAPER

In this illustration you will see the eight basic stroke applications combined in various ways to depict a number of different surface textures. These range from sawn wood, towelling, china, leather, fake hair, cottonwool stuffing and the crosshatch texture of woven cloth to a distant tree seen through the dark interior of a wooden building.

It also demonstrates the importance of cast shadow areas and other strong contrasts that help to define light forms. Contoured applications of parallel lines define the shapes of forms and, where areas of white paper remain untouched by the pencil, highlights help to achieve a three-dimensional effect. Look at this study very closely to develop your understanding of how overlaid texture and tone reinforce the richly textured shapes and shadows.

Crisscross application may be achieved either by lifting the pencil from the paper during execution or by retaining contact with it throughout

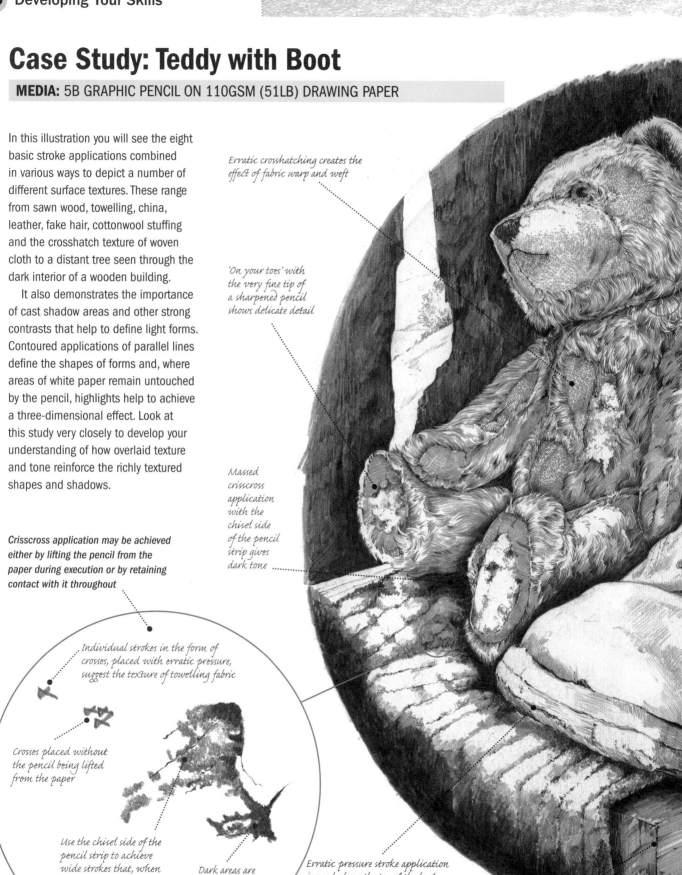

Erratic crosshatching creates the effect of fabric warp and weft

'On your toes' with the very fine tip of a sharpened pencil shows delicate detail

Massed crisscross application with the chisel side of the pencil strip gives dark tone

Individual strokes in the form of crosses, placed with erratic pressure, suggest the texture of towelling fabric

Crosses placed without the pencil being lifted from the paper

Use the chisel side of the pencil strip to achieve wide strokes that, when massed, give a textured base upon which to overlay darker tone

Dark areas are also achieved with crisscross application

Erratic pressure stroke application is used along the toe of the boot

The twist or rock erratic pressure application creates shadow lines within the wooden support

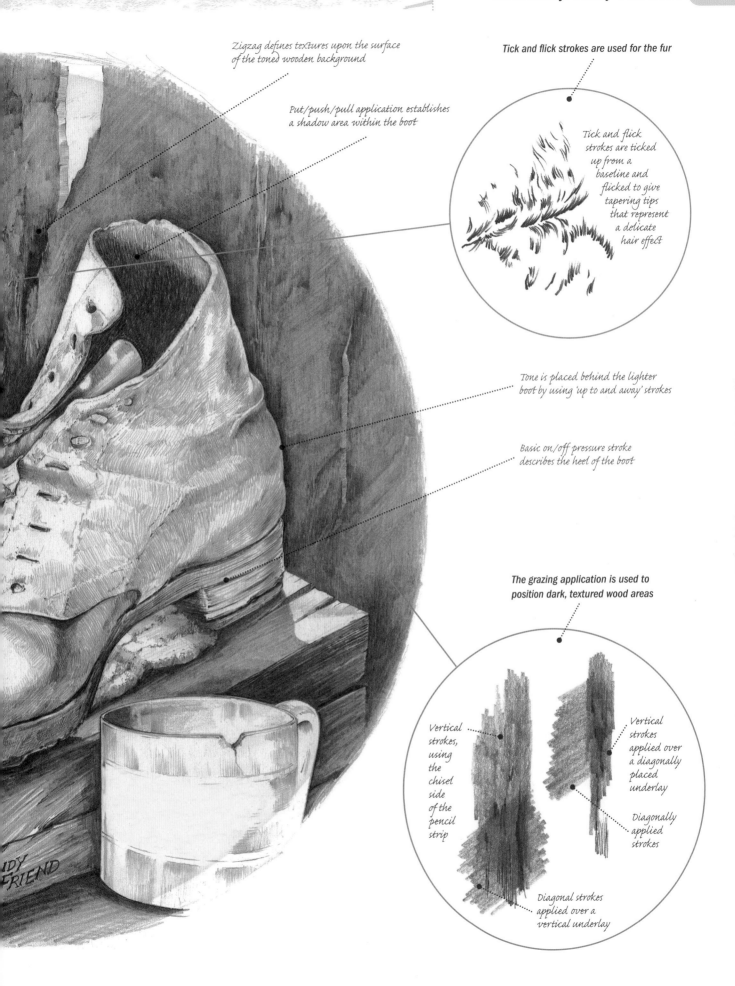

Zigzag defines textures upon the surface of the toned wooden background

Put/push/pull application establishes a shadow area within the boot

Tick and flick strokes are used for the fur

Tick and flick strokes are ticked up from a baseline and flicked to give tapering tips that represent a delicate hair effect

Tone is placed behind the lighter boot by using 'up to and away' strokes

Basic on/off pressure stroke describes the heel of the boot

The grazing application is used to position dark, textured wood areas

Vertical strokes, using the chisel side of the pencil strip

Vertical strokes applied over a diagonally placed underlay

Diagonally applied strokes

Diagonal strokes applied over a vertical underlay

Case Study: Snail

MEDIA: 4B GRAPHITE PENCIL ON 110GSM (51LB) DRAWING PAPER

This study of a snail has been reproduced actual size so that you can see how a soft pencil can help you achieve a variety of tonal values. Notice how the darkest darks are the smallest shapes and how much white paper has been retained. The background foliage treatment fades out unevenly into the white of the paper rather than being held rigidly within a specific format.

I chose this subject for its variety of textured surfaces – hard, shiny shell, soft, moist body and crispness in the supporting leaves. On the opposite page a completely different subject has been drawn with the same eight basic stroke treatment. Notice how the various applications have been used in both studies to depict the many diverse textures.

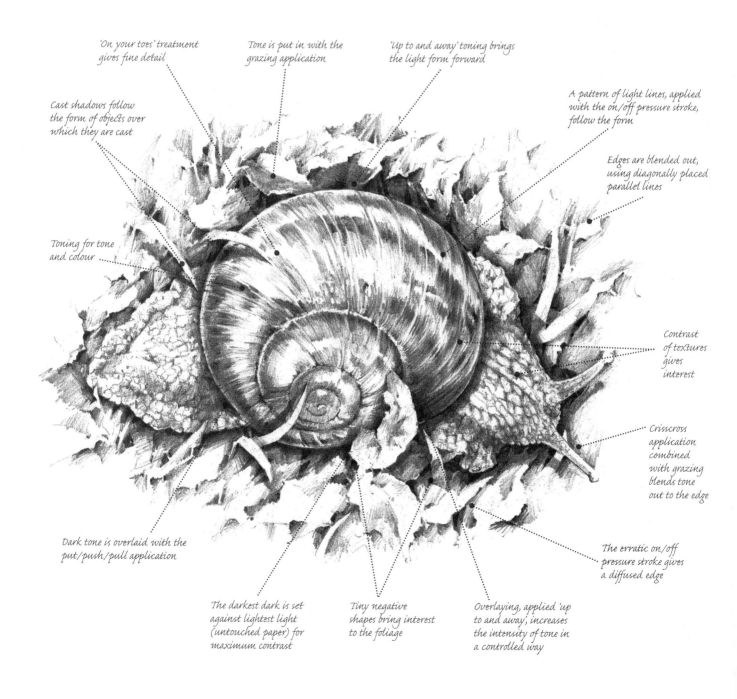

'On your toes' treatment gives fine detail

Tone is put in with the grazing application

'Up to and away' toning brings the light form forward

A pattern of light lines, applied with the on/off pressure stroke, follow the form

Cast shadows follow the form of objects over which they are cast

Edges are blended out, using diagonally placed parallel lines

Toning for tone and colour

Contrast of textures gives interest

Crisscross application combined with grazing blends tone out to the edge

Dark tone is overlaid with the put/push/pull application

The erratic on/off pressure stroke gives a diffused edge

The darkest dark is set against lightest light (untouched paper) for maximum contrast

Tiny negative shapes bring interest to the foliage

Overlaying, applied 'up to and away', increases the intensity of tone in a controlled way

Case Study: Bird

MEDIA: HB AND B GRAPHITE PENCILS ON 110GSM (51LB) DRAWING PAPER

Rather than look at the complete subject, as with the snail opposite, I have moved in closer to the bird and composed the picture within a definite format. I have chosen harder pencils to enable the fine detailing of the feathers, bill and eye.

Wandering line application enabled a suggestion of hard pebbles and stones for the background to make an interesting contrast to the delicate softness required for feather representations and crisp enhancing of bill and eye.

Although the textures are very different from the interpretations of foliage, the eight basic stroke applications are adaptable. Again shown actual size so that you may discern the detail, a close-up of the eye and bill area clearly demonstrates the treatment.

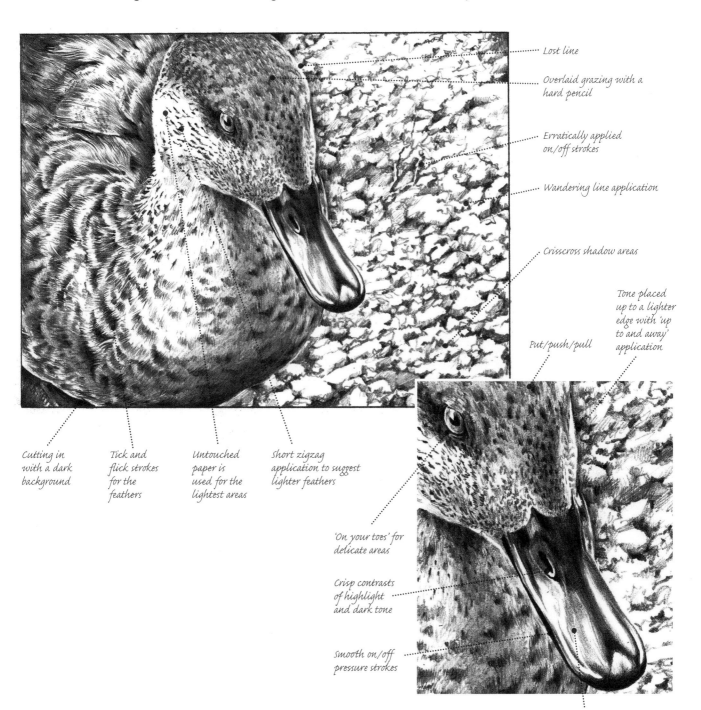

Lost line

Overlaid grazing with a hard pencil

Erratically applied on/off strokes

Wandering line application

Crisscross shadow areas

Tone placed up to a lighter edge with 'up to and away' application

Put/push/pull

Cutting in with a dark background

Tick and flick strokes for the feathers

Untouched paper is used for the lightest areas

Short zigzag application to suggest lighter feathers

'On your toes' for delicate areas

Crisp contrasts of highlight and dark tone

Smooth on/off pressure strokes

Elongated tick and flick application that follows form

Drawing Life's Contours

On this spread, the subject of drawing contours is applied to the human head. It is presented in the form of problems and solutions so that if you see areas in the illustrations below that relate to any problems you may be experiencing with portrait drawing, you can look across to the opposite page for guidance.

Depicting features at a correct angle in relation to the angle of the head often presents difficulties for beginners, and applying tone, indicating facial contours or managing the texture of hair may also cause problems. Looking at these three-quarter angles will help you in these respects, as well as giving you an understanding of the relationships between the neck and clothing.

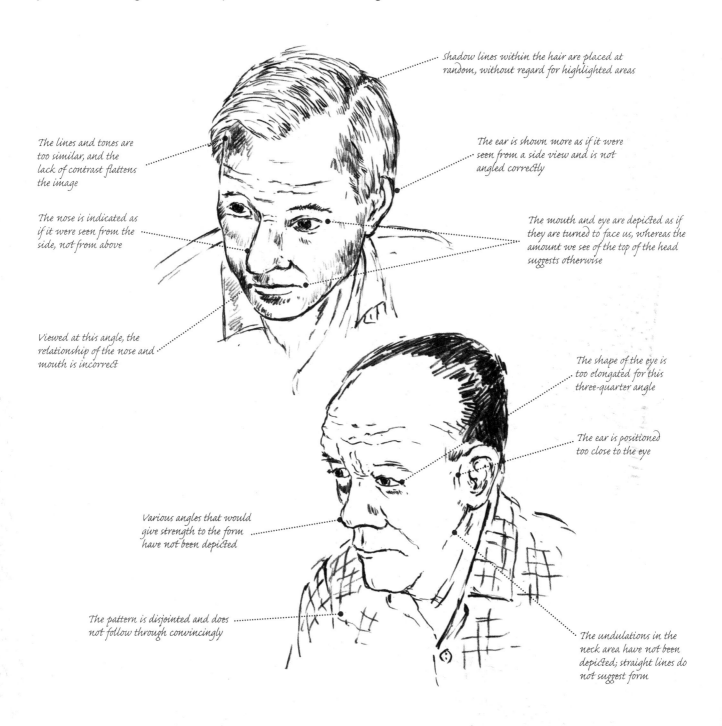

Shadow lines within the hair are placed at random, without regard for highlighted areas

The lines and tones are too similar, and the lack of contrast flattens the image

The ear is shown more as if it were seen from a side view and is not angled correctly

The nose is indicated as if it were seen from the side, not from above

The mouth and eye are depicted as if they are turned to face us, whereas the amount we see of the top of the head suggests otherwise

Viewed at this angle, the relationship of the nose and mouth is incorrect

The shape of the eye is too elongated for this three-quarter angle

The ear is positioned too close to the eye

Various angles that would give strength to the form have not been depicted

The pattern is disjointed and does not follow through convincingly

The undulations in the neck area have not been depicted; straight lines do not suggest form

Directional Stroke Application

It is important to describe form correctly when you are looking down upon a subject. Whatever style of drawing you favour, it is likely that your regard for form will influence the strokes you use.

The left-hand portrait has been executed with a controlled approach, with close crosshatching used for tonal areas and long on/off pressure strokes representing the smooth hairstyle. The portrait on the right received the more sketchy approach and you will see the use of parallel lines and zigzags. The smaller heads are drawn with arrows indicating how to consider directional stroke application.

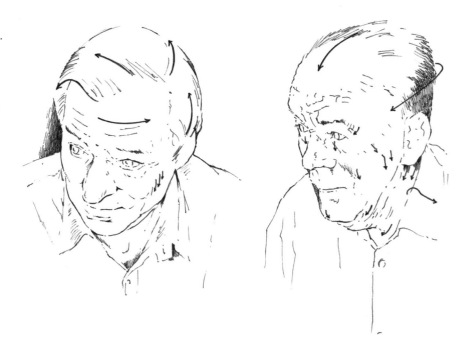

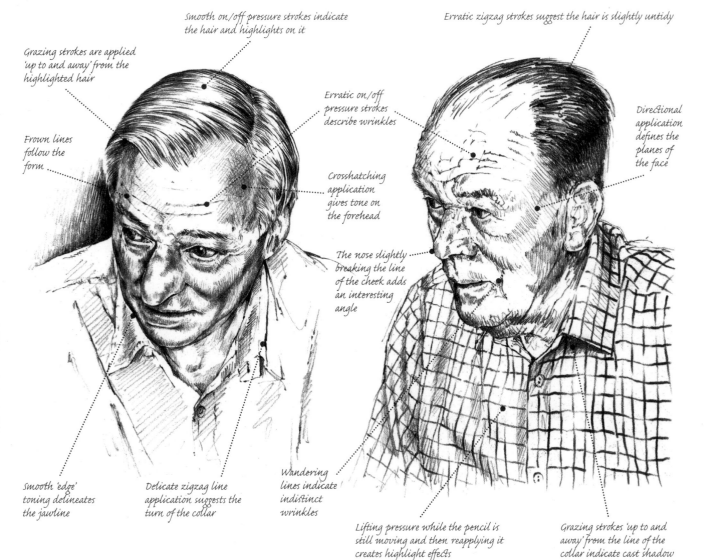

Smooth on/off pressure strokes indicate the hair and highlights on it

Erratic zigzag strokes suggest the hair is slightly untidy

Grazing strokes are applied 'up to and away' from the highlighted hair

Erratic on/off pressure strokes describe wrinkles

Directional application defines the planes of the face

Frown lines follow the form

Crosshatching application gives tone on the forehead

The nose slightly breaking the line of the cheek adds an interesting angle

Smooth 'edge' toning delineates the jawline

Delicate zigzag line application suggests the turn of the collar

Wandering lines indicate indistinct wrinkles

Lifting pressure while the pencil is still moving and then reapplying it creates highlight effects

Grazing strokes 'up to and away' from the line of the collar indicate cast shadow

Coloured Pencils

MEDIA: STUDIO PENCILS ON 190GSM (90LB) SAUNDERS WATERFORD HP PAPER

Whether you enjoy detailed drawing or prefer a loose and free approach, you will find coloured pencils an exciting medium. Their versatility lies in the vast numbers of brands and ranges available. Here I have used the Derwent Studio range with their hexagonal barrels and narrow strips, which enable finely detailed work to be executed. Their comprehensive range includes Metallic (12 highly reflective pencils that add sparkle to artwork), Signature (also available as a watersoluble medium) and Coloursoft, with their velvety softness and vibrant hues. In contrast to the Studio range, Derwent Artist's Pencils have round barrels encasing soft, slightly waxy strips.

tip

When delicacy is required, sharpen your pencils frequently and work 'on your toes' to cut in around crisp edges. Start placing components with light pressure strokes to make a pale underlay and build tone.

A Spring Scene

Firm directional pressure upon the vibrant green and yellow pencils for the execution of the grassy areas in this illustration contrasts with my execution of the gentle layering required to achieve the more subtle image opposite.

Put/push/pull application is used for the distant hedgerow

The background field is put in with flat grazing strokes

Twisting erratic on/off pressure application describes twigs

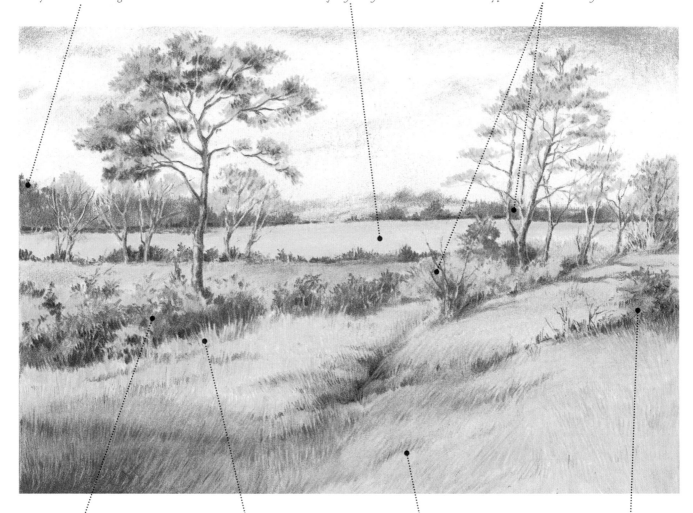

A combination of crisscross, 'on your toes' and put/push/pull applications is used for the mixed vegetation

'Up to and away' strokes from light strips represent pale grasses in front of dark shadow areas

Directional stroke application as pull down is used for foreground grasses

Crisscross application indicates shrubby foliage

Using Neutral Hues

Flat applications of numerous pencil pigment layers have been used to build this image gradually, working up a smooth-textured, subtle effect. The areas of woodwork have received a blended treatment as a final layer, using the Derwent Blender pencil – a soft, colourless pencil made from the same binder as the coloured pencils which can be used to smooth colours gently together. Layers of colour may also be burnished with the Burnisher Pencil, producing a more matt surface.

Many applications of gentle layering are applied to give a woodgrain texture

Colours are overlaid to build intensity of hue and tone

Tone is put in with vertical up and down movements of the pencil

Zigzag application is used to depict uneven textured shadow tone

Tone is placed to represent damaged areas of tin

The first pale undercoat positions the elements of the composition

Crisscross application depicts foliage

Smooth on/off pressure stroke gives a shadow line

Erratic on/off pressure application is combined with zigzag application for rough edges of timber

'Up to and away' application for areas of dark background retains the light strips required to represent grasses

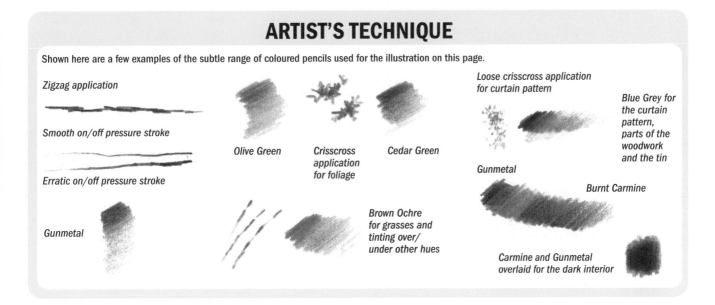

ARTIST'S TECHNIQUE

Shown here are a few examples of the subtle range of coloured pencils used for the illustration on this page.

Zigzag application

Smooth on/off pressure stroke

Erratic on/off pressure stroke

Gunmetal

Olive Green

Crisscross application for foliage

Cedar Green

Brown Ochre for grasses and tinting over/ under other hues

Loose crisscross application for curtain pattern

Gunmetal

Carmine and Gunmetal overlaid for the dark interior

Blue Grey for the curtain pattern, parts of the woodwork and the tin

Burnt Carmine

Case Study: Delicate and Detailed

MEDIA: DERWENT STUDIO COLOURED PENCILS

Derwent Studio's coloured pencils consist of a hexagonal barrel enclosing a narrow strip, giving you extra control for detailed areas such as the delicate feathers of these beautiful budgerigars.

Here I outline the main steps to achieving a detailed study using coloured pencils. If you can, it is initially advisable to produce a few sketches from life, as observing movement and detail will help you to get a better understanding about how to capture your subject.

Now you can start to work out the composition of your subject, develop the negative shapes between them and start applying colour to bring the piece to life. For the final study, you may prefer to work from a photographic reference to allow closer observation of fine detail and achieve a more realistic study.

1. Sketching from Life

It is useful to produce some quick observational sketches to improve your understanding of your chosen subject. Pay particular attention to cast shadow shapes, negative shapes and interesting line edges, which help to define form and add interest to your studies.

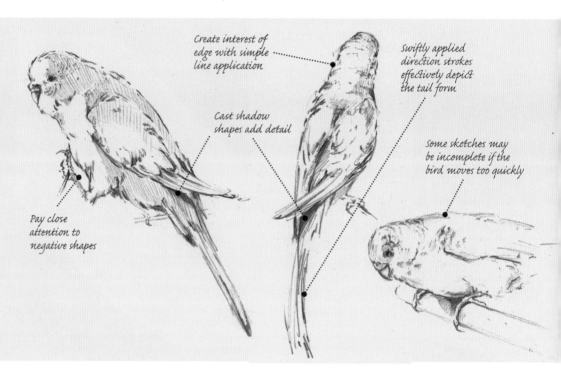

Create interest of edge with simple line application

Cast shadow shapes add detail

Pay close attention to negative shapes

Swiftly applied direction strokes effectively depict the tail form

Some sketches may be incomplete if the bird moves too quickly

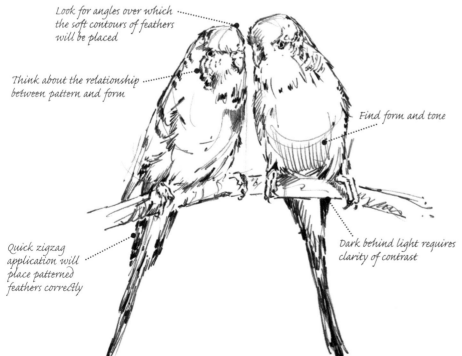

Look for angles over which the soft contours of feathers will be placed

Think about the relationship between pattern and form

Find form and tone

Quick zigzag application will place patterned feathers correctly

Dark behind light requires clarity of contrast

2. Choosing your Composition

It is invaluable to produce a quick preliminary sketch to select the positions of your subjects before adding colour and detail. Use a soft pencil on smooth white copier paper for ideal results.

Keep the detail of your subject in mind to create a more realistic study. By positioning the head of one bird slightly higher than the other, and curving the supporting branch, I have added greater interest and a more realistic effect than if they were just side by side.

3. Using Negative Shapes

Concentrate on the negative shapes between the birds, as this will enable you to place them correctly in relation to one another.

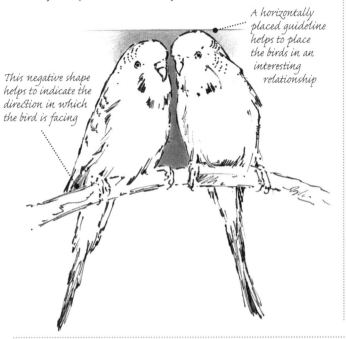

A horizontally placed guideline helps to place the birds in an interesting relationship

This negative shape helps to indicate the direction in which the bird is facing

4. Starting Colour Application

Start applying colour using a variety of strokes, as outlined below, to add interest to your work.

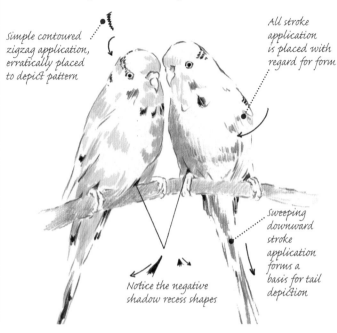

Simple contoured zigzag application, erratically placed to depict pattern

All stroke application is placed with regard for form

Sweeping downward stroke application forms a basis for tail depiction

Notice the negative shadow recess shapes

5. Completing your Study

Use a variety of coloured pencil shades (below) and a broad range of application techniques to add colour and detail to your work.

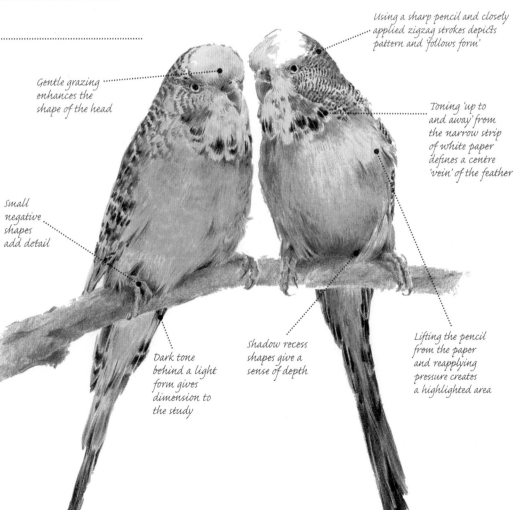

Using a sharp pencil and closely applied zigzag strokes depicts pattern and 'follows form'

Gentle grazing enhances the shape of the head

Toning 'up to and away' from the narrow strip of white paper defines a centre 'vein' of the feather

Small negative shapes add detail

Dark tone behind a light form gives dimension to the study

Shadow recess shapes give a sense of depth

Lifting the pencil from the paper and reapplying pressure creates a highlighted area

Coloured Pencils

1. Deep Cadmium

2. Golden Brown

3. Bronze

4. Grass Green

5. Mineral Green

6. Light Blue

7. Cobalt Blue

8. Blue Grey

9. Gun Metal

10. Black

Case Study: Butterfly in Coloured Pencils

MEDIA: DERWENT STUDIO PENCILS ON 190GSM (90LB) SAUNDERS WATERFORD HP PAPER

To achieve the delicacy of a butterfly wing in coloured pencils you will need to keep the coloured strips of your pencils extremely sharp. After using a knife or pencil sharpener to establish the length, gently graze this against an emery board (or fine glass paper), wiping away any surplus dust with a tissue.

It is a good idea to test the colours you choose upon a sample sheet of paper, using stroke movements that you can work out in your preliminary sketches. The image below demonstrates this, where I have suggested how a main guideline (vertical 'drop' line) can help you place the position of a wing in relation to the head. Creating a right-angle corner (shown in red) points out the negative shape between this and some of the flower petals with part of the wing. A horizontal guideline (shown in green), taken to the 'drop' line, will allow you to concentrate upon creating accuracy within a small area before moving across the image and positioning other components. The small 'shape between' (in blue) starts the second wing in a correct relationship and you can add other guidelines of your own in this way to help you continue.

The intricacies of antennae and legs are achieved by toning 'up to and away' from light strips of paper. Initially, draw the position as an outline (a), noticing the tiny shape between antennae and leg (b), then, by toning 'up to and away', carefully reduce the width of these narrow forms (c). Curve the toning around the end of the form before taking it out and away (d).

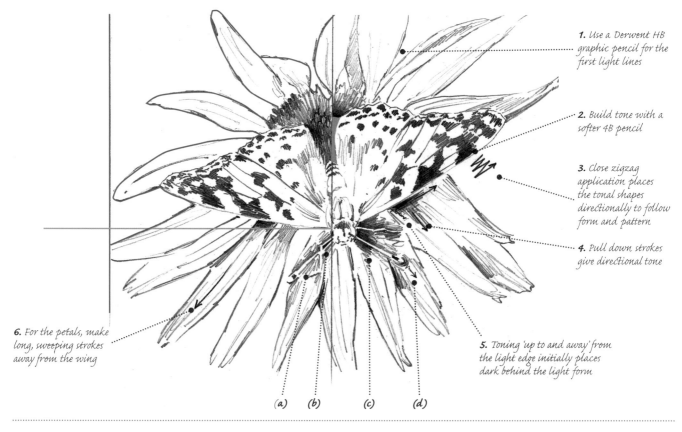

1. Use a Derwent HB graphic pencil for the first light lines

2. Build tone with a softer 4B pencil

3. Close zigzag application places the tonal shapes directionally to follow form and pattern

4. Pull down strokes give directional tone

6. For the petals, make long, sweeping strokes away from the wing

5. Toning 'up to and away' from the light edge initially places dark behind the light form

(a) (b) (c) (d)

Petal

Use zigzag application

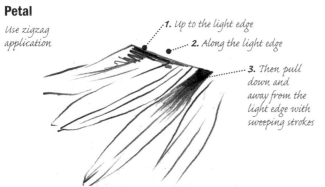

1. Up to the light edge

2. Along the light edge

3. Then pull down and away from the light edge with sweeping strokes

Wing

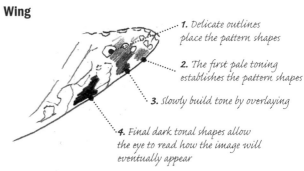

1. Delicate outlines place the pattern shapes

2. The first pale toning establishes the pattern shapes

3. Slowly build tone by overlaying

4. Final dark tonal shapes allow the eye to read how the image will eventually appear

From Monochrome to Colour

Time taken producing a monochrome image of the subject that you intend to execute in colour is never wasted; it gives you an opportunity to learn more about the subject before embarking upon many hours of detailed pencilwork in colour. You will have developed a deeper understanding of the subject and how you will be representing it in your final impression.

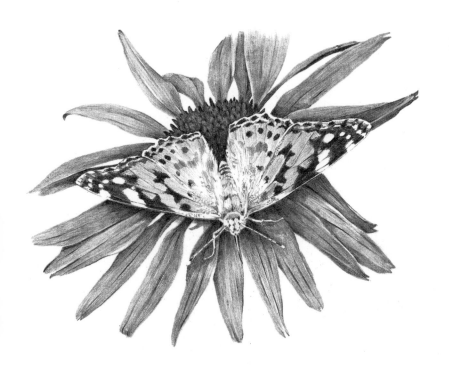

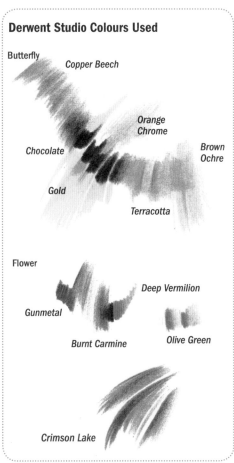

Derwent Studio Colours Used

Butterfly
Copper Beech
Orange Chrome
Chocolate
Brown Ochre
Gold
Terracotta

Flower
Gunmetal
Deep Vermilion
Burnt Carmine
Olive Green
Crimson Lake

Building Colour

The left-hand side of this image shows the first pale hues laid in, while on the right more colour has been overlaid to enrich hue and tone.

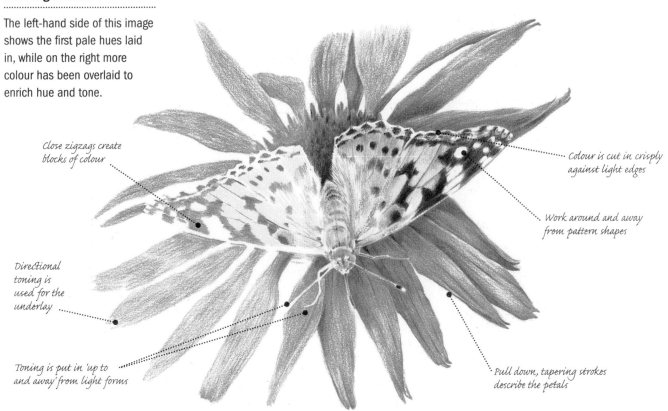

Close zigzags create blocks of colour

Colour is cut in crisply against light edges

Work around and away from pattern shapes

Directional toning is used for the underlay

Toning is put in 'up to and away' from light forms

Pull down, tapering strokes describe the petals

Tinted Charcoal: Still Life Studies

MEDIA: TINTED CHARCOAL ON 190GSM (90LB) SAUNDERS WATERFORD CP (NOT) PAPER

I am including tinted charcoal pencils in this coloured pencil section as they are so expressive, with the attributes of traditional charcoal plus a gentle tint of colour. They smudge and blend easily, producing deep rich tones, yet can be sharpened to a fine point, allowing all eight basic stroke applications to be used to full effect.

Derwent's paper stump is useful as a tool for blending or correction work and has been employed in both the study of three windfall apples below and the fungi opposite. With all the blending, attention has been paid to form and opportunities to include areas of counterchange and reflected light have been used. The objects were arranged so that negative and cast shadow shapes would enhance the composition.

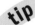

tip

Choose a paper of a weight and texture that works with your style and the soft media of charcoal. Allow the untouched paper areas to enhance contrasts with crisp and diffused edges.

Counterchange – light against dark and dark against light – is used

The application of strokes follows the form

Small shapes like this are important within relationships

Reflected light differentiates the curve of the apple from the shadow below

Derwent Charcoal

These are just a few of the exciting tinted charcoal range of colours produced by Derwent.

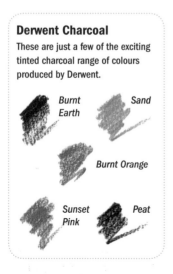

Burnt Earth

Sand

Burnt Orange

Sunset Pink

Peat

ARTIST'S TECHNIQUE

Using charcoal pencils allows you to achieve subtle blending and texture.

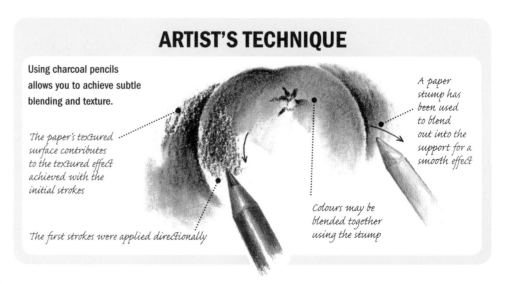

The paper's textured surface contributes to the textured effect achieved with the initial strokes

The first strokes were applied directionally

A paper stump has been used to blend out into the support for a smooth effect

Colours may be blended together using the stump

Fungi

In the study below you will see how erratic on/off pressure strokes have created interest in the areas of gills and stalk and how shadow shapes have been contrasted against the highlights. Subtle tints of these charcoal pencils work well upon the off-white surface of Saunders Waterford CP (Not) paper.

The study shown right of various fungi I collected from undergrowth was produced for Derwent as an example of techniques used with their tinted charcoal range of pencils. Their subtle hues lend themselves to the subject.

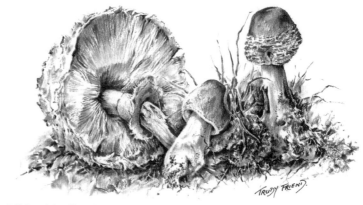

By kind permission of Derwent

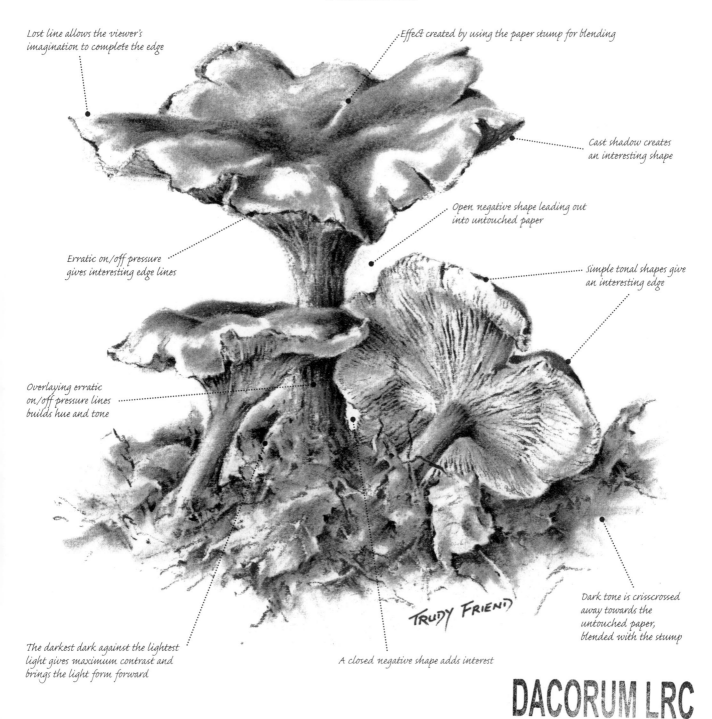

Lost line allows the viewer's imagination to complete the edge

Effect created by using the paper stump for blending

Cast shadow creates an interesting shape

Open negative shape leading out into untouched paper

Erratic on/off pressure gives interesting edge lines

Simple tonal shapes give an interesting edge

Overlaying erratic on/off pressure lines builds hue and tone

The darkest dark against the lightest light gives maximum contrast and brings the light form forward

A closed negative shape adds interest

Dark tone is crisscrossed away towards the untouched paper, blended with the stump

Pastels

Pastels are an exciting medium to use, giving you the opportunity to work with brilliant colours or more subtle ones. Their textural quality can be enhanced by using a range of rough surfaces, and their opacity makes it possible to apply them successfully on strongly coloured backgrounds.

Traditional soft pastels sometimes cause problems for beginners, as their loose, powdery, grainy texture can make them difficult to control for the inexperienced. For this reason it may be more helpful for the novice to start with pastel blocks and pencils before moving into the exciting applications afforded by soft pastel sticks, which are available in an abundance of hue and tone.

You will have plenty of opportunity to practise with a limited number before extending your range, as many are supplied individually as well as in small tins and boxes. By choosing a few colours that suit your subject matter you can practise the eight basic stroke applications in this medium in the same way as for pencil and watercolour. However, as pastels cannot be mixed like paint, manufacturers offer a vast choice of colour and tint.

Using Pastels

Winsor & Newton soft pastels are ideal for the sweeping strokes of a free approach and offer brilliance and rich texture. With a greater proportion of binder to pigment, the harder pastel blocks from Derwent are perhaps a little easier for beginners to use, certainly if fine detail is required. Their squared shape can be a great advantage for massing colour and hatching strokes and they lend themselves to all the eight basic stroke applications. They may also be shaved with a sharp blade to form a point if required.

Derwent Pastel Pencils are an extremely useful tool, being softer than hard pastel blocks and harder than the soft sticks. I have used them extensively in my illustrations and find them ideal for crisp finishing touches.

Winsor & Newton soft pastels are excellent for blocking in large areas and have a soft, powdery texture.

With Derwent pastel blocks, you can achieve fine lines using the sharp edge, block in large areas and cover smaller areas with a single stroke.

Derwent pastel pencils are ideal for fine lines but will also cover large areas effectively.

Wide blocks and wide lines made by Winsor & Newton soft pastel on Ingres pastel paper, demonstrating how the texture of the paper shows through lighter applications of pastel.

Pastel Stroke Applications

Examples of basic stroke applications using the blocks and pencils are given here so that you may familiarize yourself with their use in the form of a few simple exercises. Blocks and pencils may both be used successfully for all the basic stroke applications. The same types of pastel are used in the demonstrations on the following spreads.

Block

Pencil

Basic on/off pressure application

Pencil

Erratic on/off application in pencil

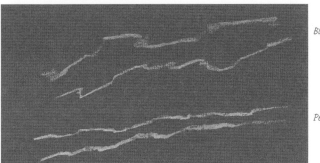

Block

Pencil

Twist application

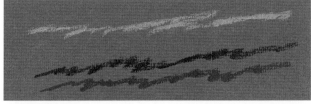

Block

Pencil

Zigzag application

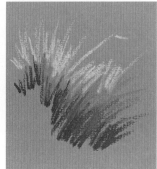

The put/push/pull application using a pastel block creates a more diffuse foliage mass than is obtained by using a graphite pencil.

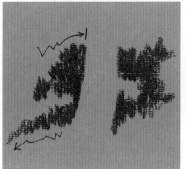

'On your toes' application with (left) a pastel block and (right) a pastel pencil gives the crisper effect of a coniferous tree.

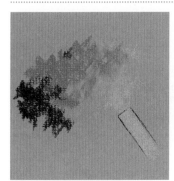

The crisscross application executed with Derwent pastel blocks.

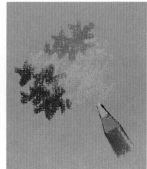

The crisscross application executed with Derwent pastel pencils, showing the finer line that can be obtained.

The 'up to and away' stroke application with Derwent pastel pencil.

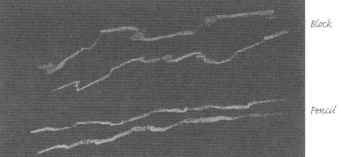

Tick and flick application with Derwent pastel pencil.

Demonstration in Pastel: Stonework

MEDIA: SOFT PASTELS, PASTEL BLOCKS AND PASTEL PENCILS ON INGRES
PASTEL PAPER AND ON PASTEL BOARD

Using pastel to paint stonework, whether dry stone walls out in the countryside or that of old buildings, can be an exciting exercise. The chance to use a variety of stroke applications is offered in the contrasts of woodwork, stonework and vegetation.

In the illustration of a dry stone wall on this page you will see that I have used the on/off pressure application for the initial drawing in black pastel. Up and down strokes of a neutral hue suggest distant trees, while long, sweeping strokes move over the green fields.

Blocking in the various planes of foreground stones gives strength to the images and directional grazing strokes of blue and white cover the sky. You can retain much of the surface hue and texture if you choose a colour that relates to the subject matter.

tip

Before beginning any work in pastel, it is important to consider the choice of hue and tone of your support and to what extent you intend to allow it to show through your applications of pastel.

Pastel pencil strokes sweep 'up to and away' from the distant tree line to place the white clouds without encroaching on the foliage

Working pale hue over an initial darker pastel layer, almost up to the edge of the stones, leaves a slender dark 'line' to add interest

Up and down application for distant trees suggests their presence without added detail

Strokes swept directionally take the eye in the desired direction

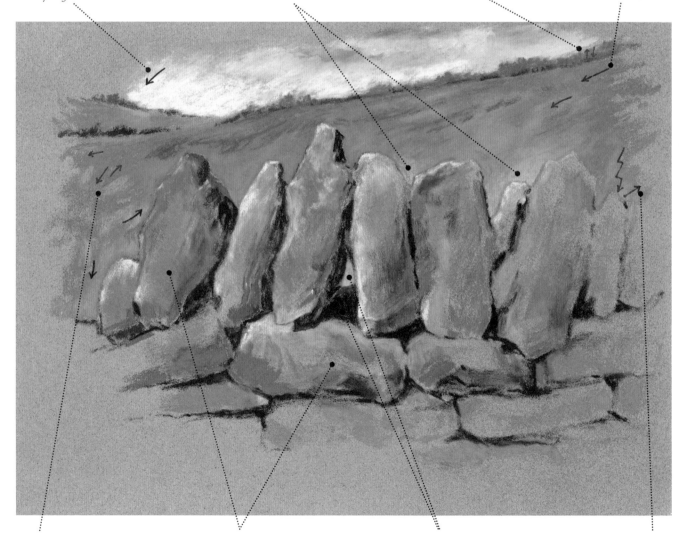

Strokes applied in different directions add interest to the effect achieved

Pastel colours are filled in to the point that they eventually create solid hue. Elsewhere, some support colour is allowed to show through

A shadow shape and negative shape create an important area of interest

Stroke work 'up to and away' from the edges of the stones provides a crisp delineation of their form

Colourful Windowbox

The stonework in this illustration is flatter, with interesting cement 'lines' weaving in and out of the main blocks. There is a multitude of textures to depict and neutral hues contrast with the vibrant colours of plants in the wooden windowbox. These, seen against the cool bluish tints of old faded woodwork, present a variety of 'blocked' shapes where plant images have been simplified for impact.

ARTIST'S TECHNIQUE

Before trying to follow the painting yourself, practise these three exercises which relate to the main applications that are used for the woodwork and the flowers.

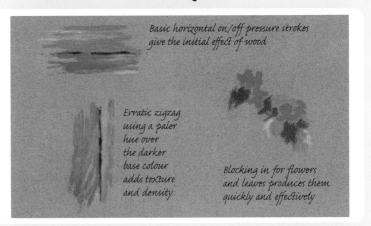

Basic horizontal on/off pressure strokes give the initial effect of wood

Erratic zigzag using a paler hue over the darker base colour adds texture and density

Blocking in for flowers and leaves produces them quickly and effectively

Pastel blocks may be used for covering large areas

On/off pressure application indicates the texture of faded woodwork

Stonework, with cement between the blocks, is depicted with on/off pressure and twisting stroke applications

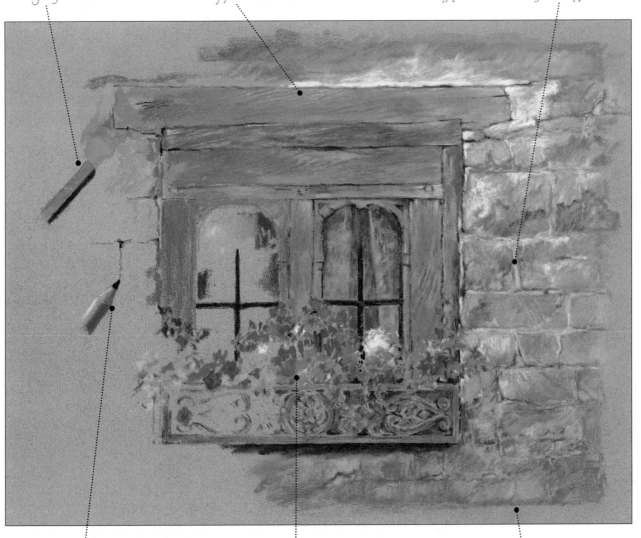

The initial drawing is executed with black pastel pencil, sharpened to a point

Simple blocking using the blunt end of a pastel block is used to place the flowerheads

Using an L-shaped mount helps to give an idea of how the completed painting will look when mounted for framing

Case Study: Derelict Boat

MEDIA: SOFT PASTELS, PASTEL BLOCKS AND PASTEL PENCILS ON TINTED PASTEL BOARD

This painting shows a derelict boat lying in a stretch of flat grassland, with distant trees and an area of water. The variety of textures – sky, trees, grass, water and woodwork – provides plenty of interest for stroke application in this tranquil scene.

As a support, I have chosen tinted pastel board of a colour that will enhance the painting as it shows through the strokes. This surface has a good 'tooth' and is a delight to work on. However, you may prefer to use Ingres paper and it is upon this surface that I am demonstrating a few relevant stroke exercises for you to try as a warm-up.

Preliminary Sketch

My little preliminary ink sketch to plan out my composition and tonal balance includes images of a pastel pencil, soft pastel stick and pastel block to show you how I built the painting using the eight basic strokes.

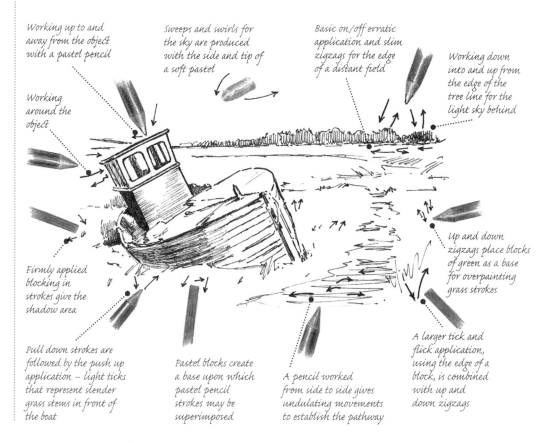

Working up to and away from the object with a pastel pencil

Sweeps and swirls for the sky are produced with the side and tip of a soft pastel

Basic on/off erratic application and slim zigzags for the edge of a distant field

Working down into and up from the edge of the tree line for the light sky behind

Working around the object

Firmly applied blocking in strokes give the shadow area

Pull down strokes are followed by the push up application – light ticks that represent slender grass stems in front of the boat

Pastel blocks create a base upon which pastel pencil strokes may be superimposed

A pencil worked from side to side gives undulating movements to establish the pathway

Up and down zigzags place blocks of green as a base for overpainting grass strokes

A larger tick and flick application, using the edge of a block, is combined with up and down zigzags

ARTIST'S TECHNIQUE

Practising these applications before you begin your own painting will help you to tackle each area with confidence, giving more strength to your painting than would come from a tentative approach.

For the distant treeline, use a fanned up and down zigzag application, keeping the pastel in contact with the support throughout

For the top of the field at the base of the treeline, use erratically placed horizontally applied strokes

Distant areas of grass are created by a constant-contact fanned zigzag application

Clumps of grass in the foreground are blocked in, also with a fanned zigzag application

For the pathway, use horizontally placed, slightly contoured, massed strokes to block in the colour

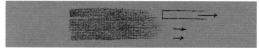

The textured effect on the boat cabin is created by dragging the flat end of a pastel block across the surface

The Finished Painting

Many beginners work right up to the edges of the support, whether painting in watercolour, pastel or other media. However, leaving a border has the advantage that strokes and colours can be tried out before working directly on areas of the painting. You can then use a mount to cover this part of the edge without losing any of your painting.

For this painting I used a smooth on/off application for the area of water and erratic on/off application for the top edge of the distant field. Sweeps and swirls of soft pastel established the sky area while the firmer pastel blocks were used for blocking in the underpainting elsewhere.

Put/push/pull strokes placed distant trees and 'on your toes' application, using either the sharp edge of a pastel block or the sharpened end of pastel pencil, defined details. Shadow areas were established with bold crisscross application and delicate tick and flick strokes combined with bolder vertical and fanned zigzags positioned clumps of grass in the foreground.

The two applications most used here were the basic zigzag and 'up to and away' to cut in with darker tones behind light forms.

tip

Overlay warm and cool colours in areas such as the grass to create an intensity of tone. This will also increase the contrast with lightly grazed areas of the pathway, adding visual interest.

Derwent pastel blocks create this effect when the whole side of the block end is used

Soft pastels are used for the sky, enabling a broad, sweeping stroke application

Pastel pencils are used for lower sky areas, working up to and away from the tree line

Horizontally applied on/off pressure strokes using a sharp pastel pencil

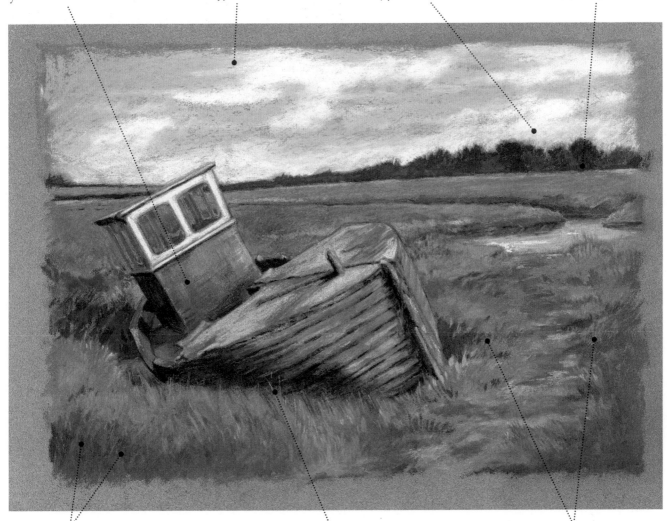

Crisscross application, combined with tick and flick, establishes the foreground grasses

The sharp edge of a pastel block will create fine lines, as will a sharpened pastel pencil

Overlays of greens are built up, while retaining a glimpse of the support hue beneath

Buildings and Foliage in Pastel Pencils

MEDIA: PASTEL PENCILS ON PASTEL BOARD

For this project I am using the cottage image from pages 180–181 to demonstrate how the eight basic stroke applications apply as much to pastel pencils as any other type of media. I have used artist's licence to introduce pathways and adjustments to the positions of foliage masses within the composition, leading the viewer's eye around the picture.

The use of pastel pencils gives the work a soft, textural quality that is ideal for a rural scene with foliage and weathered stonework.

ARTIST'S TECHNIQUE

Before beginning upon this painting, practise some of its individual elements which will require you to apply colour over pale underpainting and to work up to and away from forms.

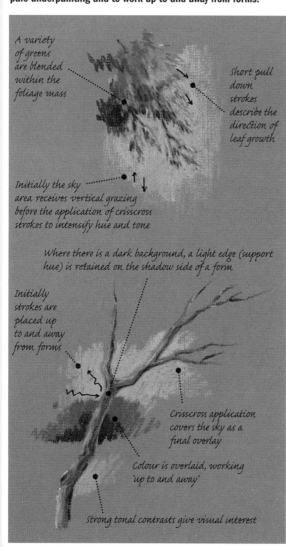

A variety of greens are blended within the foliage mass

Short pull down strokes describe the direction of leaf growth

Initially the sky area receives vertical grazing before the application of crisscross strokes to intensify hue and tone

Where there is a dark background, a light edge (support hue) is retained on the shadow side of a form

Initially strokes are placed up to and away from forms

Crisscross application covers the sky as a final overlay

Colour is overlaid, working 'up to and away'

Strong tonal contrasts give visual interest

The leaves in sunlight are painted with short, directional pull down strokes

For the window panes, blocking in is put 'up to and away' between the glazing bars

For the shadowed side of the chimney stack, blocking in strokes are applied in various directions

Twisting and turning strokes describe the twigs and branches

Up and down solid pressure strokes are used for the sunlit side of the stack

A superficial representation of the surface of the tiles is created by diagonal pull down strokes

The sky is put in with crisscross application

Put/push/pull application is used for the background foliage

The tiles are initially positioned using erratic on/off pressure application

The shadow beneath the eaves is created with a broad, horizontal zigzag application

The leaves are created with short, directional pull down strokes

Contoured grazing describes the grassy bank

Vertical grazing is used for the door

Fanned zigzag and blocking in creates the flowers and foliage

Stonework is blocked in

The grass is put in with a combination of short fanned vertically placed strokes and sweeping horizontal application

Tick and flick strokes are used for the foreground grasses

Watercolour Brush Marks

With only three or four watercolour round brushes of different sizes you will be able to execute all the strokes demonstrated in this book. However, there are many varieties of brush shape available and you may find certain shapes useful for particular effects in relation to the marks you aim to create. Many artists work constantly with just a very small number of favourite brushes and you will probably settle on three or four that best suit your way of working, but do experiment to find out which these might be.

The highest quality round watercolour brushes are made of sable hair, which is capable of holding a lot of pigment in the body of the brush but producing a very fine point. However, these brushes are expensive, and while you are still at the learning and experimenting stage you may prefer to buy the cheaper synthetic mixes, progressing to sable later on.

Here are a few brushes you may like to try, with some examples of the marks of which they are capable.

Small Round Brushes

With a pointed end and a round belly to hold the paint, round brushes are capable of a vast variety of stroke applications. A No. 10 for laying broad washes and a No. 8 for finer details will be all you need for many paintings.

Individual basic put strokes

Working on the tip of the brush to produce delicate texture forms interesting mass shapes

A fanned pull down series of strokes

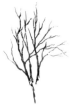

Fine twist lines for twigs, made with a small round brush

Short downward strokes with a small round brush, massed or separated

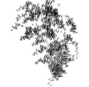

Very fine detail can be obtained by working on the tip of a small round brush

Rigger Brushes

These brushes are slender, with long hairs, and are ideal for painting long lines in a single stroke. The name derives from their original use for painting the rigging of sailing ships.

Evenly applied radiating and contoured 'open' crosshatching

Narrow line looped strokes with fine 'support' line

A series of on/off pressure contoured strokes

Swordliner Brushes

The shape of these brushes means that they will hold a lot of liquid and 'draw' a fine line through to a broader one when pressure is applied. They are ideal for intricate flower and petal work.

Single stroke leaf shapes

Press and lift strokes

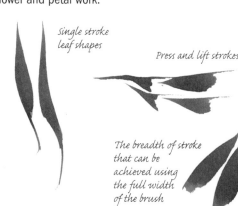

The breadth of stroke that can be achieved using the full width of the brush

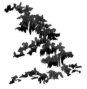
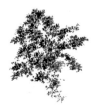

Flat Brushes

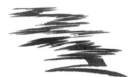

These stiff-haired brushes offer a blocking action for broad applications of paint and also a useful sharp edge for fine lines.

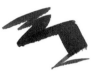

Fine lines obtained from the edge of the brush and flat stroke application

A varied angle stroke from the flat and slim sides, using different pressures

A fanned narrow zigzag application with a final block

Fan Brushes

The fan shape offers a quick way of suggesting grass and tree images and is also useful for blending.

A contoured texture achieved with a stippling application

Here the brush is dragged downwards to achieve varied texture widths

An evenly applied downward dragged series of strokes suitable for texture such as woodgrain

Hake Brushes

These soft, flat brushes, often made of goat's hair, may be up to 5cm (2in) wide. They are mainly used for washes, wet-into-wet and blending.

A fanned application using the slim side of the brush, useful for the texture of long grass

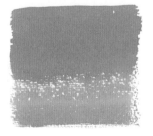

A basic flat wash stroke

A basic flat wash gaining dry brush texture as the amount of paint in the brush is dissipated

Mop Brushes

As the name implies, these brushes have a broad shape that makes them useful for expressive, loose work. When thoroughly wet, they are capable of carrying a large amount of liquid.

Repeated contoured strokes, useful for cloud formations

Horizontal strokes of varied width can be obtained by fanning the hairs as they are grazed across the paper

A basic flat wash

Depicting Hair in Watercolour

Beginners often experience difficulties with the depiction of hair, both human and animal. The answer is to simplify matters with your application of brushstrokes.

In the same way that we can simplify the foliage mass of a tree by observing dark recessive shadows and painting tonal shapes, so we can look at recessive shadow shapes within clumps of hair. Just as we bring light foliage masses forward by painting dark tones behind them, so we can do the same with hair mass. I am demonstrating this way of working in the watercolour of a teddy bear, particularly down the left-hand side.

It can be helpful to use soft toys as subjects when you are practising watercolour techniques. It is also challenging to try to show the character and texture of each as an individual. However, it will enable you to deal with many of the aspects you will encounter when you are depicting human and animal subjects.

tip

Partially close your eyes when you look at an area of hair or fur and try to discern the shadow shapes within the mass. Starting with a monochrome exercise before you attempt the final study will help.

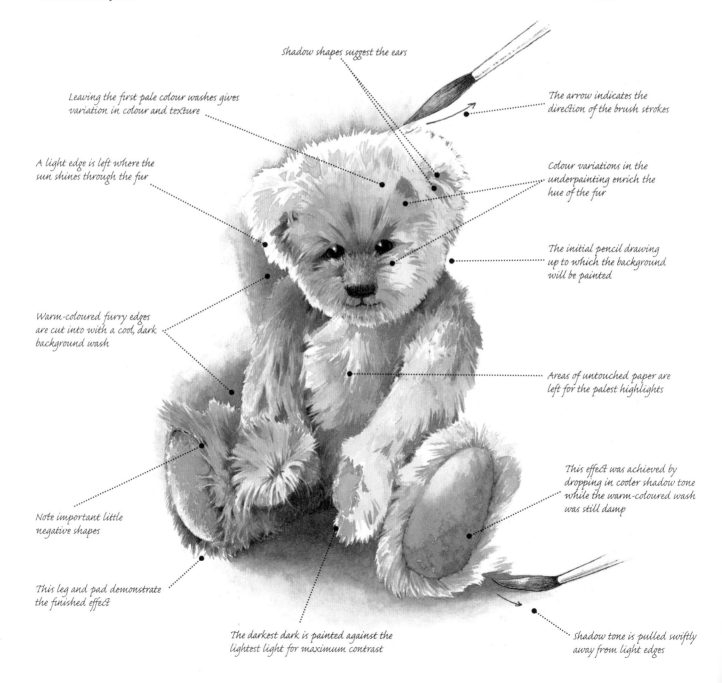

Shadow shapes suggest the ears

Leaving the first pale colour washes gives variation in colour and texture

The arrow indicates the direction of the brush strokes

A light edge is left where the sun shines through the fur

Colour variations in the underpainting enrich the hue of the fur

The initial pencil drawing up to which the background will be painted

Warm-coloured furry edges are cut into with a cool, dark background wash

Areas of untouched paper are left for the palest highlights

This effect was achieved by dropping in cooler shadow tone while the warm-coloured wash was still damp

Note important little negative shapes

This leg and pad demonstrate the finished effect

The darkest dark is painted against the lightest light for maximum contrast

Shadow tone is pulled swiftly away from light edges

Hard and Soft Textures in Watercolour

The doll illustrated in drawings on pages 36–39 has now been placed alongside a different teddy to the one on the opposite page. With folded cloth behind them and against a stone wall recess, there are a variety of textures to interpret: fabric, lacework, smooth fabric, wool (the doll's hair) and ribbon all have to be given consideration as to how they will be treated.

Many strokes in my painting have been loosely applied with a No. 8 or No. 10 brush, while others have required a smaller brush for detail. The painting is 41 x 31cm (16 x 12½in), so once the initial composition had been planned there was room for a spontaneous approach.

Strokes have been placed with regard for direction of form as well as for texture and attention has been paid to areas of contrast – especially small dark shadowed recessive shapes and negative shapes.

*Cutting in with dark tone behind
clumps of light hair brings it forward*

*The shadowed recessive shape between folds of
cloth brings the light form of the arm forward*

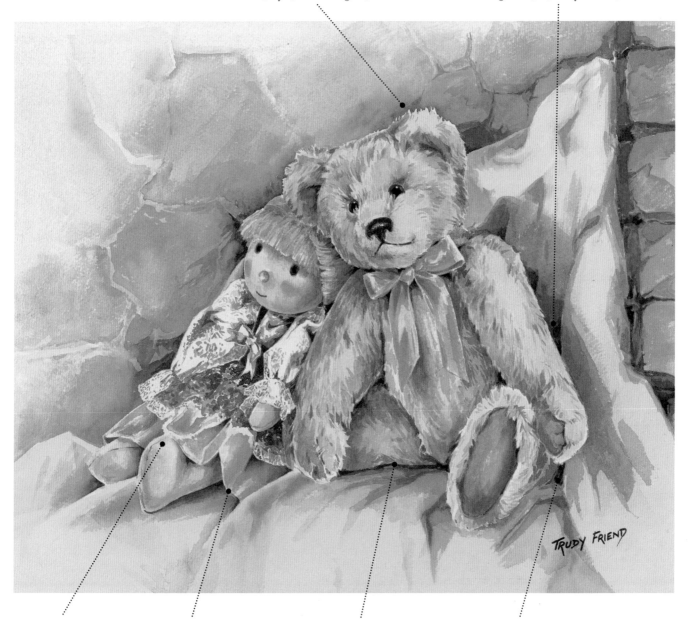

TRUDY FRIEND

*A lost line avoids an
outlining effect*

*The darkest dark is set
against the lightest light*

*A shadow line is put in
with zigzag application*

*An important small negative
shape adds interest*

Watercolour: Painting Loosely

This complex image of a lobster has been loosely executed to retain the spontaneity that can make watercolour painting so exciting. However, without attention to the underdrawing you will not have a solid foundation upon which to build your loose washes, so take care with the first stage of your work, which is to make a pencil sketch.

When you are happy with your representation of your subject in your sketchbook you can transfer it on to watercolour paper, using the window or lightbox method (see tip, page 74), with a brush drawing instead of pencil. This means that your later brush strokes need not be as restrained as they might if a pencil were used to trace the image.

For this study of a lobster I used a pale pink for the brush drawing. On the textured paper, the brush strokes created interest of line where dry brush effects appeared. The washes were then painted directionally, with sweeping strokes, allowing the paper to remain untouched where highlights were required. I used wet-into-wet techniques on the body and head, but generally I painted simple crisp-edged tonal shapes with regard to form.

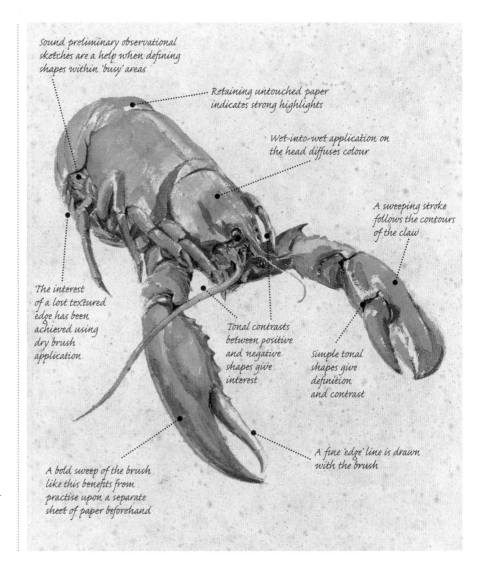

Sound preliminary observational sketches are a help when defining shapes within 'busy' areas

Retaining untouched paper indicates strong highlights

Wet-into-wet application on the head diffuses colour

A sweeping stroke follows the contours of the claw

The interest of a lost textured edge has been achieved using dry brush application

Tonal contrasts between positive and negative shapes give interest

Simple tonal shapes give definition and contrast

A fine 'edge' line is drawn with the brush

A bold sweep of the brush like this benefits from practise upon a separate sheet of paper beforehand

ARTIST'S TECHNIQUE

This study of a prawn was built by overlaying translucent washes wet on dry to gradually increase tonal values. White paper has been retained for highlights and to contrast with shadowed areas.

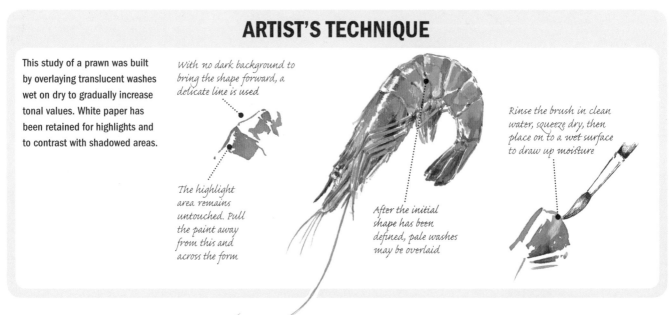

With no dark background to bring the shape forward, a delicate line is used

The highlight area remains untouched. Pull the paint away from this and across the form

After the initial shape has been defined, pale washes may be overlaid

Rinse the brush in clean water, squeeze dry, then place on to a wet surface to draw up moisture

Simplifying your Subject

This is an exercise in how you can depict your subject with as few marks as possible, using simple washes and minimal drawing with the brush. Some areas may lack definition yet still represent the image successfully, for example, the loosely indicated lower fins on the brown trout below. Pale washes are the best way to start. Use plenty of water with your pigment and work with your board tilted at a good angle so that the washes can be easily encouraged down the paper.

Wet-into-wet and crisp-edged applications can work well together and you will need to decide which areas will benefit from one or the other. Practise upon a separate sheet of paper if you are unsure.

For this study of two trout the merest suggestion of a background was sufficient as a support for their forms. Some line drawing, using a fine brush, has given definition where required and hints of colour have been used to retain a delicate effect.

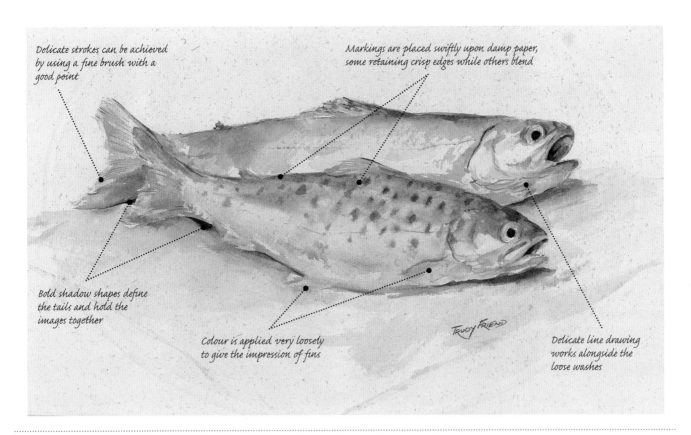

Delicate strokes can be achieved by using a fine brush with a good point

Markings are placed swiftly upon damp paper, some retaining crisp edges while others blend

Bold shadow shapes define the tails and hold the images together

Colour is applied very loosely to give the impression of fins

Delicate line drawing works alongside the loose washes

TRUDY FRIEND

Study of a Crab

It is important to understand which paper and brushes suit your style of working. Also, you may be more comfortable using brushes with handles of a certain shape. Winsor & Newton produce a range with sculptured handles and a matt finish.

For this study of a crab I have used their artist's watercolour sable brush No. 2 rigger for the initial 'drawing' in paint and a pointed round No. 5 for the washes. Used upon Saunders Waterford CP (Not) paper, this combination produced the desired effect.

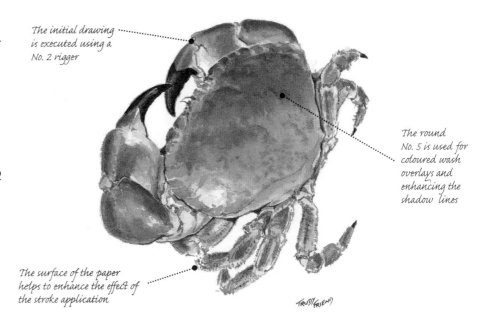

The initial drawing is executed using a No. 2 rigger

The round No. 5 is used for coloured wash overlays and enhancing the shadow lines

The surface of the paper helps to enhance the effect of the stroke application

TRUDY FRIEND

Watercolour: Botanical Studies

In contrast to the loose approach of the previous spread, this one goes to the opposite extreme with detailed botanical studies. All of the illustrations on this spread are shown actual size to give you an idea of scale and details and the need for close observation when you are painting such delicacy of form.

Flowerheads

It is your choice as an artist to paint as much or as little as you wish of your subject. Sometimes, just as an exercise, you may feel that all you want to represent is a simple relationship, such as these two flower heads. It is surprising how much you can learn from limiting yourself in this way.

Use a very fine round brush size – 2 or 3 – and work outwards from the central area, with pale washes and linear strokes. Try not to feel any pressure regarding the time it takes you to execute a study of this nature – it is what you will learn from doing so that is important.

Two Flowerheads with Leaf

By painting one flowerhead against a background of white paper and the other against a dark leaf from the plant, you will be able to compare the effect and value of a dark background. It also presents an extra relationship and contrasts of hue, tone, shapes and textures.

Formats

Botanical studies lend themselves to a variety of formats. Consider not just portrait formats but also squares and rounded or oval shapes.

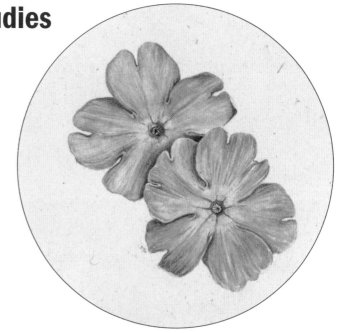

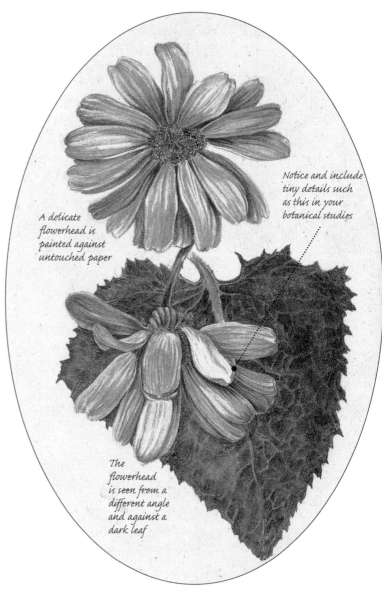

A delicate flowerhead is painted against untouched paper

Notice and include tiny details such as this in your botanical studies

The flowerhead is seen from a different angle and against a dark leaf

Four Flowerheads and Buds

With a larger number of flowerheads the relationship between them requires even greater thought, as there are more overlapping forms to create negative shapes of different shapes and sizes. These negative shapes are just as important within the composition as the positive (flower and leaf) shapes. Even with a small study such as this we need to consider the arrangement of all the elements.

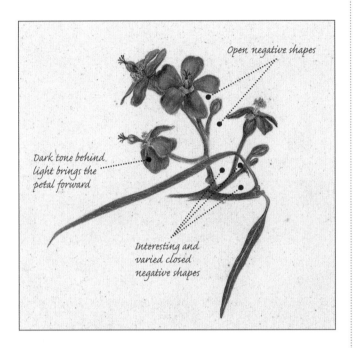

Open negative shapes

Dark tone behind light brings the petal forward

Interesting and varied closed negative shapes

Monochrome Study

Working in monochrome will give you an opportunity to concentrate upon tonal values and your watercolour techniques. Where possible, allow the white paper to work for you, and emphasize contrasts of shape, texture and form.

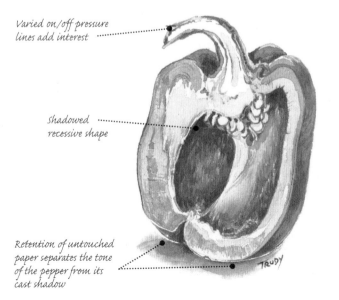

Varied on/off pressure lines add interest

Shadowed recessive shape

Retention of untouched paper separates the tone of the pepper from its cast shadow

Leaf Arrangements

Where there is a profusion of leaves within a pot plant arrangement you may choose to look closely at just one area and include as many or as few leaves as you wish. In this illustration you will see a few very small dark negative shapes within the leaf mass, as well as shadowed recessive shapes which are less dark. These shapes are very useful behind lighter forms, bringing them forward.

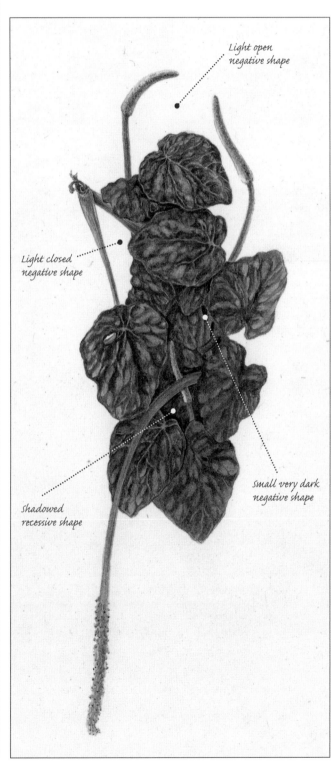

Light open negative shape

Light closed negative shape

small very dark negative shape

Shadowed recessive shape

Using Watercolour Pencils

MEDIA: INKTENSE ON 190GSM (90LB) SAUNDERS WATERFORD ROUGH PAPER

There is a vast choice of watercolour pencils available and colours vary from the subtle hues of Derwent Graphitint to the vibrancy of their Inktense range, which are permanent once dry.

The latter can be applied in many ways, but, for the purpose of this section, I am covering those employed for the illustrations on the following three spreads as they may be used with other watercolour pencil ranges.

A popular method is that of drawing with a pencil, dry on dry, and then wetting the image with a brush that has been dipped in clean water. This will require some thought beforehand – it may be that you wish to retain areas of white paper to represent highlights and will need to be careful that these are not lost by careless application of a wash.

As an introduction to watercolour pencils, the image of tree bark texture and the more delicate interpretation of barbed wire are related to a foliage background to demonstrate a variety of stroke applications. They have been executed upon Saunders Waterford Rough paper as this enhances these particular textures.

ARTIST'S TECHNIQUES

There are several other methods of applying the pigment to the paper already in watercolour form, as opposed to blending it on the surface with clean water.

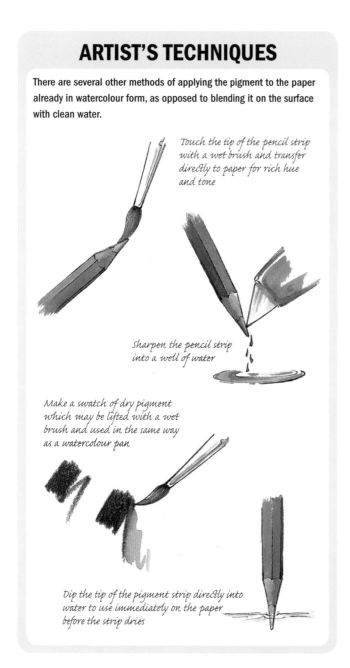

Touch the tip of the pencil strip with a wet brush and transfer directly to paper for rich hue and tone

Sharpen the pencil strip into a well of water

Make a swatch of dry pigment which may be lifted with a wet brush and used in the same way as a watercolour pan

Dip the tip of the pigment strip directly into water to use immediately on the paper before the strip dries

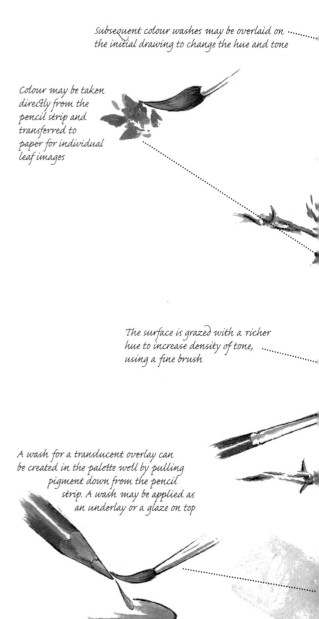

Subsequent colour washes may be overlaid on the initial drawing to change the hue and tone

Colour may be taken directly from the pencil strip and transferred to paper for individual leaf images

The surface is grazed with a richer hue to increase density of tone, using a fine brush

A wash for a translucent overlay can be created in the palette well by pulling pigment down from the pencil strip. A wash may be applied as an underlay or a glaze on top

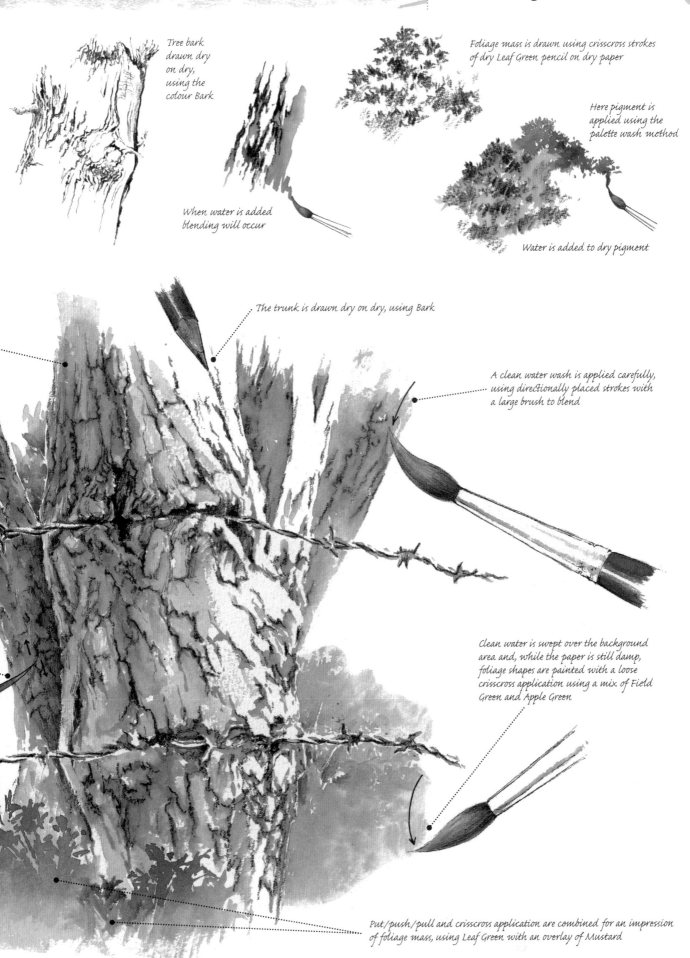

Tree bark drawn dry on dry, using the colour Bark

When water is added blending will occur

Foliage mass is drawn using crisscross strokes of dry Leaf Green pencil on dry paper

Here pigment is applied using the palette wash method

Water is added to dry pigment

The trunk is drawn dry on dry, using Bark

A clean water wash is applied carefully, using directionally placed strokes with a large brush to blend

Clean water is swept over the background area and, while the paper is still damp, foliage shapes are painted with a loose crisscross application using a mix of Field Green and Apple Green

Put/push/pull and crisscross application are combined for an impression of foliage mass, using Leaf Green with an overlay of Mustard

Case Study: Timber-Cladded Barn

MEDIA: INKTENSE PENCILS ON 190GSM (90LB) SAUNDERS WATERFORD CP (NOT) PAPER

For this demonstration I am showing the process of painting a timber-cladded building in a garden setting. Beginners sometimes become confused by the diversity of textures presented within a study of this nature and it is helpful to analyse the components before starting. I have done this with a study of the door. However,

you may feel you would like to practise techniques using a window as the subject instead.

The initial drawing may be made entirely in one colour, dry on dry. Try to vary the direction of your stroke applications with regard for content – foliage, grass, wood cladding or door.

The Underdrawing

This drawing makes a bolder statement than I would normally start with so that you can clearly see the first stage.

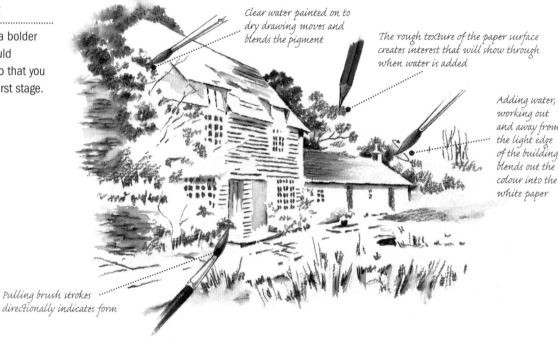

Clear water painted on to dry drawing moves and blends the pigment

The rough texture of the paper surface creates interest that will show through when water is added

Adding water, working out and away from the light edge of the building, blends out the colour into the white paper

Pulling brush strokes directionally indicates form

Initial Study

This study of a door demonstrates a number of applications to help you complete the painting. If you wish to increase the intensity of hue and tone gradually to allow yourself time to consider the effect, washes may be overlaid wet on dry, using classical watercolour techniques.

For areas that require rich darks you can draw in dry pigment on to a damp surface. If you want a more textured effect, draw dry upon the dry painting.

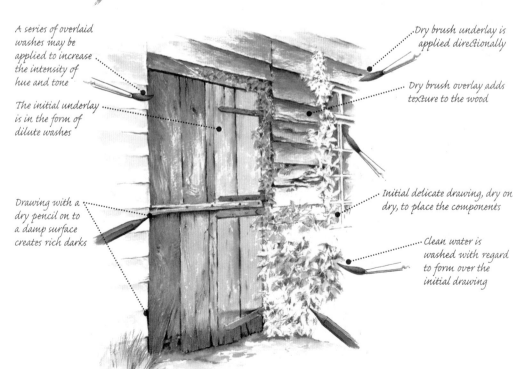

A series of overlaid washes may be applied to increase the intensity of hue and tone

The initial underlay is in the form of dilute washes

Drawing with a dry pencil on to a damp surface creates rich darks

Dry brush underlay is applied directionally

Dry brush overlay adds texture to the wood

Initial delicate drawing, dry on dry, to place the components

Clean water is washed with regard to form over the initial drawing

The Completed Painting

The diversity of textures in an image such as this provides the ideal opportunity to use all the eight basic stroke applications covered in the first section of this book and also to combine a variety of watercolour pencil techniques. The main ones used here after initial placing of images, dry on dry (to receive washes), are:

1. Sharpening into palette wells. A large plastic palette with a number of small wells surrounding a few larger central ones is ideal for this method. Your chosen colours may then be sharpened directly into their respective wells and water added to each to mix. They may then be reconstituted when dry and used in the future in the same way as watercolour pans.

2. Touching the tip of the pencil with a wet brush to pick up intense hue for the treatment of small dark areas.

3. Drawing into damp areas using a sharp dry pencil to enrich hue and tone.

4. Gentle grazing overdrawing after the painting has thoroughly dried where more textured effects are required.

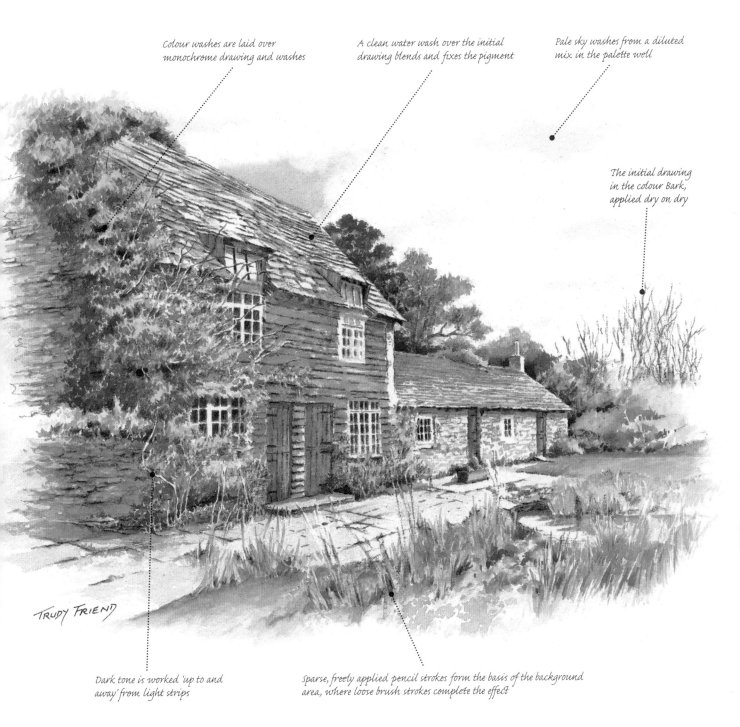

Colour washes are laid over monochrome drawing and washes

A clean water wash over the initial drawing blends and fixes the pigment

Pale sky washes from a diluted mix in the palette well

The initial drawing in the colour Bark, applied dry on dry

TRUDY FRIEND

Dark tone is worked 'up to and away' from light strips

Sparse, freely applied pencil strokes form the basis of the background area, where loose brush strokes complete the effect

Inktense Pencils: Sunflower

MEDIA: INKTENSE PENCILS ON 190GSM (90LB) BOCKINGFORD PAPER

The Inktense range of pencils includes a graphite Outliner pencil for making an underdrawing upon which washes may be laid. These images of a sunflower viewed from different angles demonstrate three stages of development using this method. I have used a Bockingford paper as it is an ideal surface upon which to apply the smooth background wash behind the painted image.

Stage 1: The initial drawing, using a very sharp pencil, is applied delicately with on/off pressure strokes. When they are lightly in place you may use firmer pressure to intensify edge lines and to start adding the tonal shapes. The next step is to clarify cast shadows and shadowed recessive shapes. Crisscross and put/push/pull strokes are the main applications for the central area.

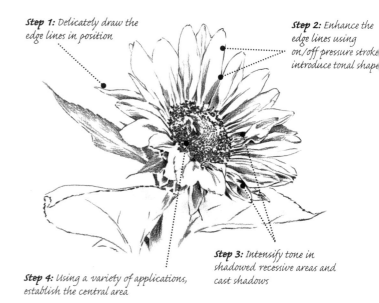

Step 1: Delicately draw the edge lines in position

Step 2: Enhance the edge lines using on/off pressure stroke introduce tonal shape

Step 3: Intensify tone in shadowed recessive areas and cast shadows

Step 4: Using a variety of applications, establish the central area

Stage 2: Although there is a choice of 71 colours in the Intense range it is a good idea to limit your palette to about six colours of your choice. The methods of application in this study are pulling pigment from the pencil strip into the palette well using a wet brush (to use as washes) and touching the tip of pencil strip with a wet brush (for stronger hue).

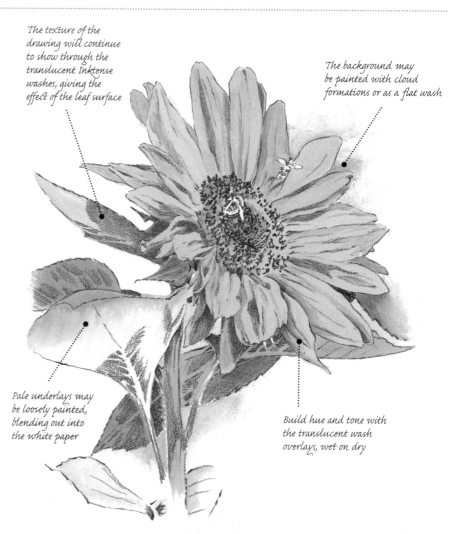

The texture of the drawing will continue to show through the translucent Inktense washes, giving the effect of the leaf surface

The background may be painted with cloud formations or as a flat wash

Pale underlays may be loosely painted, blending out into the white paper

Build hue and tone with the translucent wash overlays, wet on dry

Inktense Pencils Used

Choose a limited palette to make your use of colour simple and cohesive.

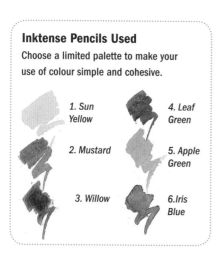

1. Sun Yellow
2. Mustard
3. Willow
4. Leaf Green
5. Apple Green
6. Iris Blue

Stage 3: Before any water or pigment has been added there is a strong texture apparent when Outliner pencil marks are made upon the dry surface. Once washes have been placed, if more graphite is added over the dry wash, you will find that texture is reduced. If you wish to retain the more noticeable texture, complete the drawing before adding pigment and refrain from drawing over the washes.

A diluted blue wash was placed over the whole background behind the sunflower, up to and away from the initial drawing, leaving the flower, stem and leaves untouched

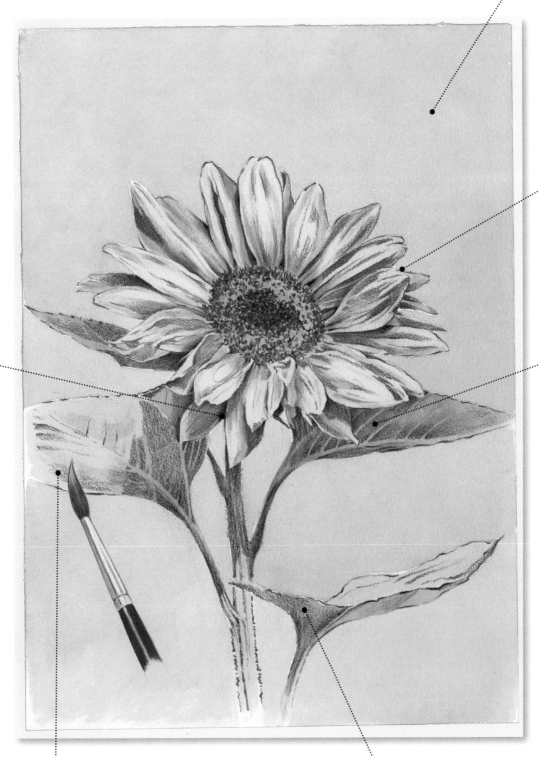

Lost lines appear where petals overlap or are seen against the background

Strong contrasts of light and dark tone add interest and drama

The pencil texture is smoother where it appears upon the painted surface

Washes overlaid wet on wet increase the intensity of the colour

The texture of the first Outliner marks is more noticeable than the subsequent pencil overlays on colour

Graphitint Pencils: Heavy Horse Trotting

MEDIA: GRAPHITINT PENCILS ON 190GSM (90LB) SAUNDERS WATERFORD HP PAPER

With some ranges of watercolour pencils there is a very noticeable change of colour after water has been added. This is most apparent in the colour Chestnut from the Derwent Graphitint range. These pencils, with their hint of soft, subtle hues, offer the merest suggestion of colour when used dry on dry and are ideal for delicate pencil work upon an HP surface. Once water has been added they transform into vibrant colours. The choices they give you range from soft greys, blues and greens to glowing russets, plums and browns.

On pages 182–183 you can see them used for a landscape subject. In this demonstration it is the transformation of the Chestnut pencil that is emphasized in the study of a trotting horse.

The First Sketch

Before beginning on the drawing proper, the first stage is a lively 'guidelines' sketch (see page 184), placing the subject against a suggestion of background grass and trees.

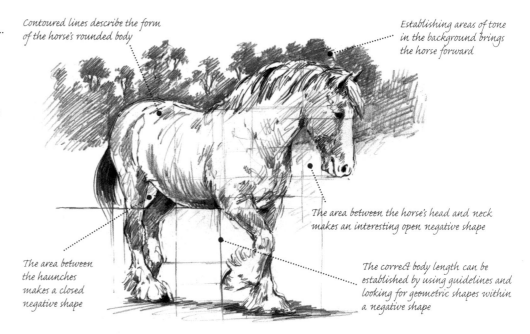

Contoured lines describe the form of the horse's rounded body

Establishing areas of tone in the background brings the horse forward

The area between the horse's head and neck makes an interesting open negative shape

The area between the haunches makes a closed negative shape

The correct body length can be established by using guidelines and looking for geometric shapes within a negative shape

The Dry Drawing

Using the window or a lightbox, transfer the image on to your chosen support (see tip, page 74). I have used HP paper, as a smooth finish represents the close texture of the animal's coat. The pencils were grazed lightly over the paper surface, either diagonally or with crosshatching and crisscross application, depending upon the area depicted.

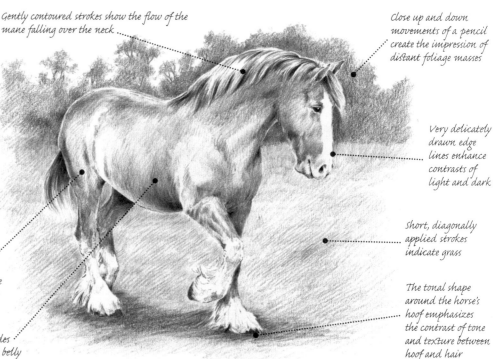

Gently contoured strokes show the flow of the mane falling over the neck

Close up and down movements of a pencil create the impression of distant foliage masses

Very delicately drawn edge lines enhance contrasts of light and dark

Short, diagonally applied strokes indicate grass

The tonal shape around the horse's hoof emphasizes the contrast of tone and texture between hoof and hair

White paper is retained for highlights as well as to indicate white hair on the face and legs

Contoured crosshatching provides tone that describes the rounded belly

Wetting the Drawing

When water is added to the drawing, the colours intensify. After the paper has dried, further drawing and washes may be added to build up more hue and tone.

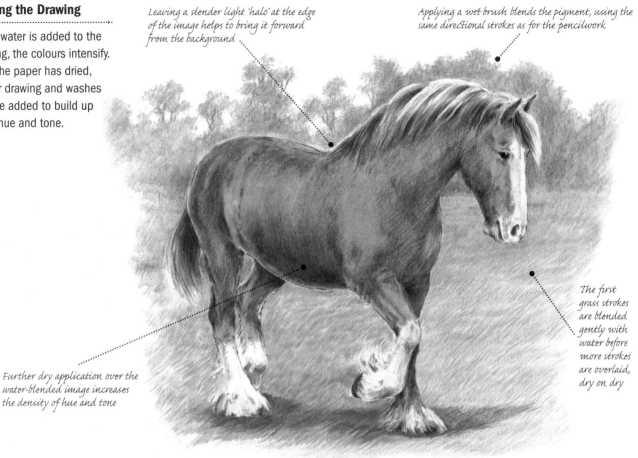

Leaving a slender light 'halo' at the edge of the image helps to bring it forward from the background

Applying a wet brush blends the pigment, using the same directional strokes as for the pencilwork

The first grass strokes are blended gently with water before more strokes are overlaid, dry on dry

Further dry application over the water-blended image increases the density of hue and tone

Graphitint Pencils

1. Cocoa

2. Russet

3. Slate Green

4. Ivy

5. Chestnut

6. Midnight Black

7. Green Grey

8. Meadow

ARTIST'S TECHNIQUES

Practising the dry and wet applications shown here will help you to anticipate the results you will obtain in a painting.

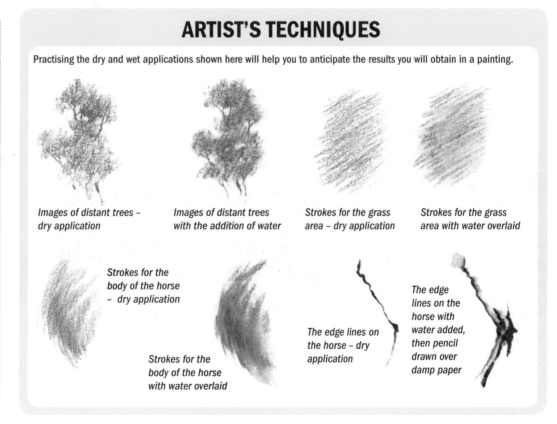

Images of distant trees – dry application

Images of distant trees with the addition of water

Strokes for the grass area – dry application

Strokes for the grass area with water overlaid

Strokes for the body of the horse – dry application

Strokes for the body of the horse with water overlaid

The edge lines on the horse – dry application

The edge lines on the horse with water added, then pencil drawn over damp paper

Painting with Acrylics

The versatility of acrylics makes them a popular medium for those who wish to apply paint with either watercolour or oil techniques, since acrylic paint may be used watered down, in the same way as watercolour paints, or applied thickly, straight from the tube.

Just as with watercolours, there are mediums and retarders available to add to acrylic paint. These mediums adjust consistency and create various effects, for example, a gloss or matt finish.

Watercolour Techniques

As the fast-drying synthetic resin of acrylic may become a little dull when a large amount of water is added to produce a translucent watercolour wash, it is advisable to dilute the paint with a medium instead. The use of too much water will also prevent the polymers binding and the translucent layers may lack stability. The medium available is a synthetic resin with no pigment.

On the opposite page I have illustrated how acrylic paint may be used with watercolour techniques and you will see that, in the same way as when painting with watercolour, white paper has been retained for the strongest highlights and areas of rushing water.

The small dark negative shapes around and within falling water provide interesting contrasts of treatment and tone, helping to suggest movement.

Opaque Techniques

On pages 126–127, still working upon watercolour paper but this time with thicker paint, a monochrome study illustrates the use of tonal values. In order to achieve this a large quantity of Titanium White was used, as the painting was overlaid on a pre-painted support hue.

The illustration of a wolf on pages 128–129 was executed upon a gesso primed board, the white surface of which was retained as a base for the image of the animal, while surrounding areas received an application of coloured acrylic upon which the background could be built.

The final spread in this section demonstrates how, by mixing together remaining pigments from the wolf painting, the resulting colour provides a useful support hue covering the paper, upon which to make full use of paler colours and contrasts. It is always worth considering the use of existing palette mixes as a base for a future painting, rather than simply cleaning them off the palette when you have finished a work.

(above) From watercolour techniques to thick paint applications as seen here, acrylic paints show their versatility in both monochrome and full colour within this section.

These six different colour blocks demonstrate typical mixes obtained from the palette after a painting is finished.

Waterfall in Acrylic

Here, lightly drawn pencil marks put the elements of the picture in position before the first diluted pale colour washes place shadow shapes and lines as guides upon which to overlay paint with the watercolour wash technique. White paper has been retained to depict the strongest highlights and rushing water. Both techniques of wet-into-wet and wet on dry have been used to build the painting, with strong contrasts emphasized where dark shadowed recessive shapes are set against the lightest lights.

No masking fluid (see page 11) was used in this painting, but if you feel you may encounter problems retaining areas of white paper when depicting the water, it will provide a solution.

Acrylic Colours Used

1. Bright Green 6. Payne's Grey

2. Lemon Yellow 7. Hooker's Green

3. Raw Umber 8. Cobalt Blue

4. Yellow Ochre 9. Phthalo Blue

5. Burnt Sienna 10. Bright Green

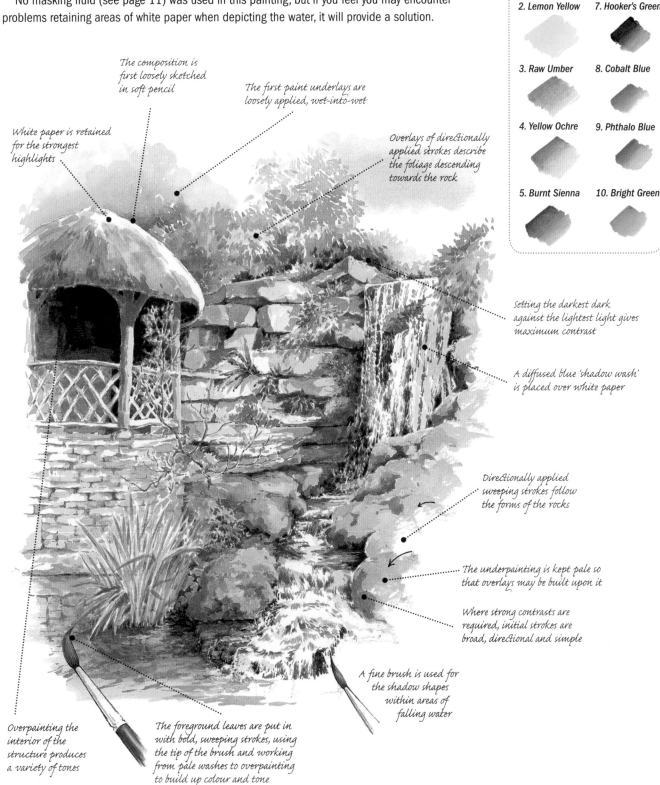

The composition is first loosely sketched in soft pencil

The first paint underlays are loosely applied, wet-into-wet

Overlays of directionally applied strokes describe the foliage descending towards the rock

White paper is retained for the strongest highlights

Setting the darkest dark against the lightest light gives maximum contrast

A diffused blue 'shadow wash' is placed over white paper

Directionally applied sweeping strokes follow the forms of the rocks

The underpainting is kept pale so that overlays may be built upon it

Where strong contrasts are required, initial strokes are broad, directional and simple

A fine brush is used for the shadow shapes within areas of falling water

Overpainting the interior of the structure produces a variety of tones

The foreground leaves are put in with bold, sweeping strokes, using the tip of the brush and working from pale washes to overpainting to build up colour and tone

Acrylic Painting in Monochrome

MEDIA: ACRYLIC PAINTS ON 110GSM (90LB) SAUNDERS WATERFORD CP (NOT) PAPER

This derelict building provides an interesting subject with which to practise tonal values. Begin by drawing a preliminary sketch where you can plan out your composition and give some thought to the direction in which you will apply various brush strokes.

The main stroke applications in the painting are diagonally and vertically placed zigzags for both linear and tonal depictions; crisscross application to indicate massed foliage and for executing flat walls; and short pull down strokes used for delicate distant tree foliage and short grasses.

Preliminary Sketch

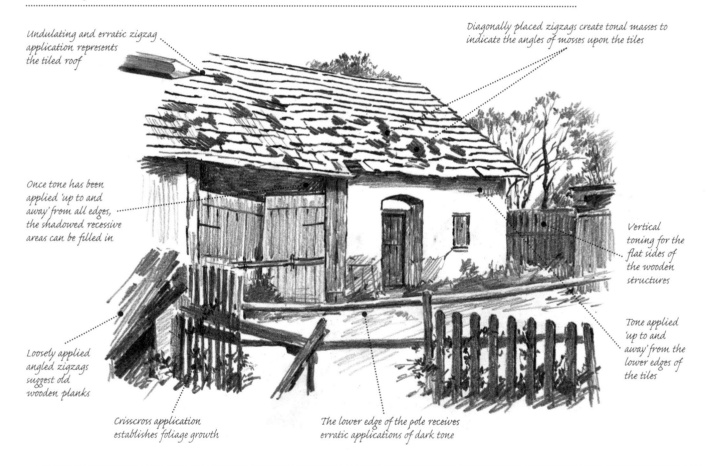

Undulating and erratic zigzag application represents the tiled roof

Diagonally placed zigzags create tonal masses to indicate the angles of mosses upon the tiles

Once tone has been applied 'up to and away' from all edges, the shadowed recessive areas can be filled in

Vertical toning for the flat sides of the wooden structures

Tone applied 'up to and away' from the lower edges of the tiles

Loosely applied angled zigzags suggest old wooden planks

Crisscross application establishes foliage growth

The lower edge of the pole receives erratic applications of dark tone

ARTIST'S TECHNIQUES

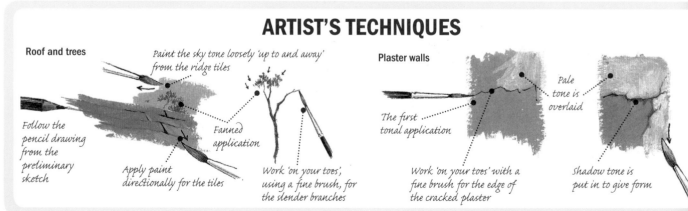

Roof and trees

Paint the sky tone loosely 'up to and away' from the ridge tiles

Follow the pencil drawing from the preliminary sketch

Apply paint directionally for the tiles

Fanned application

Work 'on your toes', using a fine brush, for the slender branches

Plaster walls

The first tonal application

Pale tone is overlaid

Work 'on your toes' with a fine brush for the edge of the cracked plaster

Shadow tone is put in to give form

The Finished Painting

Working in monochrome will help you to become more aware of tonal contrasts within your painting, which can be more difficult to see when you are working with a range of colours. Before beginning to paint, create a tonal scale from white to the darkest tone of your chosen hue, with midtones in between. Referring to this as you work will help you to get your tones right in relation to each other.

In this painting, dark silhouette shapes in the foreground encourage the main images to recede visually. Maximum contrasts of dark and light on the pole also enhance this effect.

Mix Burnt Sienna and Ivory Black for your monochrome colour and add Titanium White so that you can achieve a variety of medium and light tones.

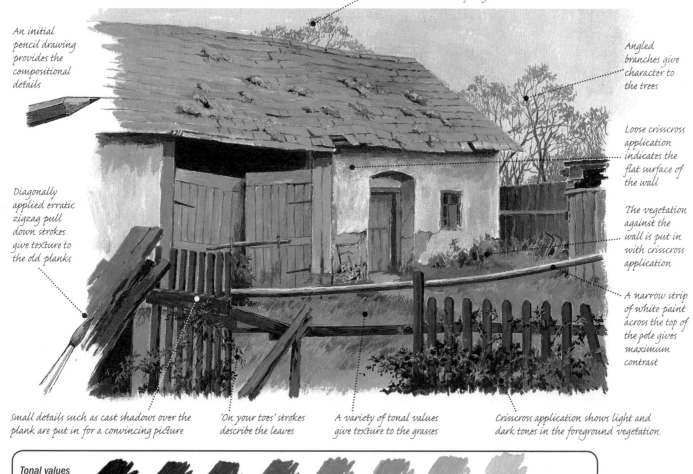

A fanned application of short downwards pull strokes describes distant foliage

An initial pencil drawing provides the compositional details

Angled branches give character to the trees

Loose crisscross application indicates the flat surface of the wall

Diagonally applied erratic zigzag pull down strokes give texture to the old planks

The vegetation against the wall is put in with crisscross application

A narrow strip of white paint across the top of the pole gives maximum contrast

Small details such as cast shadows over the plank are put in for a convincing picture

'On your toes' strokes describe the leaves

A variety of tonal values give texture to the grasses

Crisscross application shows light and dark tones in the foreground vegetation

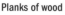

Tonal values

Planks of wood

Swiftly applied zigzag strokes using a variety of tones describe the texture of weathered wood

Pole

Crisscross application contrasts the rough texture of the grass with the smoothness of the pole

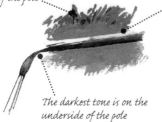

Pure white paint along the top of the pole contrasts with the darker background

The darkest tone is on the underside of the pole

The palings

Place the background tone first

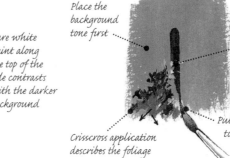

Pure white stands forward over other tones

Crisscross application describes the foliage

Pull down dark tone for the individual palings

A Wolf in Acrylics

MEDIA: ACRYLIC PAINTS ON THICK GREY CARDBOARD

The preliminary sketch for the painting of the wolf opposite was executed in medium-grade charcoal pencil, paying attention to the direction of the strokes and how they indicated the direction of hair growth and the form beneath. Noting this in your preliminary sketches will help you to paint the final study convincingly.

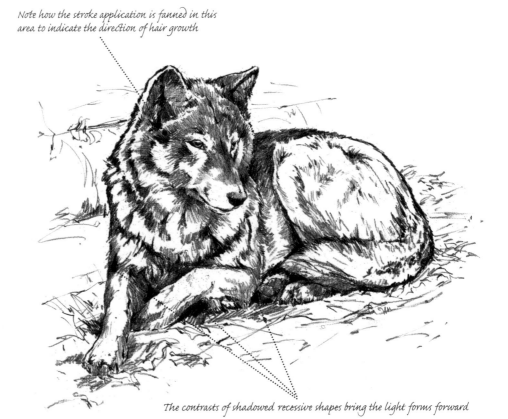

Note how the stroke application is fanned in this area to indicate the direction of hair growth

The contrasts of shadowed recessive shapes bring the light forms forward

Painting in Six Stages

The painting is built by a series of step-by-step stages, starting with the transferring of the sketch on to board prepared with acrylic gesso primer. I have left this painting incomplete so that you can easily see the six stages.

Step 1
Using a flat bristle (or synthetic bristle) brush, cover the unprimed board with acrylic gesso primer, using crisscross stroke application to add interesting texture. When the surface is dry, draw the image of the wolf, using a soft drawing pencil.

Step 2
Mix a suitable base colour to provide a toned ground for the background of your painting. Apply this 'up to and away' from the edges of the drawn image, leaving the drawing initially upon a white surface. Two coats of colour will probably be required to cover the white completely.

Step 3
Using a mix of Raw Sienna and White, lay the first washes of colour using watercolour techniques, which will induce some blending of the pencil and paint and give a good start to your painting.

Step 4
Gradually allow your paint application to consist of thicker pigment as you fill in the whole of the image, using directionally placed strokes to describe the fur and form beneath.

Step 5
Mix more Titanium White with Raw Sienna, Burnt Sienna and Payne's Grey and introduce a suggestion of background twigs, leaves and bark.

Step 6
Build the final layers, creating strong contrasts. These may be in the form of tone, shapes, textures and colour. The inclusion of a little green in the representation of a few grasses in the foreground and the log in the background provides contrast between the soft form of the animal and the solid trunk behind.

Step 3: *The second layer of support colour intensifies the tone over the base primer*

Step 2: *The first layer of colour is put over the primer*

Step 1: *Acrylic gesso primer is applied to the surface of thick grey card*

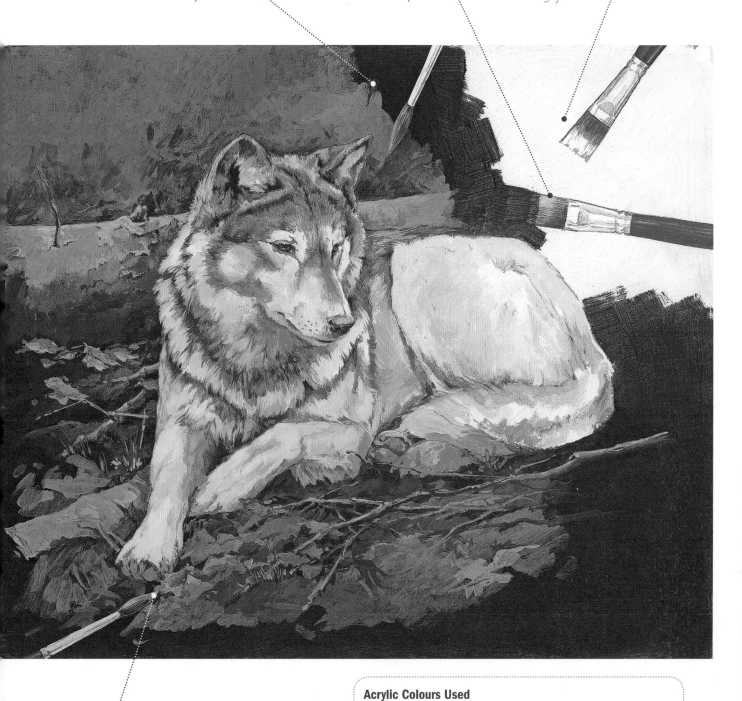

Step 4: *The ground colour is painted up to the image – the wolf drawing remains untouched at this stage*

Acrylic Colours Used

1. Raw Umber 2. Payne's Grey 3. Yellow Ochre 4. Black

5. Cadmium Yellow 6. Emerald Green 7. Burnt Sienna 8. Titanium White

Case Study: Derelict Lorry

MEDIA: ACRYLIC PAINTS ON 190GSM (90LB) BOCKINGFORD PAPER

On pages 128-129 I demonstrated the advantage of retaining some of the white primer undercoat as a base upon which to build the main image while the surrounding areas received two layers of strong colour. For this painting of a derelict lorry I chose to paint a strong colour over the whole sheet of Bockingford paper upon which I worked. This colour is a mixture of all the remaining hues from the wolf painting and in places can be seen showing through, particularly around the edges of the image.

Preliminary Sketches

I made two preliminary drawings for this study, observing the image from different angles, before deciding upon the lower one as the position of choice for my painting. A sepia Pentel hybrid roller pen glided subtly over the surface of the lightweight Bockingford paper I used and produced enough texture in the strokes to supply interest in the way they were made.

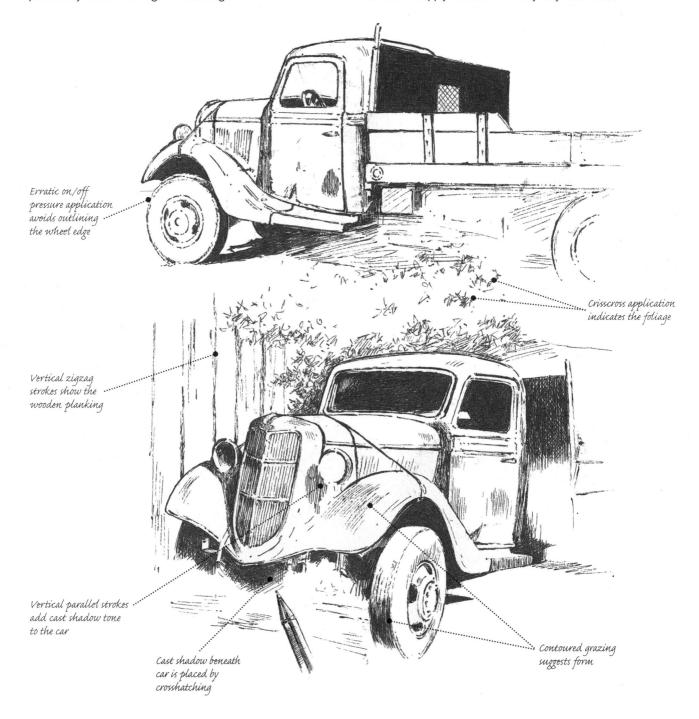

Erratic on/off pressure application avoids outlining the wheel edge

Crisscross application indicates the foliage

Vertical zigzag strokes show the wooden planking

Vertical parallel strokes add cast shadow tone to the car

Cast shadow beneath car is placed by crosshatching

Contoured grazing suggests form

From Sketch to Colour

When you are working upon a dark base colour you can draw the image using a fine brush and white paint or a light hue. Adjustments may be made to the drawing as the painting progresses, since with acrylics it is easy to paint light over dark. Choose the colour of the mount card you wish to use and offer it up to the painting from time to time during execution, as it will change the overall tonal effect.

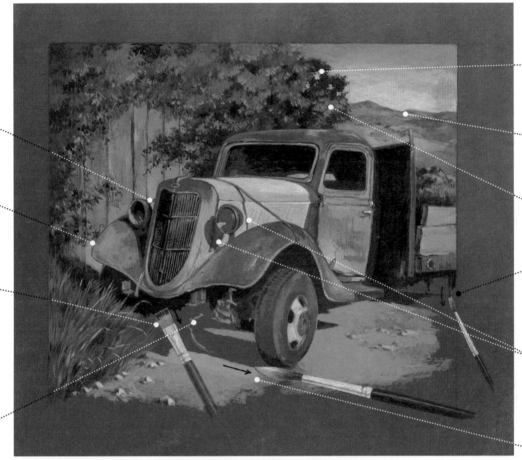

Notice important little negative shapes such as this

A slim 'edge line' consisting of ground colour may be retained in order to separate two light surfaces

A small flat bristle brush is useful for painting in dark-shadowed areas

The initial drawing is made in white paint

White/light blue negative shapes are framed between foliage masses

Distant hills are kept cool, in neutral hues

Short fanned pull down strokes represent the foliage

A small round brush is used for delicate details

Cast shadow follows the shape of the form over which it is cast

A medium round brush is sympathetic to ground undulations that may include stones

ARTIST'S TECHNIQUES

The initial underlay hue receives pale leaf shapes while silhouetted edges against the sky are darker.

Bright Green

Emerald Green

Burnt Sienna

Phthalo Blue

Vertically applied strokes for the wood panels behind the wheel arch contrast with the crisscross application on the metal.

Payne's Grey

Burnt Sienna

Crimson

Titanium White

Raw Sienna

Gouache in Monochrome

MEDIA: GOUACHE ON 190GSM (90LB) SAUNDERS WATERFORD CP (NOT) PAPER

While gouache is especially renowned for its bold, vibrant, opaque hues, it is also very effective when it is applied as thin washes, using watercolour painting techniques. As this medium dries very quickly in the palette you may find it helpful to use it out of a stay-wet palette, as is necessary with fast-drying acrylic paints.

This monochrome painting, executed in Winsor & Newton's Designer's Gouache Vandyke Brown, required the use of just

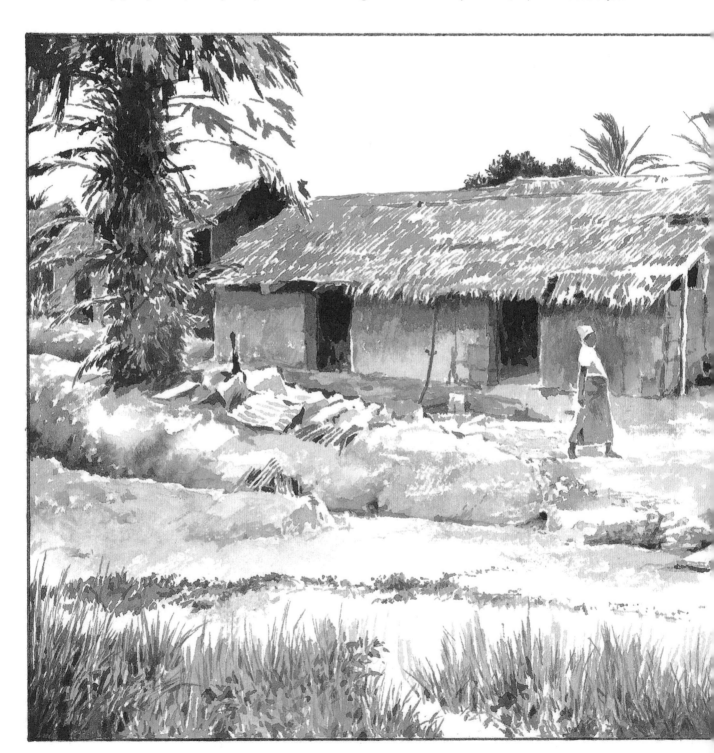

two ordinary palette wells. One contained paint direct from the tube with the addition of only a small amount of water, while the other received more water for a diluted mix. The fluidity of the former was retained by giving it a fine mist of water from a diffuser from time to time.

On the following three spreads you will see gouache used in its thick, opaque form and with dry brush application. However, here I am demonstrating how the pigment may be applied very dilute in places to have the same effect as loose watercolour washes. These provide an interesting contrast to the dense darks of the shadow areas.

Gouache is an exciting and versatile medium that can be used in many ways – even varnished when complete to bring up the colours. However, you should try to avoid overdoing the number of layers as this may lead to a muddy effect.

I have demonstrated images on white paper and coloured supports in this section and hope they will help you to understand and enjoy this versatile medium if you have not tried it before.

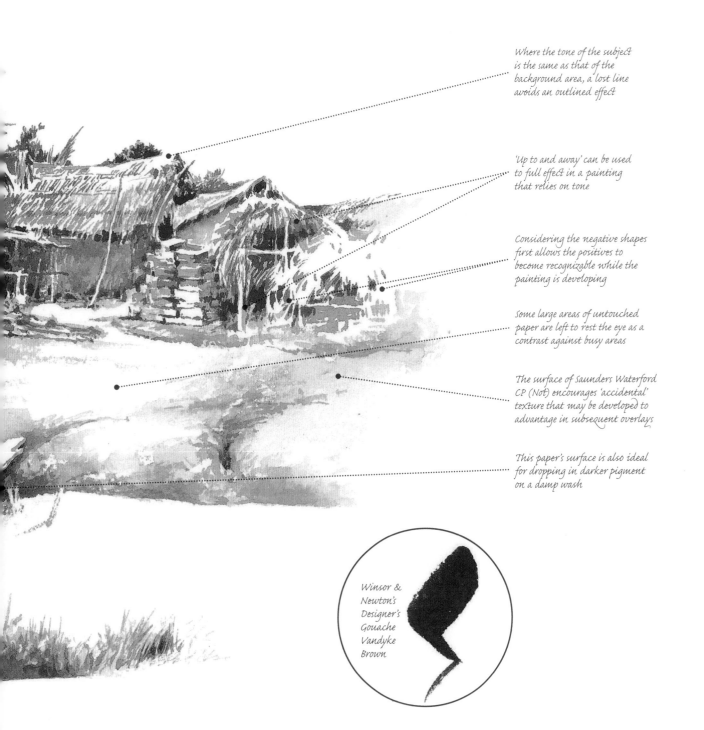

Where the tone of the subject is the same as that of the background area, a lost line avoids an outlined effect

'Up to and away' can be used to full effect in a painting that relies on tone

Considering the negative shapes first allows the positives to become recognizable while the painting is developing

Some large areas of untouched paper are left to rest the eye as a contrast against busy areas

The surface of Saunders Waterford CP (Not) encourages 'accidental' texture that may be developed to advantage in subsequent overlays

This paper's surface is also ideal for dropping in darker pigment on a damp wash

Winsor & Newton's Designer's Gouache Vandyke Brown

Case Study: A Garden Scene

MEDIA: GOUACHE ON 190GSM (90LB) SAUNDERS WATERFORD CP (NOT) PAPER

When you are making preparatory sketches in a garden you may find it helpful to draw a couple of unrelated objects on the same sketchbook page to see which you prefer to include in your finished painting, especially if you are able to make a comparison, as I have here, between two objects viewed at different angles. The top image, with foliage behind and overlapping in front, is seen mainly from below eye level whereas the other image is viewed from above. I chose the lower image as my subject for a painting as the viewpoint and the bright red tulips made it more interesting.

Both of these sketches and the underdrawing for the painting were executed with a 0.1 pigment liner pen. Using guidelines will help you to achieve accuracy in a painting (see page 184) and they will eventually be covered by the layers of gouache.

Preliminary Sketches

These sketches were both executed upon Bockingford paper, as its surface encourages interesting textured line and tone in response to penwork.

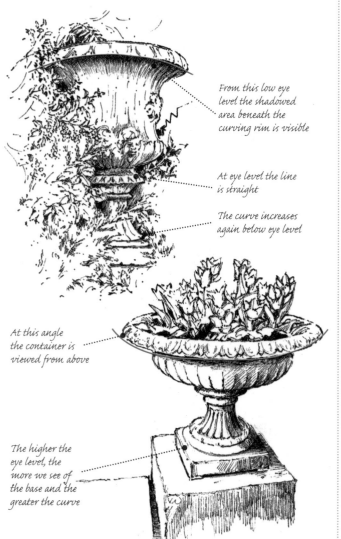

From this low eye level the shadowed area beneath the curving rim is visible

At eye level the line is straight

The curve increases again below eye level

At this angle the container is viewed from above

The higher the eye level, the more we see of the base and the greater the curve

The Method of Working

This little study of the focal point of the painting shows the order in which penwork and paint established the image and how important it is to line up the components in correct perspective to each other.

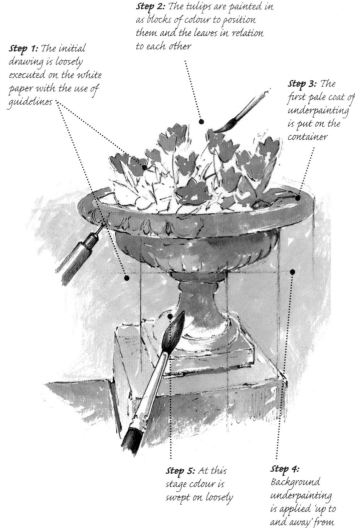

Step 2: The tulips are painted in as blocks of colour to position them and the leaves in relation to each other

Step 1: The initial drawing is loosely executed on the white paper with the use of guidelines

Step 3: The first pale coat of underpainting is put on the container

Step 5: At this stage colour is swept on loosely

Step 4: Background underpainting is applied 'up to and away' from the container

Creating the Painting

Although nearly all of the white paper will disappear beneath the layers of gouache, you may wish to allow some small shapes of untouched paper to glint through, in addition to any pen marks that will add interest to the representation.

For this painting I used a flat brush to cover large expanses, a medium round for the main painting, a small round brush for details and a tiny bristle brush for dry brush texture. The paper is stretched upon solid board, using a gummed strip, which provides a good, taut working surface.

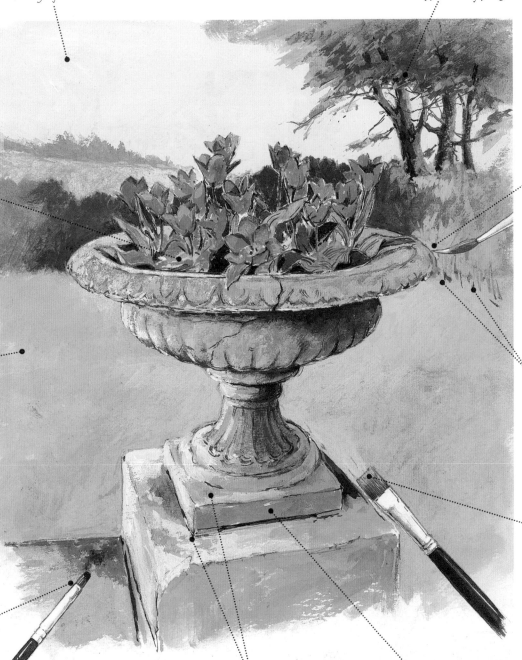

The sky is painted in as flat colour, using a flat brush

The side of a flat brush is ideal for the directional application of foliage

This underpainting hue will probably be completely covered by subsequent layers of paint

The foliage is worked 'up to and away' from the edge of the container

Bright, pale underlay may be retained in places to glint through final overlays in grass

Quick suggestions of where the hedge will eventually be are made using a fine brush and dark pigment

A flat brush is useful for large background areas, cutting in against objects

A small bristle brush is useful where the impression of a rough-textured surface is required

Some loose pen drawing may be retained in the completed painting to add interest

Some white paper may be retained within the completed painting

Gouache on a Coloured Support

Working upon coloured paper enables you to use white gouache to full effect. You can purchase coloured paper or card or, if you wish to choose your own colour, you can lay a tinted wash yourself on white paper. A translucent watercolour wash, or one of acrylic paint, is suitable – in the picture opposite, I have used a wash using diluted pigment from Inktense coloured pencils.

Coloured Papers

A variety of coloured papers are available, and in the detail of an apple with leaves I have used Ingres pastel paper. This delicate tint enables both light and dark hue and tone to contrast effectively. The study of a tree right demonstrates how a darker, textured paper enables greater contrast to be achieved when lighter gouache mixes are used, as here for a pale sky.

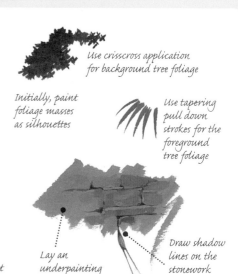

Pull down strokes describe the leaves

A sweeping grazing application is used for the sky

The pale blue of the sky is cut in after the initial trunk, branch and foliage mass shapes have been painted

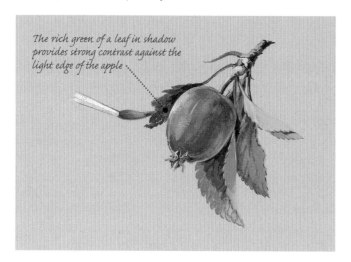

The rich green of a leaf in shadow provides strong contrast against the light edge of the apple

ARTIST'S TECHNIQUES

The coloured ground on which these studies are worked is produced by covering Saunders Waterford CP (Not) paper with a diluted Inktense wash. I have drawn the images in pencil, but you may prefer an ink drawing for greater clarity. Eventually all will disappear beneath paint layers, unless you wish to leave a few lines visible in the final artwork.

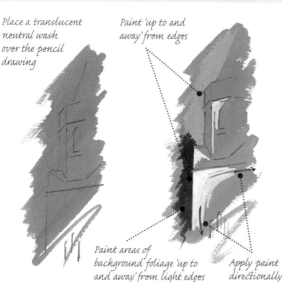

Place a translucent neutral wash over the pencil drawing

Paint 'up to and away' from edges

Paint areas of background foliage 'up to and away' from light edges

Apply paint directionally

Use crisscross application for background tree foliage

Initially, paint foliage masses as silhouettes

Use tapering pull down strokes for the foreground tree foliage

Lay an underpainting for the stonework

Draw shadow lines on the stonework with a brush

White Building in Gouache

Here a plain area of sky contrasts with busy treatment of the foliage and foreground shapes and textures around the building. All the stroke applications are the same as those relating to pencil and watercolour applications. Much of the left-hand side of the painting is complete while, on the right, I have left areas incomplete so that you may see the various stages of overpainting on the neutral hue underpainting.

'On your toes' application is used for silhouette edges of foliage mass against the sky

Details are added at the final stage

Crisscross application gives light areas within foliage masses

A first wash of dilute Zinc White is laid over a neutral underpainting

Zinc White gouache is used straight from the tube for maximum contrast

Paint is laid around the pencil lines of the railings, with dark paint added later

A fine brush is used for drawing on/ off pressure shadow lines within the stonework

Pale washes are placed over a darker underpainting

A wash of neutral Inktense hue is used to tint the surface of the Saunders Waterford CP (Not) paper

Choosing a Composition in Gouache

The painting on this spread was taken from a photographic reference. While photographs can be very useful for recording a scene to paint later on, many beginners find it a problem to know where to start when they try to translate them to paper; a photograph will often contain too much detail and lack a feeling of depth.

I endeavour to plan my composition as much as possible when I am taking the photograph, bearing in mind that areas will probably be edited out and added in when I eventually begin painting. For this study, where a pathway between trees separates two busy areas, I looked for a specific shape or contrast that my eye could easily be drawn back to, and then worked from there. This is indicated in my 'working out' sketch (*below left*).

After drawing the chosen shape I worked across the study, positioning tonal shapes and being conscious of undulations in the ground (*below right*). There was no need for further detail at this stage; the sketch was doing no more than providing thinking time for familiarization with the subject matter around my focal point.

tip

Use an A3 sheet of copier paper upon which to sketch the positions of the components of your painting. Start where you know your eye can easily return to a strong shape or contrast. When you have worked out your composition from that point, the A3 paper may be cropped. In this way you will not have been restricted to working within a predetermined format.

On/off pressure twists and turns of the pencil suggest angled branches and twigs

A very slim line of support colour is left to define the subject against the background

The first drawing in white gouache places the subject

Painting right up to the edge of the subject sets light against dark

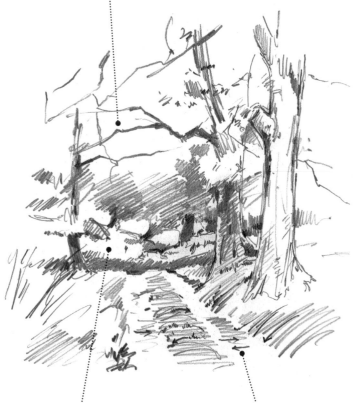

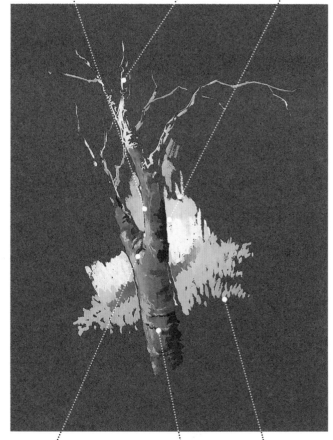

The sketch is kept simple, with tonal shapes to position the components in order to be aware of the light negatives

Drawing directional arrows helps you to remember the direction for brush stroke applications

Working into the form with light and dark tones gives it solidity

Curved strokes define form

Up and down application suggests the growth of the vegetation

Progressing the Painting

In this painting, areas have remained incomplete so that you may see how the painting was executed, working sky and subject matter along together rather than one before the other. I find this an exciting way of painting, providing opportunities for the consideration of shapes, tones, textures, relationships and so forth as the work progresses. When I feel I have placed all I wish at the extremities, I stop and crop.

It is a good idea to cut a mount before you crop your painting and position it to give you some idea of the overall impression. Working upon a coloured support that complements the content means that you can blend out into the support rather than feel you have to take all your picture right up to the edges. Choose a sheet of paper that is larger than you intend the final painting to be so that you don't find you run out of space.

For this study I started with the same structure shape shown in the sketch opposite. Working up and down from this I related the root system of the second trunk and surrounding grassy areas. The third trunk was then positioned, plus foliage masses above (see detail right).

Next I painted the light negative area at the far end of the pathway formed by the angled tree on the left. Then the pathway was started from that area, widening into the foreground. The foliage masses and twigs above soon followed and finally the tree on the left.

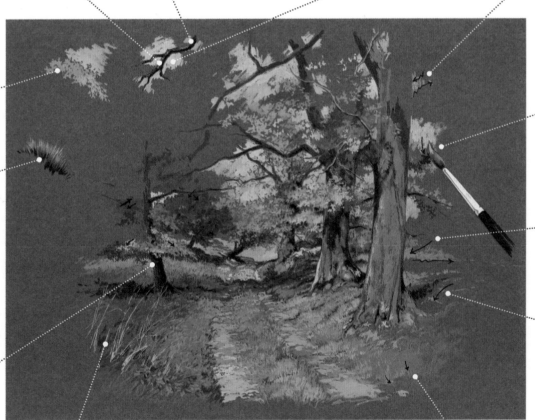

Medium tone was painted first to position the branch

Dark tone, representing the shadow side, was introduced next

The light sky area was painted 'up to and away' from the edges of the branches

The sky was painted 'up to and away' from the trunk

The foliage was painted first, with the sky placed 'up to and away', leaving a chink of support colour to add interest

Mid to light green grass was painted first, using pull down strokes, followed by lighter tips and then dark shadow shapes below

Pull down strokes of lightest lights appear in the foliage over the dark of the trunk

Paint was pulled down towards the foliage and cut in around leaf masses

Paint was applied 'up to and away' from the trunk

Undulations in the ground are suggested

'Flick' strokes of pale stems in front were superimposed with a fine brush

Short pull down strokes were put in with a fine brush for the grasses

Pen Techniques

The wide selection of pens available offers the artist a range of effects derived by using different techniques and nib types. A dip pen is the earliest form of pen, here used with acrylic ink for the first little exercise in grass and woodgrain textures, but more modern versions, including fine liner and brush pens, have their own considerable attractions.

Pen and ink is an ideal medium for illustrative work and my study of an iris demonstrates how lines may be applied to follow the form and create a strong impression. Linear pen marks can also be combined with wash to add tone to an illustration.

Using a Dip Pen

Dip pens give the opportunity for fine linework and have a characteristic traditional quality to their marks. You can use them with permanent ink for longevity, or with watersoluble inks if you wish to introduce a wash. The illustration of grass and wood shown here is executed with Raw Sienna acrylic ink.

Tick and flick strokes are built up to create positive shapes of massed grasses

Closer application of strokes gives dark negative recessive shapes

The slightly scratchy quality that can be obtained with a dip pen is excellent for giving the effect of woodgrain

Using Lines to Follow Form

Pen and ink is ideal for drawing contoured lines, allowing you a great deal of control and a delicate touch. Remember though that for most subjects you will need to vary the pressure you put on the pen or your lines will look artificial and mannered.

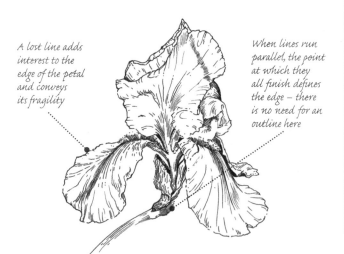

A lost line adds interest to the edge of the petal and conveys its fragility

When lines run parallel, the point at which they all finish defines the edge – there is no need for an outline here

Liner Pens

Versatile fine liner pens are available in a variety of colours and sizes and are effective used alone, creating intense areas of detail, or with monochrome or coloured washes overlaid. In these tree studies, a variety of strokes using a black pigment liner pen with watercolour wash overlay is shown.

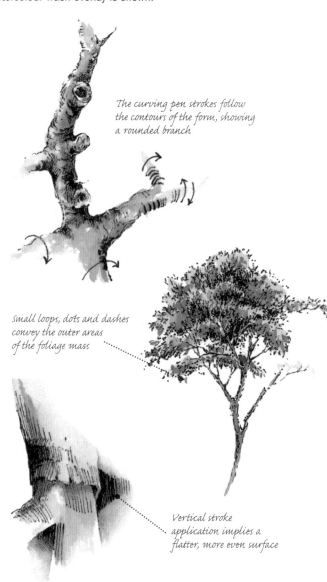

The curving pen strokes follow the contours of the form, showing a rounded branch

Small loops, dots and dashes convey the outer areas of the foliage mass

Vertical stroke application implies a flatter, more even surface

Methods of Application

This illustration of a cottage is divided into three sections, showing an intensive application of ink alone, a combination of ink and monochrome wash, and watercolour washes over ink drawing. From this treatment you will be able to compare similar surfaces handled with different techniques, all using a 0.1 pigment liner pen as the starting point.

This handling of the subject using pen alone relies on intricate overlaying of fine strokes to build the image

For penwork with monochrome washes, less detailed work is required to put in areas of tone

Here pen and ink is supplemented with watercolour washes that add colour to the subject

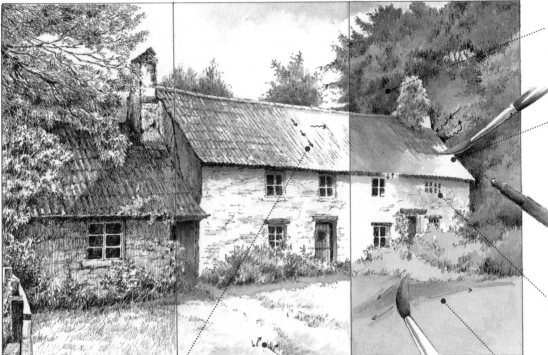

Building intensity in the foliage is done with colour washes over the ink drawing, with more ink drawing overlaid

Filling in with subsequent strokes enriches the area, adding areas of dark tone

A 0.1 pigment liner pen is used for the drawing throughout

The first lightly grazed, vertically applied, pen strokes depict the position of the windows

Not only the outline but also the directional application of strokes conveys the downward-sloping roof

Tick and flick with the pen indicates the grass in the foreground

Sweeping directional strokes of the brush cover the ground with watercolour washes, wet on dry

ARTIST'S TECHNIQUES

The following stroke applications were all used in the drawing of the cottage.

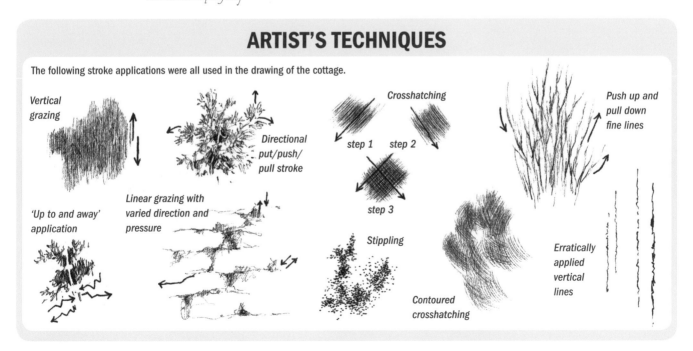

Vertical grazing

Directional put/push/ pull stroke

Crosshatching

step 1 *step 2*

step 3

Push up and pull down fine lines

'Up to and away' application

Linear grazing with varied direction and pressure

Stippling

Contoured crosshatching

Erratically applied vertical lines

Pen Techniques for Texture

Whatever the subject, basic stroke applications with the pen can be adapted to follow the form and describe texture. On this spread I show the strokes used to depict the solid surface of wood, human hands, cloth, long (partially rosetted) hair on a guinea pig and the varied hair length of a dog. Within them there are so many different contours, surfaces and textures, yet, by adapting strokes, all these surfaces are convincingly represented here, in brown and black inks.

Hands of an Elderly Lady

This study of hands, executed with a sepia artist's pen, has arrows that show the direction of stroke application and little demonstrations to help you relate various treatment to areas of the image. In terms of texture and contour, elderly hands can be more interesting to draw than those of young people.

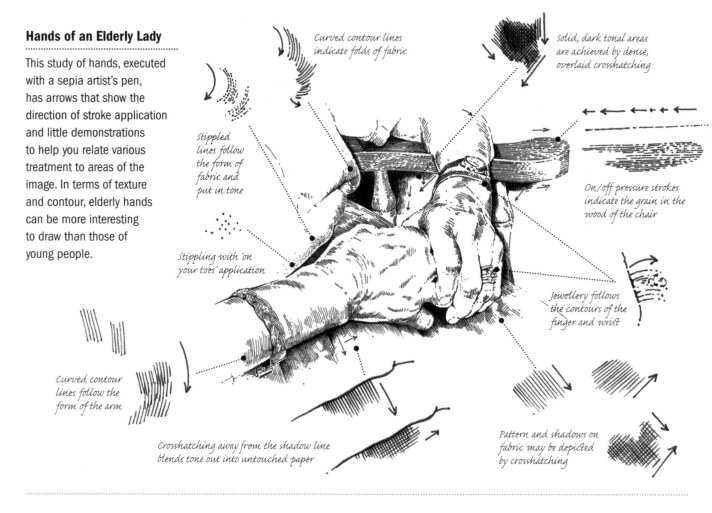

Curved contour lines indicate folds of fabric

Solid, dark tonal areas are achieved by dense, overlaid crosshatching

Stippled lines follow the form of fabric and put in tone

On/off pressure strokes indicate the grain in the wood of the chair

Stippling with 'on your toes' application

Jewellery follows the contours of the finger and wrist

Curved contour lines follow the form of the arm

Crosshatching away from the shadow line blends tone out into untouched paper

Pattern and shadows on fabric may be depicted by crosshatching

Guinea Pig

Here swiftly applied long, flowing contoured strokes, changing direction as required, have shadowed recessive shapes within the masses. These need to be enriched by placing short, overlaid strokes to create dark shapes within the clumps of hair.

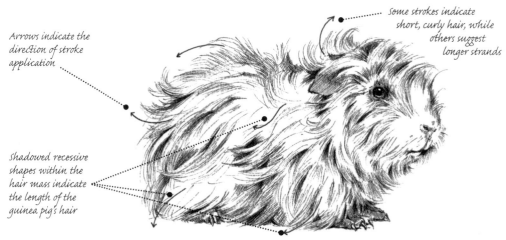

Arrows indicate the direction of stroke application

Some strokes indicate short, curly hair, while others suggest longer strands

Shadowed recessive shapes within the hair mass indicate the length of the guinea pig's hair

Collie Dog

The introduction of a tint above the eyes, the side of the cheeks and on the ears allows areas of white hair to contrast with tone and colour. Notice how much untouched paper has been retained within the study, which is executed with a Profipen 0.1 and a pigment liner pen.

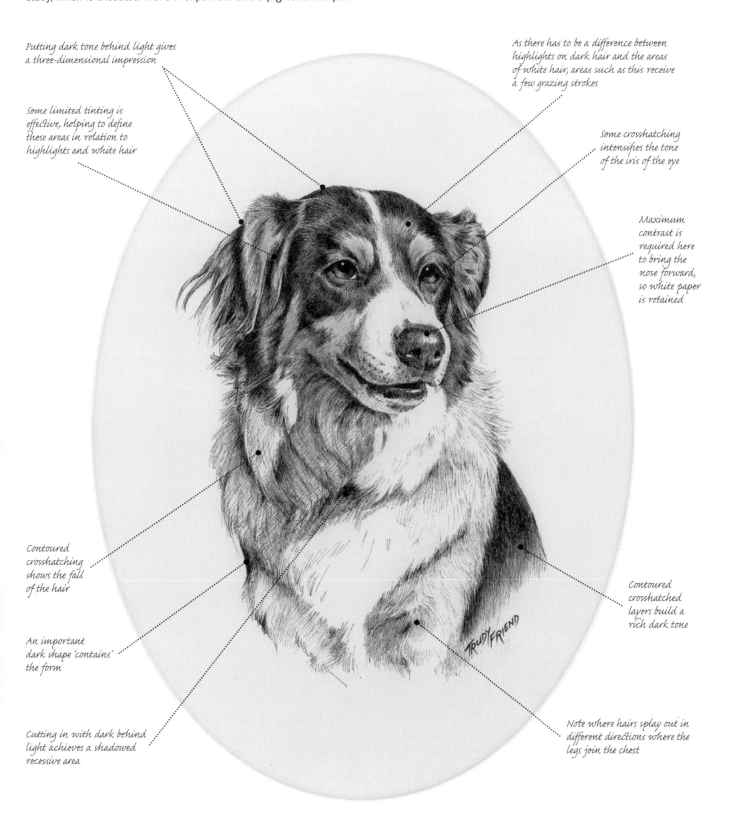

Putting dark tone behind light gives a three-dimensional impression

Some limited tinting is effective, helping to define these areas in relation to highlights and white hair

As there has to be a difference between highlights on dark hair and the areas of white hair, areas such as this receive a few grazing strokes

Some crosshatching intensifies the tone of the iris of the eye

Maximum contrast is required here to bring the nose forward, so white paper is retained

Contoured crosshatching shows the fall of the hair

An important dark shape 'contains' the form

Cutting in with dark behind light achieves a shadowed recessive area

Contoured crosshatched layers build a rich dark tone

Note where hairs splay out in different directions where the legs join the chest

Faber-Castell Pitt Artist Pens

MEDIA: PEN ON 110GSM (90LB) CARTRIDGE DRAWING PAPER

The vibrant hues in this brush pen range act as an encouragement for the artist to search for colourful subject matter to depict. Here, bright blue doors contrasting with the surrounding foliage in texture and shape as well as colour are viewed at an interesting angle, partially hidden by the other shapes. The pens used are from the ranges Landscape, Basic, Shades of Grey and Terra.

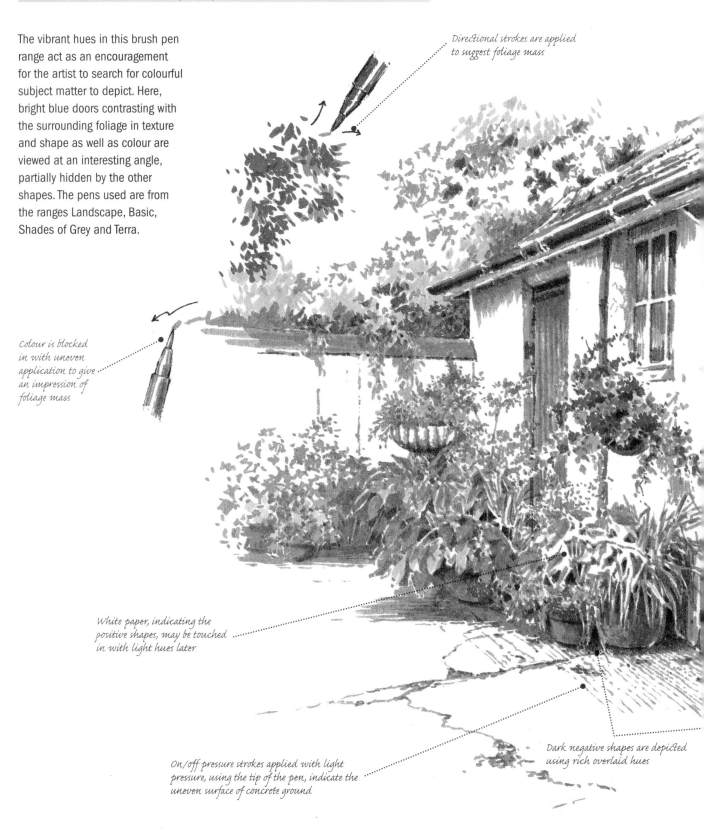

Directional strokes are applied to suggest foliage mass

Colour is blocked in with uneven application to give an impression of foliage mass

White paper, indicating the positive shapes, may be touched in with light hues later

On/off pressure strokes applied with light pressure, using the tip of the pen, indicate the uneven surface of concrete ground

Dark negative shapes are depicted using rich overlaid hues

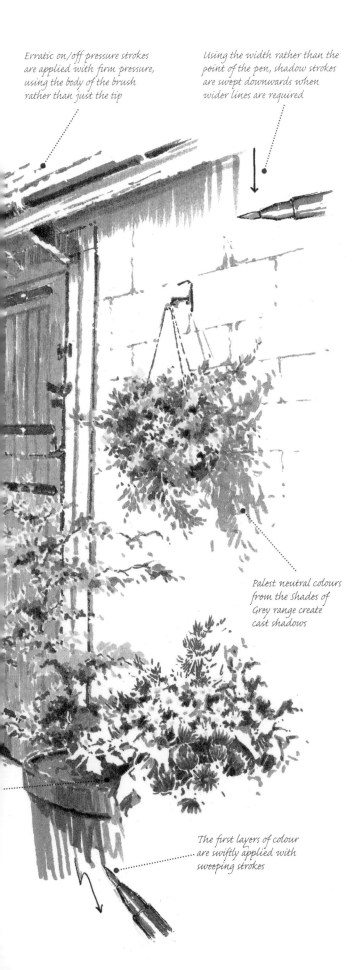

Erratic on/off pressure strokes are applied with firm pressure, using the body of the brush rather than just the tip

Using the width rather than the point of the pen, shadow strokes are swept downwards when wider lines are required

Palest neutral colours from the Shades of Grey range create cast shadows

The first layers of colour are swiftly applied with sweeping strokes

ARTIST'S TECHNIQUE

Landscape Colours

The colours shown below all appear in the illustration on this spread. Practise overlaying them and using directional strokes to see the effects they give.

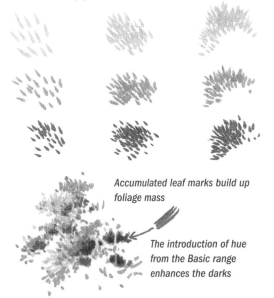

Accumulated leaf marks build up foliage mass

The introduction of hue from the Basic range enhances the darks

Shades of Grey Colours

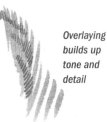

Fine lines create a contoured pattern

Overlaying builds up tone and detail

Basic Range Colours

Creating the shadowed side of floral mass

Colours are overlaid to create a mix

Terra Colours

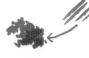

A single colour is used for the first underlay

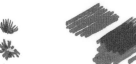

Overlaying a light hue creates highlights and builds up colour and form

Overlaying darker tones indicates shadowed areas

Sketching with a Pen

Pen and ink is an ideal sketching medium when you are out and about. You may often find an opportunity for sketchbook work in cafés and restaurants, where people are relatively stationary and will be too occupied with their companions to peer over your shoulder and make you feel self-conscious about your work. Using an A5 sketchbook will make you even more unobtrusive.

Unoccupied chairs are often arranged in a way that presents you with interesting angles and contrasting shapes, both positive and negative, that lead the eye into the picture. When seats are occupied and food and drinks are on tables, contrasts of scale can help to create greater interest.

tip

If you feel a little tentative about working in ink you will find that a textured paper surface is helpful as it allows gentle grazing to produce textured lines rather than immediate harsh lines.

Leading the Eye

Take advantage of angles and shapes to draw the viewer's eye into and through the composition. Of course, you do not have to adhere strictly to reality – if something is blocking a 'pathway' you can leave it out.

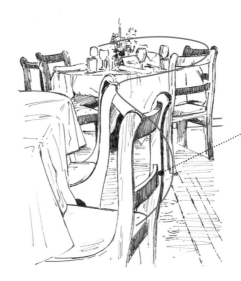

This composition contains an 'S' shape, indicated by the superimposed line. The chairs of the table in the foreground lead the eye up towards an area of interest in the far table arrangement and, on the way, a variety of negative shapes add interest within the positives

Including Figures

Adding figures can make for a more complex composition, but the same principles apply. In the sketch shown here, the eye is taken from the large scale of the bottle in the foreground along the arm of one of the diners, up into the middle of the composition and an important closed negative shape.

From there we look towards an open negative shape within a group of diners on another table, where there is the interest of a silhouetted figure and a strong vertical shape that leads us back into the foreground images.

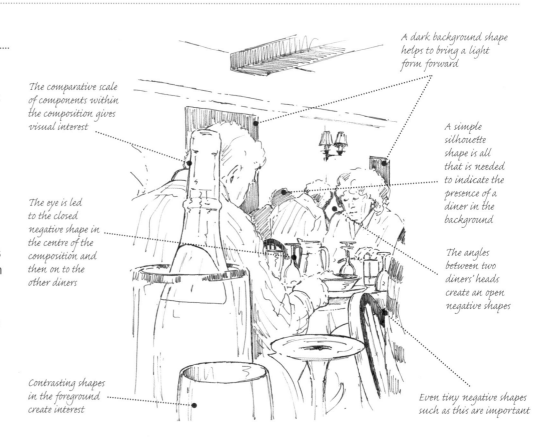

The comparative scale of components within the composition gives visual interest

The eye is led to the closed negative shape in the centre of the composition and then on to the other diners

A dark background shape helps to bring a light form forward

A simple silhouette shape is all that is needed to indicate the presence of a diner in the background

The angles between two diners' heads create an open negative shapes

Contrasting shapes in the foreground create interest

Even tiny negative shapes such as this are important

Close-up Studies

You may have a companion who is willing to pose while you make a quick sketch, or you can use objects on the table as still life subjects, perhaps moving them slightly first to create interesting 'shapes between'.

There may not be enough time to put much detail into your sketch when you are drawing a person. However, for a still life group you may have longer, especially when you are relaxing at the end of a meal.

Figure Study

In this sketch the raised glass connecting hand and head provides a series of angles leading from the wrist upwards, with the contours of the glass presenting a contrast of shapes. The pen strokes are swift and simple.

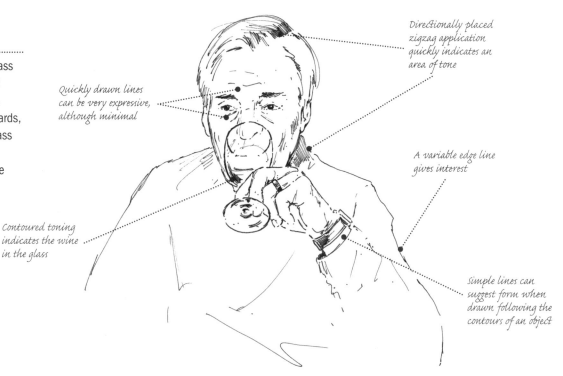

Quickly drawn lines can be very expressive, although minimal

Directionally placed zigzag application quickly indicates an area of tone

A variable edge line gives interest

Contoured toning indicates the wine in the glass

Simple lines can suggest form when drawn following the contours of an object

Still Life

A small bottle of wine against a larger water jug may look out of place and could be edited out if preferred. In this study it has been retained as it provided an interesting 'shape between' that helped establish a relationship between three objects.

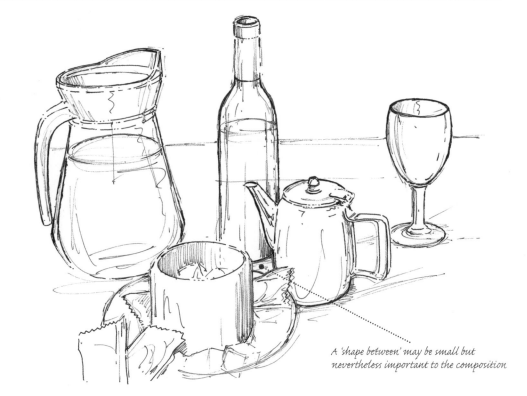

A 'shape between' may be small but nevertheless important to the composition

Mixed Media

MEDIA: PEN, INK AND WATERCOLOUR PENCILS ON 190GSM (90LB) BOCKINGFORD PAPER

When it comes to using mixed media, pen, ink and wash is a popular choice, with the wash element often in watercolour. However, watercolour pencils work equally well. When only a tint of colour is required, the method of placing a small amount of dry pigment on the paper and lifting this with a wet brush works well. It is the same principle as lifting watercolour paint from a pan.

Experimenting with different paper surfaces can lead you to discover exciting results. For example, the strong texture of a Rough surface paper allows delicate grazing of the surface with the pen to gradually build up texture and tone.

You will probably find it helpful to leave a border of white paper around your picture, upon which you can practise strokes, test colours and lay patches of dry pigment from which to lift colour with a wet brush.

Two Pheasants

The technique of layering translucent washes to gradually build intensity of hue and tone over a pen and ink drawing is demonstrated in this study of a pair of pheasants against strong grasses. It is an example of how a background relates to, and supports, the main image, but only as far as is necessary to make them stand forward.

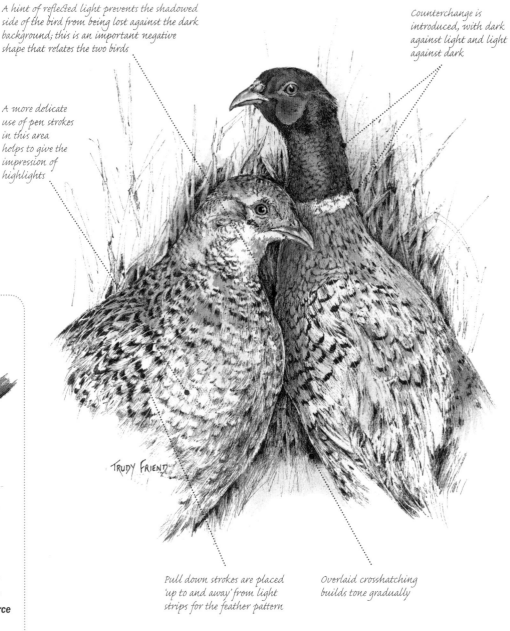

A hint of reflected light prevents the shadowed side of the bird from being lost against the dark background; this is an important negative shape that relates the two birds

Counterchange is introduced, with dark against light and light against dark

A more delicate use of pen strokes in this area helps to give the impression of highlights

TRUDY FRIEND

Making swatches of watercolour pencil on a spare piece of paper allows you to use them as a source of paint to lift off with a damp brush.

Pull down strokes are placed 'up to and away' from light strips for the feather pattern

Overlaid crosshatching builds tone gradually

Watercolour Over Drawing

A loose interpretation of the background area allows the detailed drawing and painting of the main subject to stand forward. I have also used warmer hues for this detail and emphasized the strong contrasts of highlights against darker shadow areas. Cast shadow follows the form of the stones upon which it falls, and the texture of these contrasts with that of the ring and chain.

All the components in this study were positioned in pencil first, with the texture of the paper softening the effect and allowing watercolour overpainting to blend effectively in the washes.

Know Your Papers

It is important to be aware of how different mediums work together when used upon a variety of paper surfaces. The pencil drawing of the chain and ring has benefited from being executed upon the textured surface of Bockingford paper in contrast to a smoother HP surface, which would produce a different effect.

A number of translucent washes were overlaid to enhance dark areas and care was taken not to encroach upon areas where lighter hue/tone needed to be retained. This paper enables final overdrawing in pencil to intensify the darkest darks.

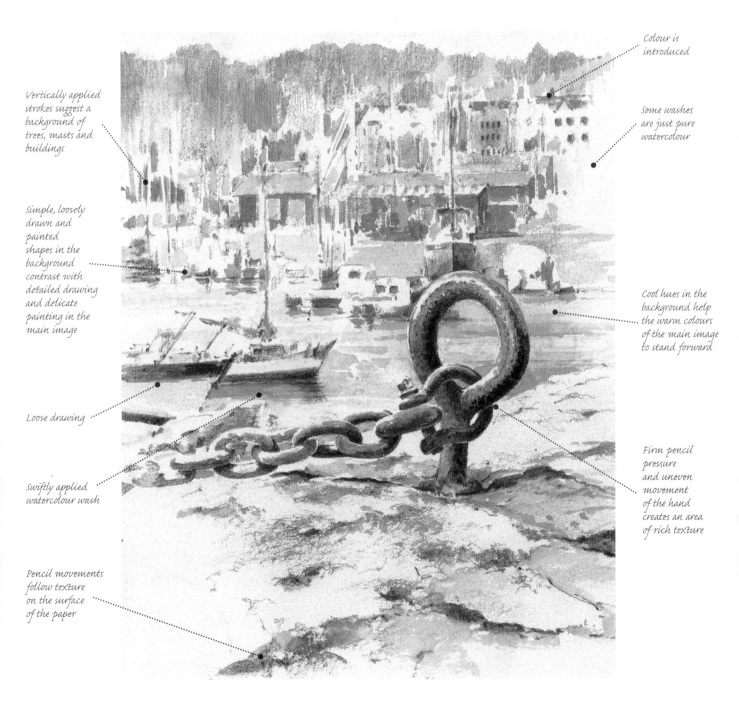

Vertically applied strokes suggest a background of trees, masts and buildings

Simple, loosely drawn and painted shapes in the background contrast with detailed drawing and delicate painting in the main image

Loose drawing

Swiftly applied watercolour wash

Pencil movements follow texture on the surface of the paper

Colour is introduced

Some washes are just pure watercolour

Cool hues in the background help the warm colours of the main image to stand forward

Firm pencil pressure and uneven movement of the hand creates an area of rich texture

Mixed Media

MEDIA: CARBON, CHARCOAL AND COLOURED PENCILS

Carbon and charcoal pencils produce strong texture and tone with which an interesting drawing may be created that lends itself to a coloured overlay. A layer of fixative spray will prevent unwanted smudging before the colours are added.

The sketches on this page are typical of those that may be drawn in a sketchbook. However, on the opposite page you can see how, viewed from a different angle, the same group of objects can make an interesting composition.

Garden Shed

This sketch demonstrates some of the basic stroke applications that may be used to create interest of line and textured tone and how a light grazing of coloured pencil can enliven a black and white drawing. By placing colour around the refuse bin, it benefits from rich contrasts behind.

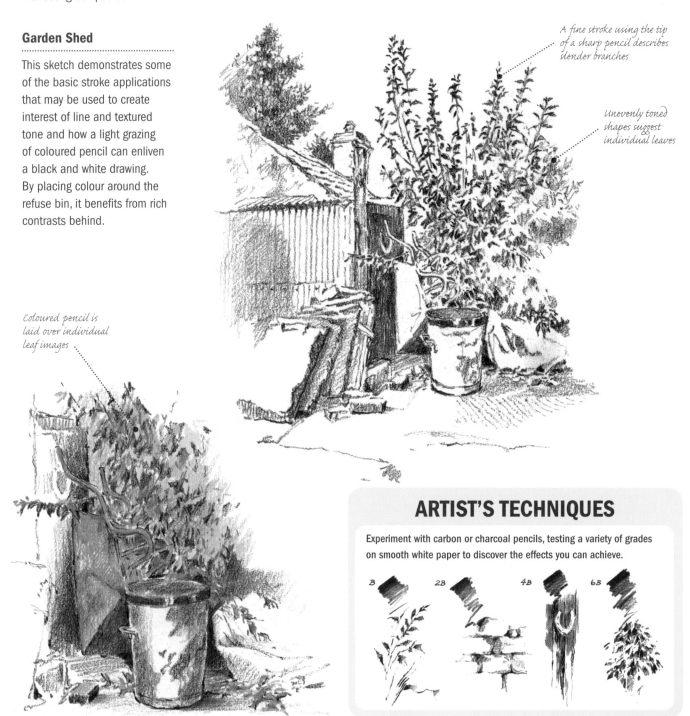

A fine stroke using the tip of a sharp pencil describes slender branches

Unevenly toned shapes suggest individual leaves

Coloured pencil is laid over individual leaf images

ARTIST'S TECHNIQUES

Experiment with carbon or charcoal pencils, testing a variety of grades on smooth white paper to discover the effects you can achieve.

B 2B 4B 6B

The Wider View

It is always a good idea to observe your chosen subject from various viewpoints before deciding upon layout and composition. After the sketchbook studies on the opposite page I have considered how to take the eye into the picture. By executing the sketch from a position where an area that 'rests the eye' may be included, in contrast to the 'busy' area of the focal point, I have found a more pleasing composition.

Watercolour washes over drawings can be very effective and this mix of media allows for a loose, free interpretation of the subject matter. Natural hues in the foreground encourage us to look at the stronger colours of the focal point.

Pencil strokes are pushed away from the light edge to create the foliage mass behind, using 'up to and away'

Erratically applied line and tone for leaves on twigs

Simple negative shapes appear amid the foliage

Textured tonal shapes represent the stone wall

Negative shapes and shadow lines on slabs of stone, shown before the application of colour

Vertical lines take the eye into the picture

An area that 'rests the eye'

Textured darks behind light forms bring them forward

Mixed Media: Exploring Textures

There are so many possibilities for the artist working with mixed media – and not all of them are obvious. For example, on this page I have used watercolour paint and watercolour pencils for my study of a toad.

You may find that in order to achieve the colour mixes you seek, combining two media that appear similar in this way may be the answer. If you have a limited choice of watercolour tubes or pans, yet have a few watercolour pencils with the colours you need, you may consider glazing your watercolour painting with a diluted pencil mix. There may also be areas where watercolour washes may benefit from gentle dry pencil grazing to add texture.

Study of a Toad
Pencil Sketch

Starting with an investigative pencil sketch in order to work out the strokes that may be suitable for the interpretaion is always the best way to embark on a finished painting. All the basic strokes executed in graphite in this illustration may be applied in the same way using coloured pencils, watercolour pencils or paint and brush.

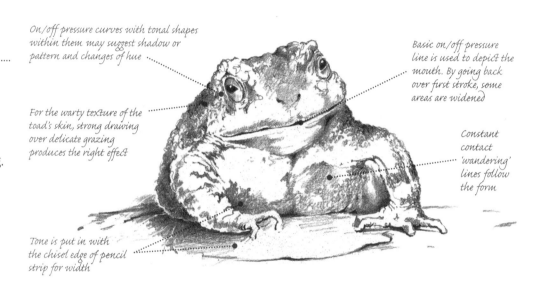

On/off pressure curves with tonal shapes within them may suggest shadow or pattern and changes of hue

Basic on/off pressure line is used to depict the mouth. By going back over first stroke, some areas are widened

For the warty texture of the toad's skin, strong drawing over delicate grazing produces the right effect

Constant contact 'wandering' lines follow the form

Tone is put in with the chisel edge of pencil strip for width

The Finished Study

For the finished study, I used watercolour paint and Derwent watercolour pencils. The subtle texture of Saunders Waterford CP (Not) paper allowed gentle blending from around the form to be taken out into the paper, providing a support for the image without any strong definition.

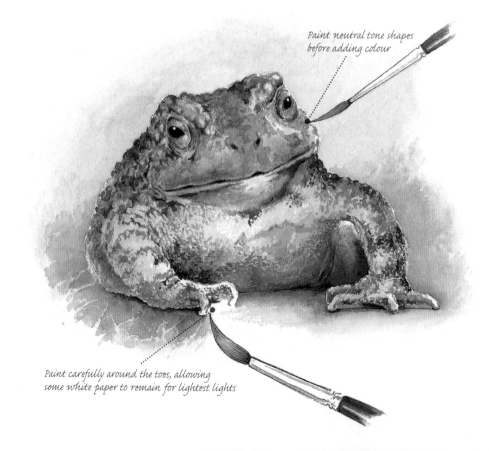

Paint neutral tone shapes before adding colour

Paint carefully around the toes, allowing some white paper to remain for lightest lights

Mixed Media: Coloured Textured Supports

In art supplies shops you will be able to find coloured textured papers that lend themselves to certain techniques, media and subject matter. A midtone paper allows you to work with contrasts of light and dark paint or pastel, using the untouched paper as your midtone rather than your highlights.

Maran Hen

Poultry are delightful subjects to depict, offering interest of colour, shape and texture. After a preliminary sketch, I made a small study of the head of a Maran hen.

A tinted paper with slight texture and containing flecks of grey proved ideal for this mixed media painting executed in Chromacolour and watercolour pencil. By using white pencil behind the image, contrast was achieved, allowing feather textures to stand out where required, then to blend into the paper's hue and texture at the base of the neck.

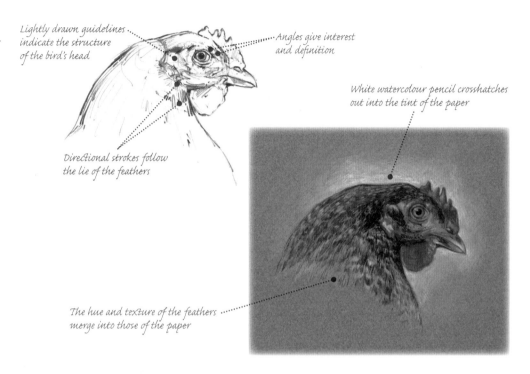

Lightly drawn guidelines indicate the structure of the bird's head

Angles give interest and definition

Directional strokes follow the lie of the feathers

White watercolour pencil crosshatches out into the tint of the paper

The hue and texture of the feathers merge into those of the paper

Big and Bold

A more illustrative style has been used for this study of a cockerel's head, executed in charcoal pencil and gouache. The raised, flecked texture of this tinted paper seemed a natural choice for a large interpretation (38 x 23cm/ 15 x 9in) of this colourful bird.

Charcoal overlay grazing has been used to enhance texture on the comb

Delicate brush strokes suggest a sheen upon the hard surface of the beak

Working upon a coloured ground enhances contrasts where dark charcoal pencil shadow areas cut in against the lightest lights

White gouache has been used neat in places for maximum effect of shape and highlights. Elsewhere it has been mixed with yellow and ochre for light feathers

Mixed Media: Children's Toys

MEDIA: INK AND INKTENSE PENCILS AND WATERCOLOUR ON WATERCOLOUR BOARD

Depicting brightly coloured children's toys gives you the chance to use vibrant hues, in this case in a painting full of detail. The first stage is to do a pencil drawing to establish the positions of all the elements before making the pen and ink drawing. The pencil strokes may then be erased before the watercolour washes are added.

An image like this teddy on a toy train will allow you to experiment with contrasting shapes and textures. The solid, angled and curved shapes of the train contrast with the soft fur effects of the bear, while the subtle hues of the fur contrast with the vibrant colours of the painted wood.

The train and bear are positioned in a way that produces interesting negative shapes. The two small and two larger shapes are closed negatives, while the one between the funnel and body of the train is an open negative. Notice how a cast shadow follows the form from the funnel across the engine's surface and the strong cast shadow beneath the roof helps to emphasize the overhang with intense tone.

Inktense pencil washes were placed over some of the watercolour washes in some areas, for example, Sun Yellow over the wheels, Teal Green over the carriage walls, Bright Blue over the roof and Poppy Red on the engine. With a wash of Willow across the supporting table to add richness to the wood effect, this coloured ink drawing demonstrates a mixture of three mediums working together to create a vibrant interpretation.

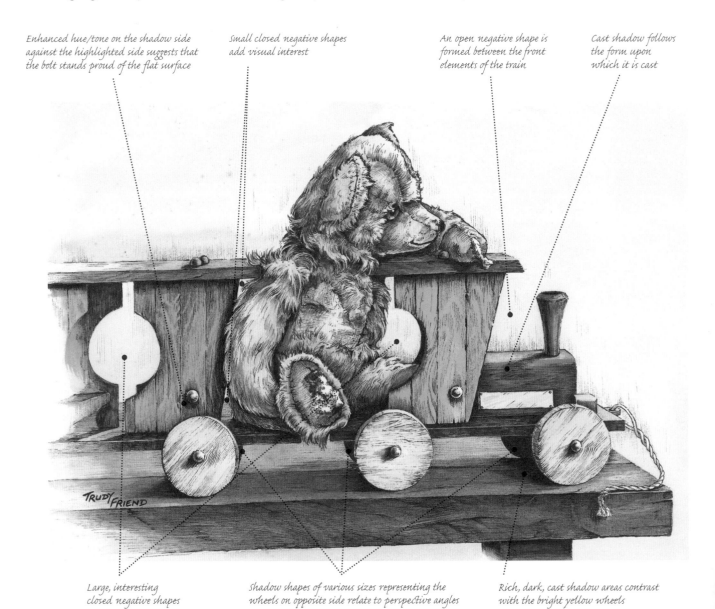

Enhanced hue/tone on the shadow side against the highlighted side suggests that the bolt stands proud of the flat surface

Small closed negative shapes add visual interest

An open negative shape is formed between the front elements of the train

Cast shadow follows the form upon which it is cast

Large, interesting closed negative shapes

Shadow shapes of various sizes representing the wheels on opposite side relate to perspective angles

Rich, dark, cast shadow areas contrast with the bright yellow wheels

Textured Coloured Card

MEDIA: WATERCOLOUR PENCILS, GOUACHE AND MOUNT CARD

Working upon a textured coloured card can add extra dimension to an illustration and in the blue area of this one you can see how the support's texture affects the finished result.

An opportunity to use primary and secondary colours as a support for the more subtle hues of the bear, built upon pen and ink drawing, is demonstrated here within a circular format. White gouache was applied with a fine brush to depict light hairs and Derwent watercolour pencils were overlaid, dry on dry (using firm pressure) before blending with clear water washes. Once those had dried, further layering of the pencils, dry on dry, increased the intensity of hue and tone.

Coloured Pencils used

1. Lemon Cadmium

2. Deep Cadmium

3. Brown Ochre

4. Golden Brown

5. Copper Beech

6. Terracotta

7. Orange Chrome

8. Rose Pink

9. Light Violet

10. Crimson Lake

11. Deep Vermilion

12. Imperial Purple

13. Spectrum Blue

14. Mineral Green

15. Emerald Green

16. Blue Grey

The background is created by laying Mineral Green watercolour pencil dry on dry over the pen and ink drawing. After washing clear water over the green to blend it and allowing it to dry, Emerald Green is applied firmly, dry on dry

A variety of hues are overlaid for the hair: Golden Brown, Brown Ochre and Copper Beech, with Deep Cadmium shadows

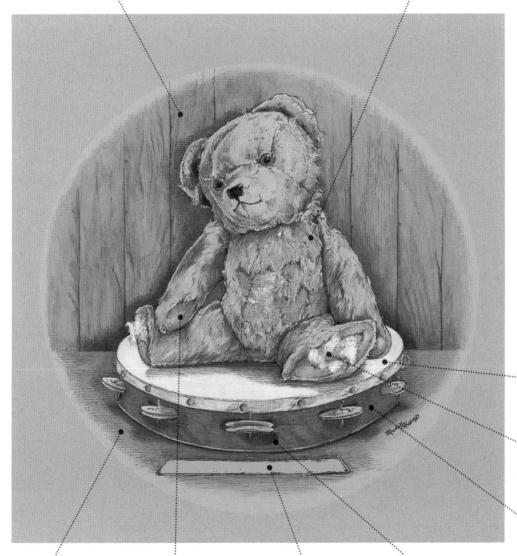

Lemon Cadmium and White are used for the skin of the tambourine

Blue Grey is used for shadows within the stuffing

The wood of the tambourine is coloured with Deep Vermilion, dry on dry, then blended with a clear water wash

Spectrum Blue is used for the surface on which the tambourine is placed. The surface of the card gives a textured effect

Overlays of Rose Pink, Light Violet, Imperial Purple and Orange Chrome are used for the pawpad

An area of the background surface has been left blank to form a label, perhaps to add the name of a child

Crimson Lake provides a darker tone in shadowed recessive areas and for cast shadows over the body of the tambourine

Problems and Solutions

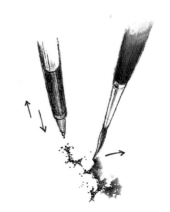

Both beginners and 'improvers' may experience problems that arise as a result of underdeveloped observational skills as well as a lack of practise in, and understanding of, methods and media.

On the following eight spreads I have shown typical problems and their solutions that occur with still life objects, bird life and figures in various media, including pen and ink, gouache and watercolour. However, many of the problems illustrated also relate to other media techniques.

Overeagerness to progress with a work can be a stumbling block for some novice artists, whose work suffers from a lack of patience in the preliminary stages. In order to produce the best work of which you are capable, it is essential to spend time making preliminary sketches of your chosen subject and working on exercises to develop your practical skills.

You should also make a practise of pausing during the execution of your artwork in order to analyse progress and giving thought to its conclusion to prevent spoiling it by overworking it. Recognizing when to stop is a valuable skill that is acquired by trial and error; rushing ahead will tend to favour the latter. Studying the illustrations in this section, you will find it valuable to see how those that have gone wrong have largely done so as a result of decisions taken without enough thought and observation beforehand.

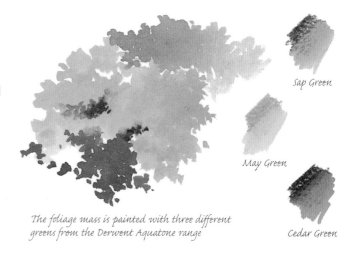

Sap Green

May Green

Cedar Green

The foliage mass is painted with three different greens from the Derwent Aquatone range

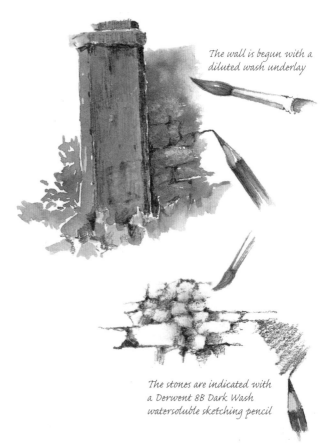

The wall is begun with a diluted wash underlay

The stones are indicated with a Derwent 8B Dark Wash watersoluble sketching pencil

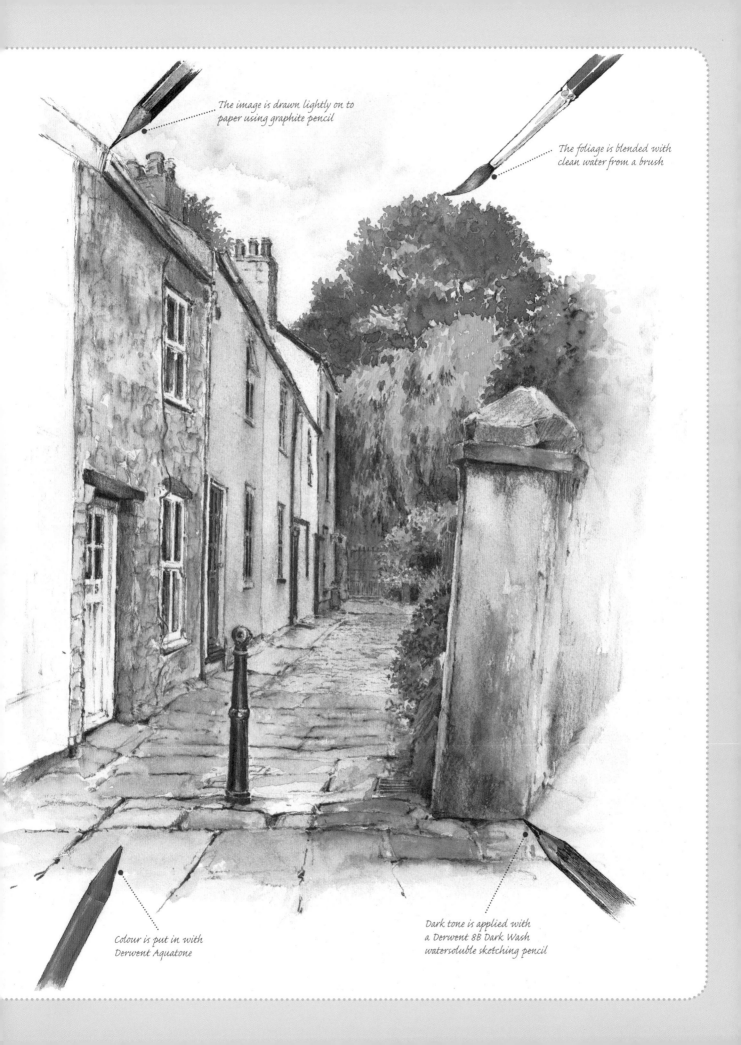

The image is drawn lightly on to paper using graphite pencil

The foliage is blended with clean water from a brush

Colour is put in with Derwent Aquatone

Dark tone is applied with a Derwent 8B Dark Wash watersoluble sketching pencil

Contours and Textures

MEDIA: PEN, INK AND WASH ON 190GSM (90LB) BOCKINGFORD PAPER

Here I am comparing two watersoluble inks used to depict very different subjects in terms of both contour and texture. Both are in the form of roller pens, yet one responds more rapidly to the addition of water than the other.

Watercolour washes have been laid over the pen drawing, with the addition of white poster paint (gouache or acrylic white may be substituted) to lift the light florets of the cauliflower. Painting these two subjects will help you to understand how to compare the contrasts and contours seen on the shiny surface of a copper kettle with the textures and shadow shapes to be found within the leaves and florets of a cauliflower.

Problems

These little 'problem' images demonstrate how a lack of understanding of the subject matter can lead to a flat representation of it. You need to give yourself 'thinking time' before starting to draw so that you can absorb the relevant forms and surface textures both visually and mentally.

Here there is a failure to represent the florets in relation to the leaf formation

Lack of close observation has resulted in a flat rather than three-dimensional impression of the cauliflower

An absence of guidelines in the initial drawing has resulted in an inaccuracy of proportion and contour

Solutions

Using the appropriate stroke applications and paying attention to form transforms the two images. Remember that you should never draw what you think you know about a subject – clear all preconceptions from your mind and draw what you can actually see.

To depict the cauliflower florets, use the pen 'on your toes', touching and lifting the pen for a stippling effect

Put in tone to show the bumpy surface by using a fine brush, touching it with clean water and pulling away to blend

Clean water added to watersoluble ink achieves a pale wash that gives substance to the handle of the kettle

Stippling and wash effect combine to depict a granular surface with bumps and crevices

Horizontal and vertical guidelines help to place components correctly in relation to each other

An initial pencil drawing to analyse the subject identifies potential errors before any further work is begun

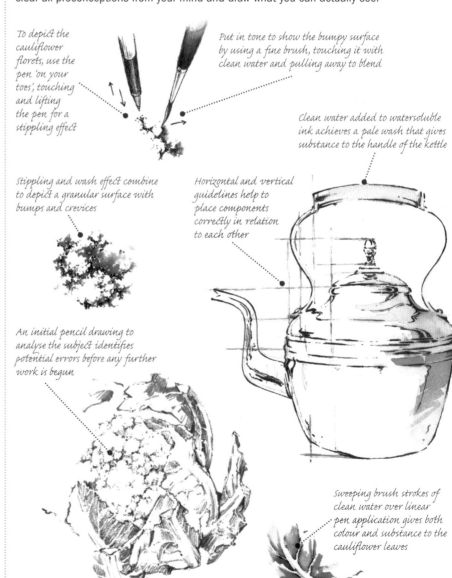

Sweeping brush strokes of clean water over linear pen application gives both colour and substance to the cauliflower leaves

The Completed Images

Preliminary work in the form of pencil sketches and quick exploratory pen, ink and wash studies will give you the confidence to feel you understand your subject well enough to tackle a finished study with success.

It is a good idea to draw your chosen subject from different angles before deciding upon which one you intend to use. After drawing a straightforward side view of the kettle, I decided it looked more interesting seen from a higher eye level. Your paintings will benefit from your never accepting the first viewpoint without trying others to see if they offer something better.

Contrasts and Contours

Decide beforehand where you intend to leave white paper to represent highlights and work around these. This is particularly important on a subject with a shiny surface, such as this copper kettle. Getting the surface right is vital to describing an object; in this instance, omitting the highlights would give the impression of a rusty old object from a garden shed.

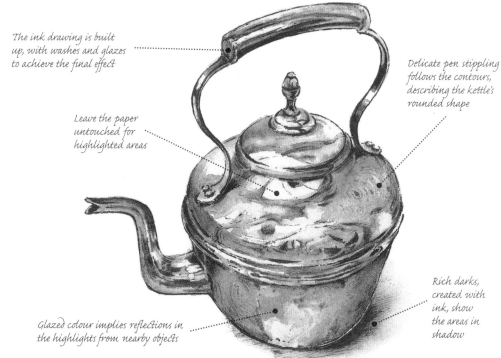

The ink drawing is built up, with washes and glazes to achieve the final effect

Delicate pen stippling follows the contours, describing the kettle's rounded shape

Leave the paper untouched for highlighted areas

Rich darks, created with ink, show the areas in shadow

Glazed colour implies reflections in the highlights from nearby objects

Texture and Shadows

The cauliflower presents a completely different challenge. Here textures are rough, with the firm mounds of the florets and the ragged leaves surrounding them containing areas of deep shadow.

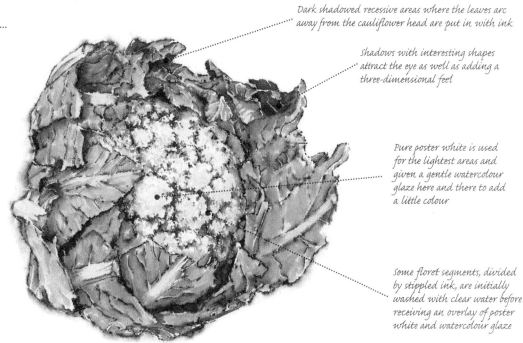

Dark shadowed recessive areas where the leaves arc away from the cauliflower head are put in with ink

Shadows with interesting shapes attract the eye as well as adding a three-dimensional feel

Pure poster white is used for the lightest areas and given a gentle watercolour glaze here and there to add a little colour

Some floret segments, divided by stippled ink, are initially washed with clear water before receiving an overlay of poster white and watercolour glaze

Using Fine Liner Pens

Beginners sometimes experience problems with techniques when using fine liner pens and here I have shown a few typical problems, and their solutions, in this illustration of a cut grapefruit. The variations in colour and texture mean that this subject requires some thought as to how to tackle it. The Artist's Techniques box opposite explains the use of these pens dry and with water added.

Problems

Whether you are stippling for skin texture or using wandering lines that indicate a juicy interior, it is vital to give consideration to the treatment you will use if the problems shown below are to be avoided.

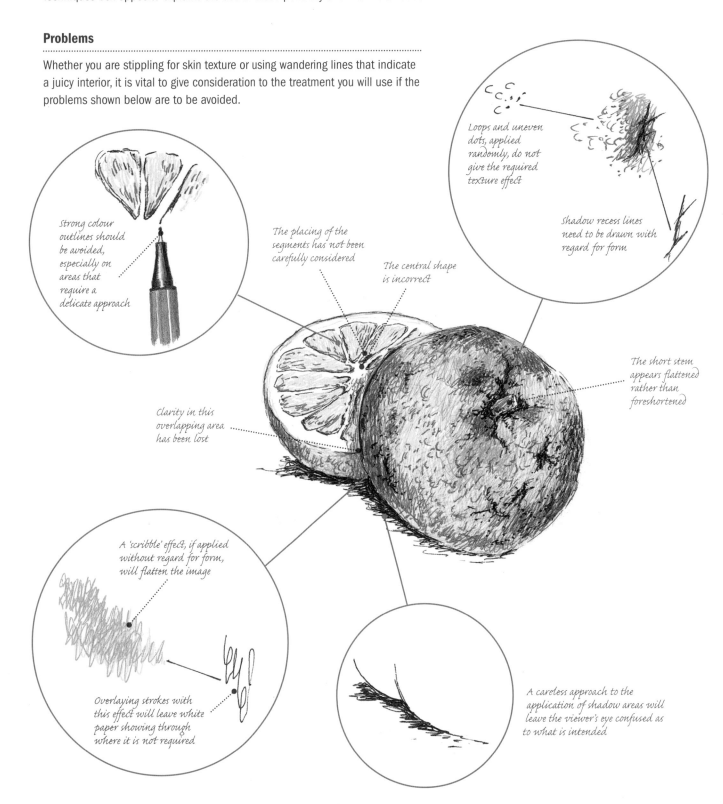

Loops and uneven dots, applied randomly, do not give the required texture effect

Strong colour outlines should be avoided, especially on areas that require a delicate approach

The placing of the segments has not been carefully considered

The central shape is incorrect

Shadow recess lines need to be drawn with regard for form

The short stem appears flattened rather than foreshortened

Clarity in this overlapping area has been lost

A 'scribble' effect, if applied without regard for form, will flatten the image

Overlaying strokes with this effect will leave white paper showing through where it is not required

A careless approach to the application of shadow areas will leave the viewer's eye confused as to what is intended

Solutions

In this study I demonstrate how to overcome the main problems by adapting the strokes to the subject matter and using careful observation as to how shapes are formed.

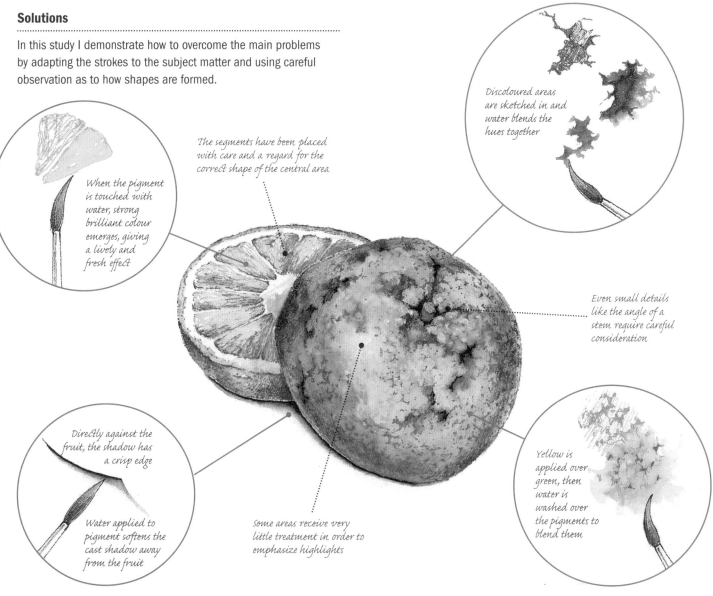

Discoloured areas are sketched in and water blends the hues together

When the pigment is touched with water, strong brilliant colour emerges, giving a lively and fresh effect

The segments have been placed with care and a regard for the correct shape of the central area

Even small details like the angle of a stem require careful consideration

Directly against the fruit, the shadow has a crisp edge

Water applied to pigment softens the cast shadow away from the fruit

Some areas receive very little treatment in order to emphasize highlights

Yellow is applied over green, then water is washed over the pigments to blend them

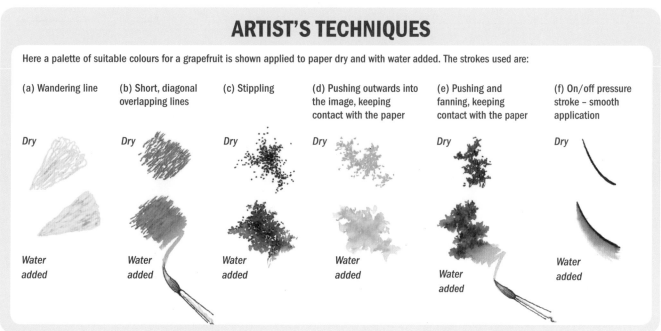

ARTIST'S TECHNIQUES

Here a palette of suitable colours for a grapefruit is shown applied to paper dry and with water added. The strokes used are:

(a) Wandering line

(b) Short, diagonal overlapping lines

(c) Stippling

(d) Pushing outwards into the image, keeping contact with the paper

(e) Pushing and fanning, keeping contact with the paper

(f) On/off pressure stroke – smooth application

Dry

Dry

Dry

Dry

Dry

Dry

Water added

Water added

Water added

Water added

Water added

Water added

Folded Textiles

MEDIA: FIBRE-TIP PEN ON 190GSM (90LB) BOCKINGFORD PAPER

Folds in cloth often present a problem for beginners, especially when the fabric is patterned. It is important to make sure that any pattern follows the form of the folds, otherwise the viewer's eye will be confused. A simple stripe will enable you to see clearly the way the pattern is distorted and for this image I have chosen a monochrome representation so that your eye is not distracted by colour.

Fibre tip pens enable swift filling in of shapes and you could use any colour of your choice to try this exercise. Just drape a striped apron over a chair back or the edge of a table and look into the contours and shadow shapes to understand how to apply the pigment.

Problems

This illustration demonstrates how lack of close observation can result in loss of form. The result is a confusing array of stripes that never quite assemble themselves into a recognizable object.

Compare this dotted guideline, relating to the support, to that on the illustration on the opposite page

Although a lost line has been left here, the blue outlining elsewhere flattens the image

Note how the level of the support has dipped, making the representation inaccurate and unconvincing

If stripes appear to widen they should correspond with others in a similar position as they will be suggesting a raised contour

Important angles have not been depicted, leaving the strap lacking in substance

Tiny unwanted areas of white paper within the blue stripes can be avoided by gently washing clean water directionally to blend

Absence of shadow flattens the form

A cast shadow has been placed carelessly

Interesting areas of white stitching have been lost in this representation

These three grey lines fail to suggest cast shadow successfully

A good attempt has been made at contours and folds but more clarity is required and the stripes should be consistent with the forms

Solutions

This little diagram demonstrates how considering the direction of the stripe contours of folds and recess areas will make the object immediately recognizable as an apron.

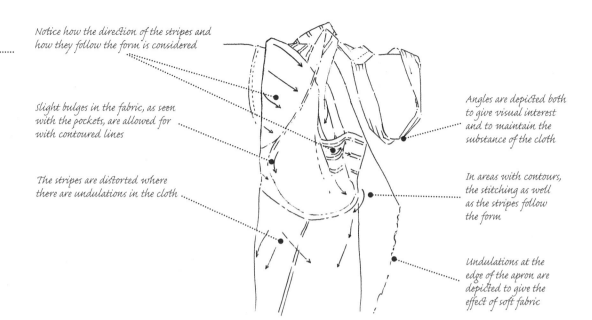

Notice how the direction of the stripes and how they follow the form is considered

Slight bulges in the fabric, as seen with the pockets, are allowed for with contoured lines

The stripes are distorted where there are undulations in the cloth

Angles are depicted both to give visual interest and to maintain the substance of the cloth

In areas with contours, the stitching as well as the stripes follow the form

Undulations at the edge of the apron are depicted to give the effect of soft fabric

Creating Folds

Even in fabric, there is inherent strength and structure. Look for undulations within its pattern and folds. Gentle suggestions of contour, using a grey pen, enhance the effect in this illustration. Care has been taken to retain the correct width of the stripes throughout, noting where they narrow as a result of perspective and where they appear their correct width over the contours.

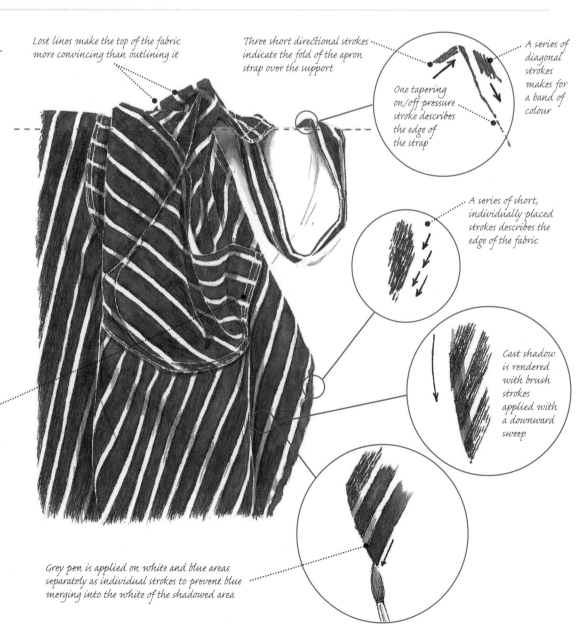

White stitching is carefully observed and incorporated

Lost lines make the top of the fabric more convincing than outlining it

Three short directional strokes indicate the fold of the apron strap over the support

One tapering on/off pressure stroke describes the edge of the strap

A series of diagonal strokes makes for a band of colour

A series of short, individually placed strokes describes the edge of the fabric

Cast shadow is rendered with brush strokes applied with a downward sweep

Grey pen is applied on white and blue areas separately as individual strokes to prevent blue merging into the white of the shadowed area

Drawing a Toy Figure

MEDIA: FIBRE-TIP PENS ON 110GSM (90LB) CARTRIDGE DRAWING PAPER

A cheerful subject such as this sand-filled fabric clown with a porcelain face and extremities will give you an opportunity to play with colour, texture, pattern and form, using fibre-tip pens in a variety of vibrant hues. However, it is easy to go astray with proportion and to fail to give the figure a three-dimensional effect.

Problems

As with the apron study on the previous page, it is necessary to consider how the striped fabric of the trousers follows the contours of folds. However, one of the main problems with this little study is that here and there white paper has been retained by accident, rather than with intent.

The features are not placed correctly in relation to each other – the nose veers towards the left eye

There is no relationship between hat and hair – a band of white paper separates the two

A hard 'tacking stitch' outline restricts the development of the form

Elongated strips of white paper are showing through the colour application as a result of repetitious diagonal strokes

Unintentional retention of white paper flattens the form

Important small details, such as placing buttons correctly in relation to supporting straps, have not been observed

Unintentional marks or drawing alterations are too obvious when black is used

There are no suggestions of areas in shadow, resulting in a flat appearance

There is confusion with the position of stripes in relation to other trouser leg

Solutions

In order to avoid unwanted white paper areas it is necessary to overlay hue and tone, creating depth within the folds of the cloth. Execution of a subject such as this may be free and loose, yet still have regard for form, contours and shadows. The trick is to maintain accuracy without falling into the trap of making tight, anxious strokes that result in a lifeless drawing.

A rapidly applied zigzag movement using the tip of the nib creates the hair

The relationship of hat and hair has been carefully considered, with the hair overlapping in places to anchor the two together

The hat, hair, face shape and features are drawn first, using a pale grey

Long and short contoured shapes produce an abstract pattern on the fabric

Other colours are used to block in certain areas

The pale grey underdrawing does not inhibit the depiction of the fabric pattern

Tiny white paper chinks (rather than strips) show through to add sparkle and liveliness

A variety of greens and yellows adds interest to the pattern

The angle and position of the button relates to the supporting strap

The pattern of the fabric follows the contours of the folds

Wider bands of colour start with a down and up movement, working from side to side

Up and down movements making double the width of the pen tip are used for narrow stripes

The same grey, applied with sweeping strokes over the colours, creates the effect of areas in shadow

Figure Studies

MEDIA: 0.1 PIGMENT LINER PEN AND WATERCOLOUR ON 190GSM (90LB) BOCKINGFORD PAPER

From the figure of a little fabric and porcelain clown we can move into representing a human figure, which poses bigger challenges for a novice artist. For these images I have used a 0.1 pigment liner pen, but two pencil studies are also included as this is always a good way to start upon a drawing or painting. Watercolour washes add colour and interest and have been loosely applied over the pen drawings.

Problems

Some of the typical problems experienced by beginners when depicting figures are achieving the correct proportions, finding the right scale in relation to the surroundings and placing the shadows in a way that does not flatten the form.

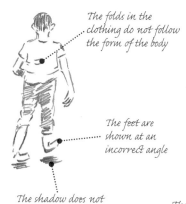

The folds in the clothing do not follow the form of the body

The feet are shown at an incorrect angle

The shadow does not relate to the figure

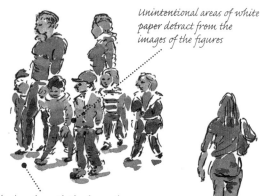

Unintentional areas of white paper detract from the images of the figures

The shadows beneath the figures have not been used to advantage – the group appears to be floating above the ground

The angle of the foot does not suggest the figure is walking away

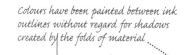

Colours have been painted between ink outlines without regard for shadows created by the folds of material

Both figures appear to be standing to attention rather than enjoying a conversation

The figure appears to be on the same level as the cart

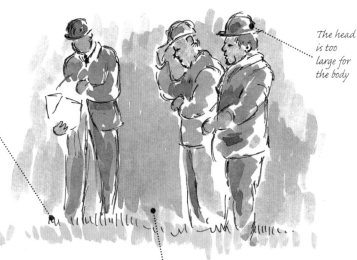

The head is too large for the body

The grass at the feet of the figures has the appearance of a fringe

The figure has been elongated – the head is too small

The image appears flat, as it is drawn in outline rather than with a wandering line that finds the form and leaves lost edges

The contrast between the greens in the setting for the figures is too sudden

Solutions

Whether you are depicting single figures or groups, stationary or moving, it is important to relate them to the ground. In these studies I have done this in two different ways, using cast shadows across the surface and obscuring the feet by grass.

Notice the freely applied pen strokes, suggesting form or movement, and the way in which I have avoided hard, wire-like outlines, which can tend to flatten forms.

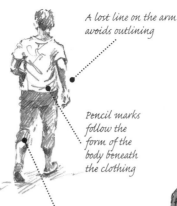

A lost line on the arm avoids outlining

Pencil marks follow the form of the body beneath the clothing

Note the contrasts of highlights and shadows

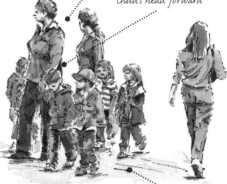

An interesting negative shape is created between the figures

This important dark shape brings the light form of the woman's arm and child's head forward

The suggestion of shadows on the ground relates the group to the passing figure

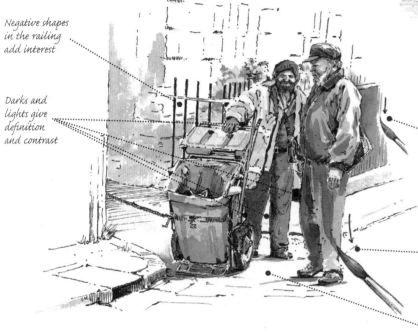

Negative shapes in the railing add interest

Darks and lights give definition and contrast

Directional strokes have been cut in behind light forms, in this instance with a flat background enhancing a contoured form

The gradual build-up of overlaid washes enables highlighted areas to be retained

Consideration has been given to the arrangement of the feet and the wheels – the figure is now standing behind his cart

An open negative shape is seen between the men's heads

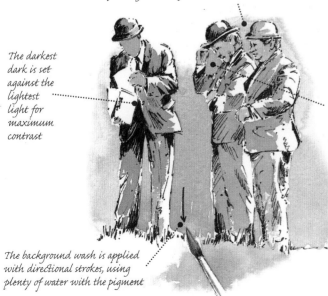

The darkest dark is set against the lightest light for maximum contrast

The closed negative shape between the arm and face is a pleasing proportion

The background wash is applied with directional strokes, using plenty of water with the pigment

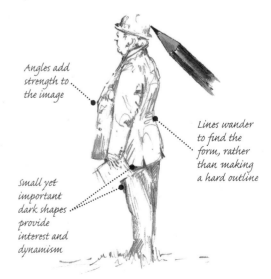

Angles add strength to the image

Lines wander to find the form, rather than making a hard outline

Small yet important dark shapes provide interest and dynamism

Scale and Perspective

MEDIA: 0.1 PIGMENT LINER PEN, WATERCOLOUR AND GOUACHE ON 300GSM (140LB) SAUNDERS WATERFORD CP (NOT) WATERCOLOUR PAPER

This interesting relationship between a figure and a boat has been represented in mixed media. Working on watercolour paper enabled the use of a watercolour wash undercoat to colour the surface before the gouache overpainting and penwork were applied.

Unlike watercolour methods, where retention of white paper is used to enhance and enliven paintings, with gouache you can use opaque white paint neat or mixed with colours to achieve paler hues. In order to take advantage of this a tinted ground is often useful. However, if you require a darker hue as a support or a particular colour that you may wish to see a hint of beneath your painting, it is a good idea to paint your own base colour upon which to work.

tip

Vary the size of brush you are using according to the scale of the components and the thickness of pigment you are applying. Paint may be overlaid thickly and as dry brush application.

Problems

Problems with scale and perspective have presented themselves in the drawing of this figure in relation to the angle of the boat. Working upon white paper has created more contrast than is wanted in some areas, resulting in a loss of subtlety.

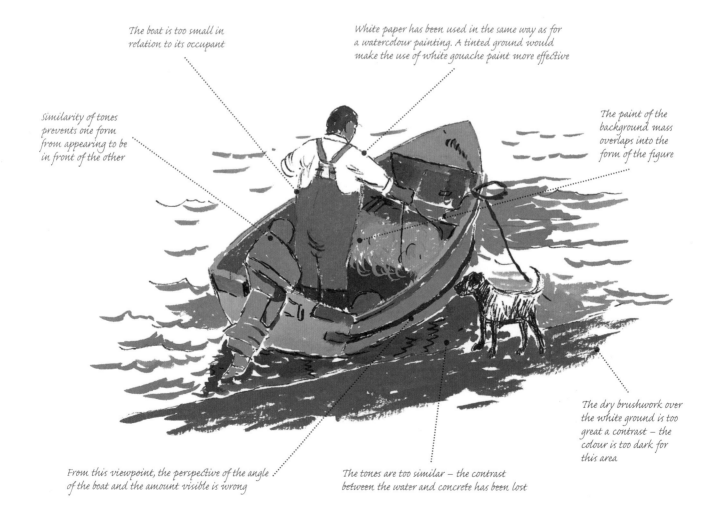

The boat is too small in relation to its occupant

White paper has been used in the same way as for a watercolour painting. A tinted ground would make the use of white gouache paint more effective

Similarity of tones prevents one form from appearing to be in front of the other

The paint of the background mass overlaps into the form of the figure

The dry brushwork over the white ground is too great a contrast – the colour is too dark for this area

From this viewpoint, the perspective of the angle of the boat and the amount visible is wrong

The tones are too similar – the contrast between the water and concrete has been lost

Solutions

In this study the painting is built layer upon layer, including some dry brushwork where textured effects are required. Delicate ink drawing enhances the effects of detailed areas and, when applied as areas of blocked-in tone, enriches areas of strong contrast.

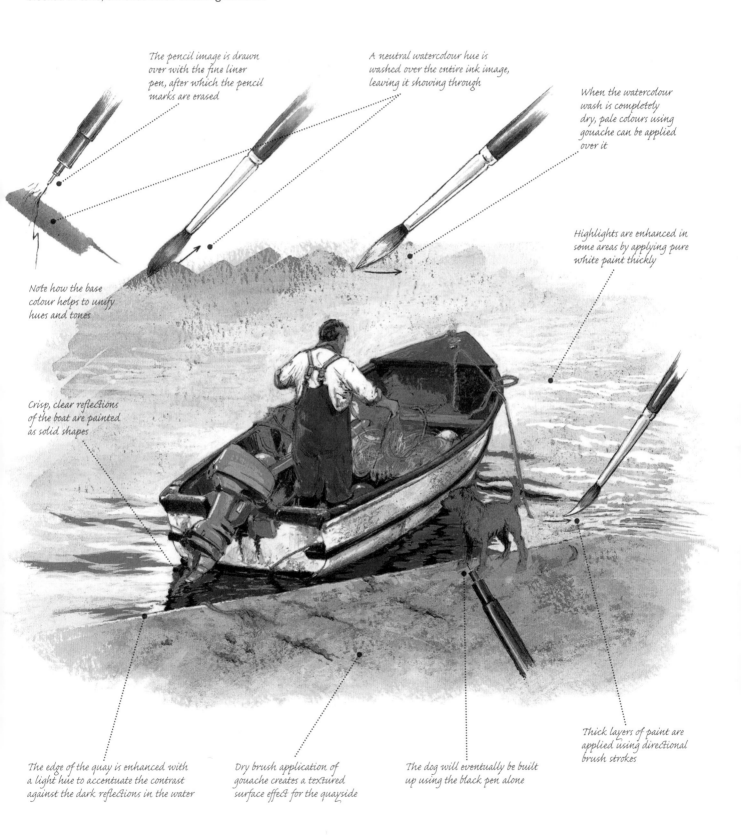

The pencil image is drawn over with the fine liner pen, after which the pencil marks are erased

A neutral watercolour hue is washed over the entire ink image, leaving it showing through

When the watercolour wash is completely dry, pale colours using gouache can be applied over it

Note how the base colour helps to unify hues and tones

Highlights are enhanced in some areas by applying pure white paint thickly

Crisp, clear reflections of the boat are painted as solid shapes

The edge of the quay is enhanced with a light hue to accentuate the contrast against the dark reflections in the water

Dry brush application of gouache creates a textured surface effect for the quayside

The dog will eventually be built up using the black pen alone

Thick layers of paint are applied using directional brush strokes

Foreshortened Forms and Background Textures

MEDIA: CHARCOAL PENCIL AND WATERCOLOUR ON 190GSM (90LB) BOCKINGFORD PAPER

Charcoal pencil drawing combines well with watercolour and the drawing can either be fixed prior to the application of washes to prevent blending or combined with the washes, as with other watersoluble pencils. A colourful bird such as a pheasant provides a good subject for the observation of pattern markings and the way feathers follow form. Around the neck and shoulder area in particular you will see how the impression of foreshortened feathers describes the form.

In a representation like this, with the contrasting textures and shapes of the bird against the background, you will have the opportunity to practise the eight basic stroke applications. Use controlled drawing and painting when working on the bird and loosely applied strokes to suggest the background areas.

Problems

In this painting, the areas of white paper occur by accident rather than by intent. White paper should be there for a purpose, such as to enhance the shape (the edges of the wing feathers) and form (under the chest of the bird).

Problem: *The placing of both the charcoal and watercolour strokes is too repetitious*

Solution: *Swiftly applied sweeping curved strokes suggest long grasses. Start by moving down into the stroke before 'ticking' up*

Solution: *Inclusion of angles will make your images more convincing*

Problem: *Two continuous charcoal lines do not give the impression of a band of white feathers*

Solution: *First directional strokes to place a series of green feathers that will merge into the white collar*

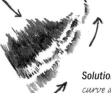

Solution: *Short up and down strokes applied in a curve are placed below and away from the green, then gently blended with clean water*

Problem: *Dark charcoal strokes do not cut in, suggesting feather edges hanging unevenly in front of a shadowed recess*

Solution: *Light underpainting with dark overlay and charcoal cut in to indicate the dark area behind*

Problem: *There is no variety or interest of line to depict the natural shape of the leaves*

Solution: *A varied pressure line where pencil was twisted during the stroke*

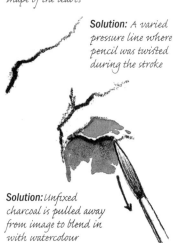

Solution: *Unfixed charcoal is pulled away from image to blend in with watercolour*

Solutions

Analyse your painting one area at a time, thinking your way through the drawing and painting process. Practising all the elements in the techniques box opposite separately before starting your final representation will help you to avoid some of the problems shown.

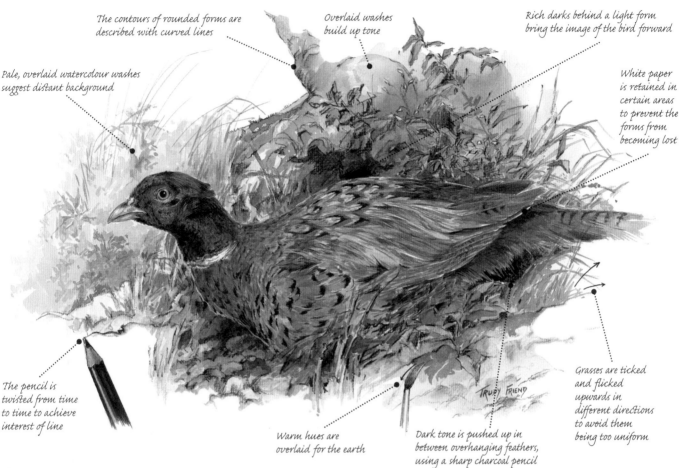

The contours of rounded forms are described with curved lines

Overlaid washes build up tone

Rich darks behind a light form bring the image of the bird forward

Pale, overlaid watercolour washes suggest distant background

White paper is retained in certain areas to prevent the forms from becoming lost

The pencil is twisted from time to time to achieve interest of line

Grasses are ticked and flicked upwards in different directions to avoid them being too uniform

Warm hues are overlaid for the earth

Dark tone is pushed up in between overhanging feathers, using a sharp charcoal pencil

TRUDY FRIEND

ARTIST'S TECHNIQUE

Combining paint and charcoal in different ways allows you to portray a range of textures within a single piece of work.

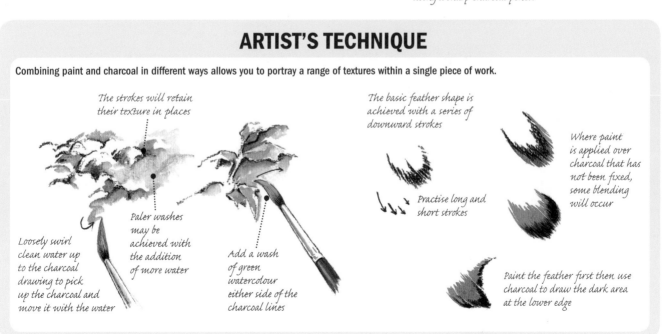

The strokes will retain their texture in places

The basic feather shape is achieved with a series of downward strokes

Where paint is applied over charcoal that has not been fixed, some blending will occur

Loosely swirl clean water up to the charcoal drawing to pick up the charcoal and move it with the water

Paler washes may be achieved with the addition of more water

Add a wash of green watercolour either side of the charcoal lines

Practise long and short strokes

Paint the feather first then use charcoal to draw the dark area at the lower edge

Still Life Groups

MEDIA: WATERSOLUBLE GRAPHITE, GOUACHE AND WATERCOLOUR PENCIL ON A DARK CARD BASE

The kitchen is often a good place to source content for a still life group. Contrasting shapes of elongated fish against rounded vegetable forms, with their variety of textured surfaces, can look effective when executed in mixed media upon coloured card. Gouache is the main medium used here, with watersoluble graphite overdrawing and watercolour pencil to soften the background effect.

A preliminary sketch was made in graphite pencil on white paper to position the components. This was then copied on to card using a Derwent watersoluble graphite pencil, grade 8B.

Problems

When care has not been taken with close observation of various forms in the initial investigative sketches, the resulting image may appear disjointed. A range of superficial marks presents us with a flat impression of the group which is more of a design than a fine art interpretation.

tip

Make full use of highlights to achieve contrasts and tone in background areas with bold, free application to support the more detailed treatment of individual foreground items.

The ground colour, being lighter than the painted area, should not be visible here

The pepper and onion appear flat

This should be a solid area of shadow

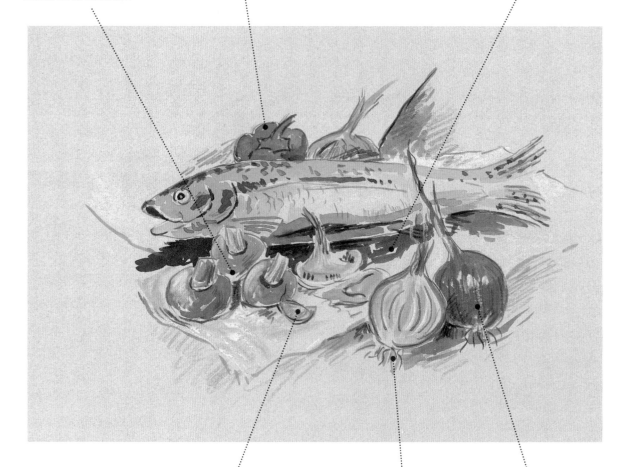

The garlic clove appears to have been drawn as an afterthought and lacks form

The onion roots are carelessly drawn

Lines suggesting the veins do not follow the form

Solutions

The use of white paint upon a dark base colour emphasizes contrasts of hue and tone, giving more dynamism. Shadow shapes define and link the images, adding interest to the composition. White gouache has been used for the lightest lights and to mix with pigments to achieve the paler hues. Watercolour pencil, grazed diagonally, has added interest of texture.

1 Cast shadow anchors the trout to the surface

2 The shape between the mushrooms has been considered when setting up the group

3 Graphite drawing over light gouache paint gives textural interest

4 A watercolour pencil overlay adds colour and texture to the dish

5 The light foreground form is emphasized against the darker hue of the fish

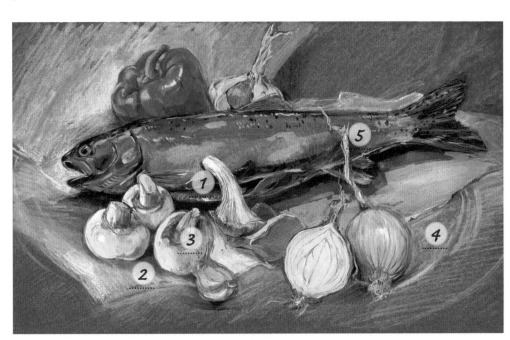

ARTIST'S TECHNIQUES

Mixing watersoluble pencil with gouache allows you to play with texture and colour, adding lighter hues over dark in a way that is not possible with pure watercolour.

Build light colours as overlaid washes

Draw directionally, using watersoluble graphite

For first washes, dilute gouache paint with plenty of water

Some areas of ground colour may remain visible between subsequent brush strokes

Mix white gouache with coloured pigments to cover dark hues and apply using directional strokes

Apply watercolour pencil swiftly across the surface to achieve interest of texture

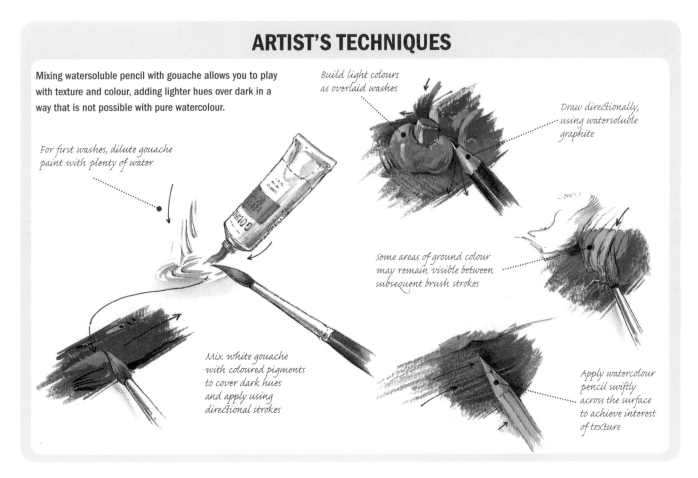

PART FOUR

Composition

 The term 'composition' refers to the design of a drawing or painting – the arrangement of various shapes, masses and contrasting areas of dark and light. These require preliminary planning in order to guide the observer's eye into and through the picture successfully.

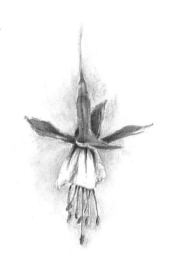

A composition may be based upon various shapes, for example an L shape or S shape (see page 183). For many centuries, artists have used the 'rule of thirds' to place their main focal points at a visually pleasing point no matter what the shape of the composition. This means imagining your composition divided by three vertical and three horizontal lines and placing your point of interest on one of the intersections of the lines; in preliminary sketches you can draw in the lines to help you with this concept at first.

In the illustration shown here you can see how this rule of thirds is achieved and how the illustration has been changed from a landscape to a portrait format. In the former, the focal point of umbrella and table has been positioned centrally, with flowers in containers on either side; after cropping, the focal point has been repositioned on the rule of thirds. As a result the viewer's eye is encouraged to enter the composition and meander in and around the various elements.

Many novices find the concept of composition hard to grasp, but, as you will see from this chapter, the important thing is to lead the eye to your focal point, with plenty of interest on the journey.

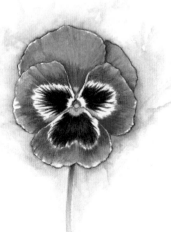

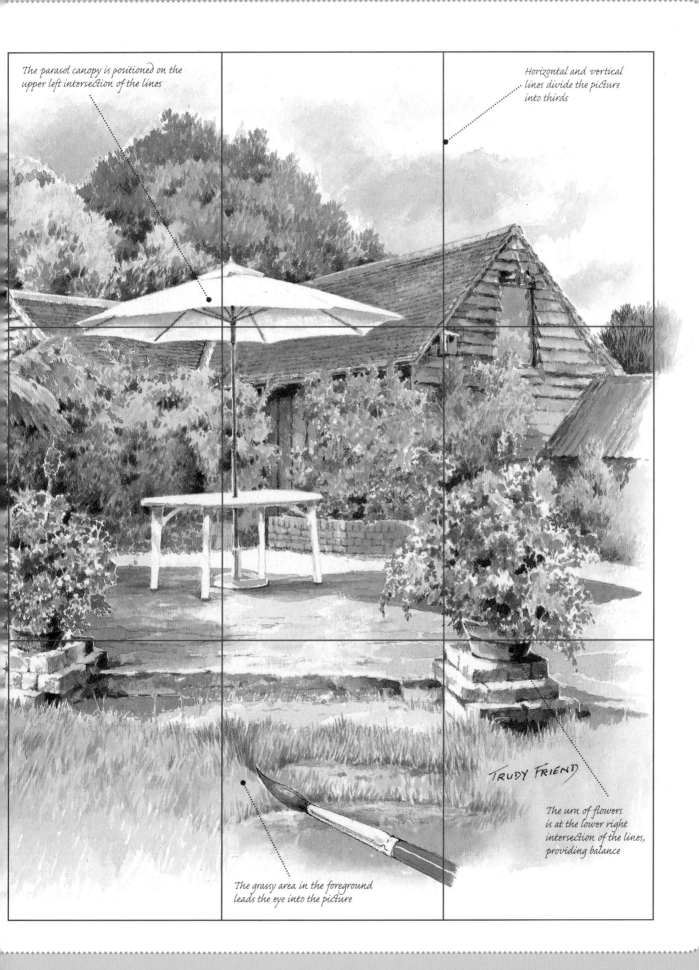

The parasol canopy is positioned on the upper left intersection of the lines

Horizontal and vertical lines divide the picture into thirds

TRUDY FRIEND

The urn of flowers is at the lower right intersection of the lines, providing balance

The grassy area in the foreground leads the eye into the picture

Pictorial Composition: Detail Sketches

Sketchbook work is invaluable for a number of reasons, and in this instance 'detail' sketches have been made of a cottage that will eventually feature as the subject of a watercolour painting.

These preliminary investigative sketches play an important part in our understanding of the subject we intend to depict. We may draw various aspects of the subject and its environment on one page as observations, without the need to be concerned with scale. The main objectives at this stage are to find out as much as possible about the subject matter, seen from different angles and with close-up observation of various components, such as the tiled roof and windows shown here.

First Sketches

Although these sketches, executed with a 5B Derwent graphic pencil on 190gsm (90lb) sketchbook paper, show the building from the front it will eventually be painted from a different angle as the picture is composed. It is a good idea to familiarize yourself with the subject and its surroundings, with a few different interpretations, before you decide upon the final viewpoint you will take.

Toning 'up to and away' from the light form will establish its position

Erratic on/off pressure strokes suggest the tiled roof as a textured effect

Swiftly applied vertical grazing indicates the shadow side of wall

Varied application of directional strokes suggests the profusion of the undergrowth

Close-up detail of the roof and wall textures

The chimney stack is executed in wandering lines that find the form

'Up to and away' application relates to the shadow side of the wall, enhancing a dark background area

The unusual finish to the tiled roof is an example of what may be observed in preliminary work

The scale of your preliminary sketches analysing the subject matter may vary, even though they are executed upon the same sketchbook page

Studies of the Setting

These three studies demonstrate different ways of executing the subject, while giving you an idea of the setting. They may be regarded as a warm-up, looking at the subject from different angles in different media – pencil and monochrome wash. I have also studied another aspect of the immediate environment – a stream running alongside the wall.

Monochrome Wash

Although rushing water alongside the cottage will not appear in the final painting (see page 181) it helped me to get the feel of the setting. If this were a place you had visited yourself, and of which you had made sketches, studies such as these would support your final interpretation, relating to your experience of having been there.

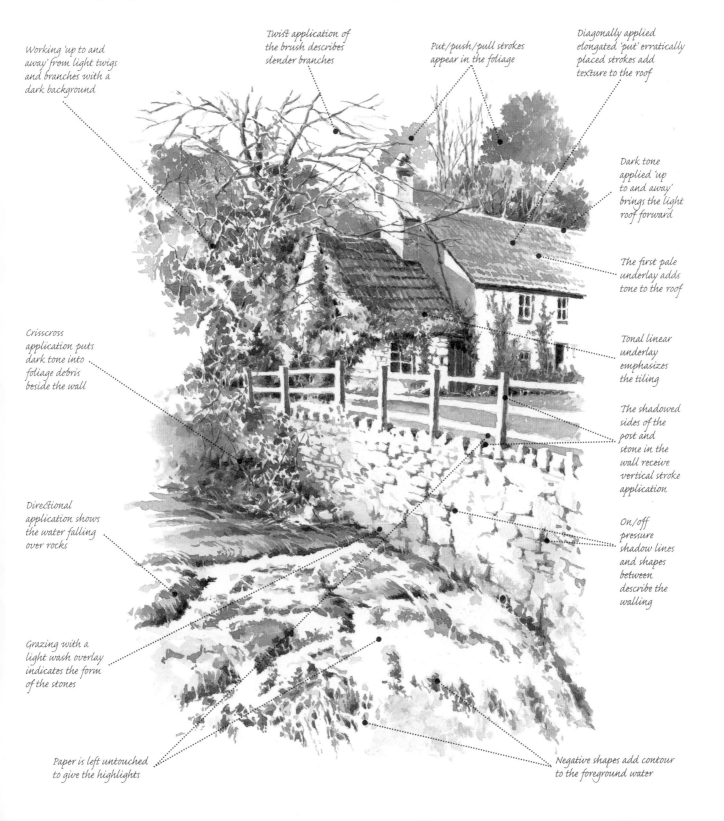

Working 'up to and away' from light twigs and branches with a dark background

Twist application of the brush describes slender branches

Put/push/pull strokes appear in the foliage

Diagonally applied elongated 'put' erratically placed strokes add texture to the roof

Dark tone applied 'up to and away' brings the light roof forward

The first pale underlay adds tone to the roof

Crisscross application puts dark tone into foliage debris beside the wall

Tonal linear underlay emphasizes the tiling

The shadowed sides of the post and stone in the wall receive vertical stroke application

Directional application shows the water falling over rocks

On/off pressure shadow lines and shapes between describe the walling

Grazing with a light wash overlay indicates the form of the stones

Paper is left untouched to give the highlights

Negative shapes add contour to the foreground water

Pictorial Composition

Delicate Pencil Study

The tranquil feel of a cottage alone among the trees has here been represented with the softness of delicate drawing upon an off-white surface – Saunders Waterford 190gsm (90lb) HP paper. The texture of the elements themselves, rather than that produced by the paper surface, is most important.

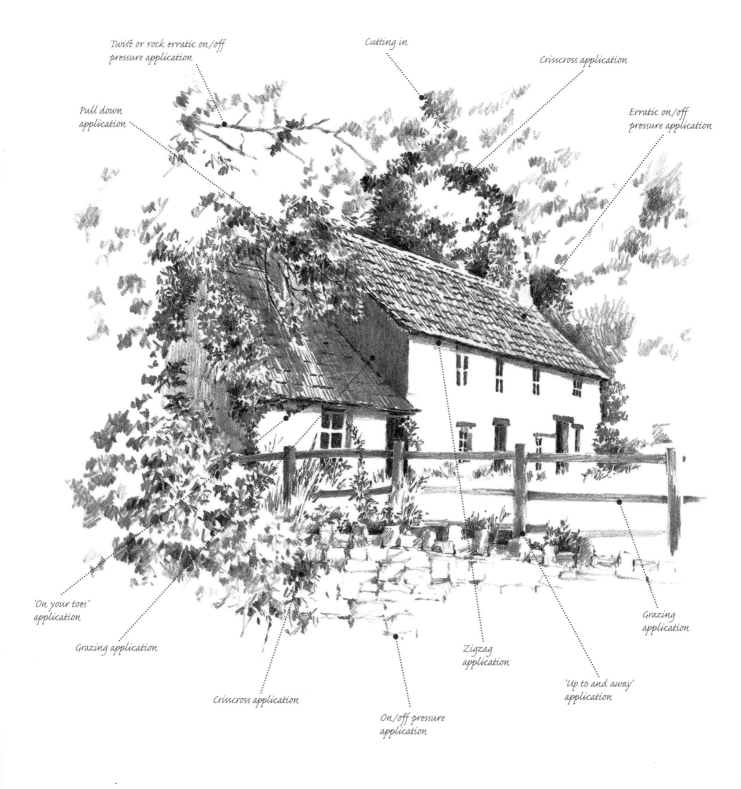

Twist or rock erratic on/off pressure application

Cutting in

Crisscross application

Pull down application

Erratic on/off pressure application

'On your toes' application

Grazing application

Crisscross application

On/off pressure application

Zigzag application

'Up to and away' application

Grazing application

Tonal Study Depicting Movement

For this study of tonal shapes I chose a soft pencil used upon slightly textured sketch book paper to add interest. I also used a photograph as reference to help with the representation of fast-flowing water. I visited the site again afterwards to refresh my memory so that I would not be relying entirely upon the photograph if I included the water in my final painting.

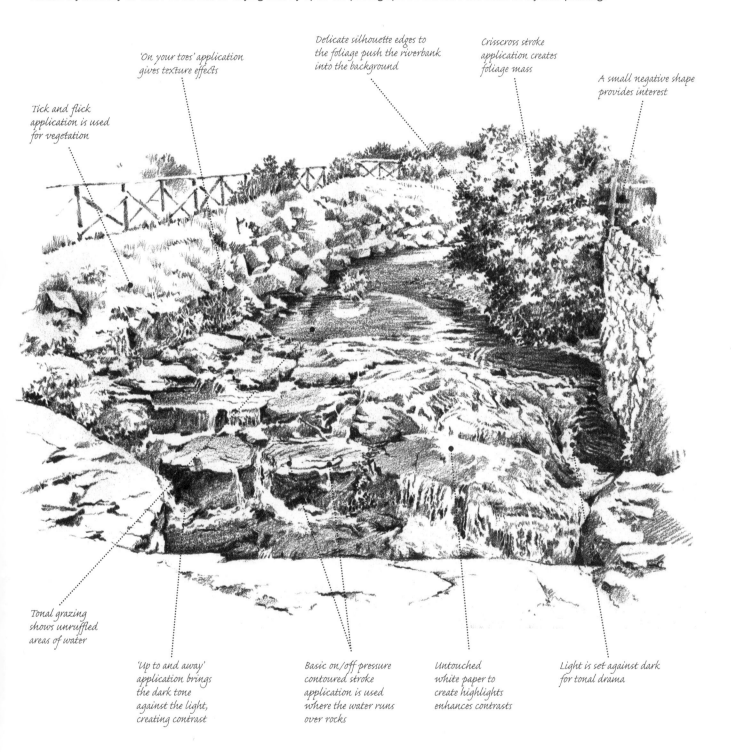

Tick and flick application is used for vegetation

'On your toes' application gives texture effects

Delicate silhouette edges to the foliage push the riverbank into the background

Crisscross stroke application creates foliage mass

A small negative shape provides interest

Tonal grazing shows unruffled areas of water

'Up to and away' application brings the dark tone against the light, creating contrast

Basic on/off pressure contoured stroke application is used where the water runs over rocks

Untouched white paper to create highlights enhances contrasts

Light is set against dark for tonal drama

Pictorial Composition: Watercolour

It is an interesting exercise to observe certain subjects at various times of the year and to depict changes in foliage, light, and so forth. However, it is also fascinating to be able to refer to an earlier painting of the subject some years later, when other changes have taken place.

My little watercolour painting on the opposite page, measuring only 15 x 19cm (7½ x 6in), shows the cottage before refurbishment. The building looks different now, some years later, to how it was when I painted it a few years ago. The sketches on the previous pages were made recently, in order to explain the role of preliminary sketchbook studies.

Even portraying the cottage as it is now, less overgrown and freshly painted, if I wished to I could use artist's licence to 'edit in' extra foliage and a few cracks in the walls, to add interest. Editing out is covered on the next spread, where two barns are depicted viewed from a more unusual angle.

Achieving Accuracy

I always use a series of vertical and horizontally placed guidelines to help achieve accuracy regarding the placing of the picture elements. This first guideline drawing of the cottage, seen at the angle I have chosen to depict, demonstrates where guidelines are most helpful. Again, stroke application is annotated to show how attention to this is important right from the beginning.

The guideline drawing may be altered as much as necessary at this stage. The next stage is to transfer the image on to good paper. This may be done in a number of ways, such as using the ordinary tracing paper method, a lightbox, a window (see tip, page 74) or Graphite Tracedown – a sheet of wax-free transfer paper which, when placed between the image and your fresh paper, allows you to trace over the outline of your drawing.

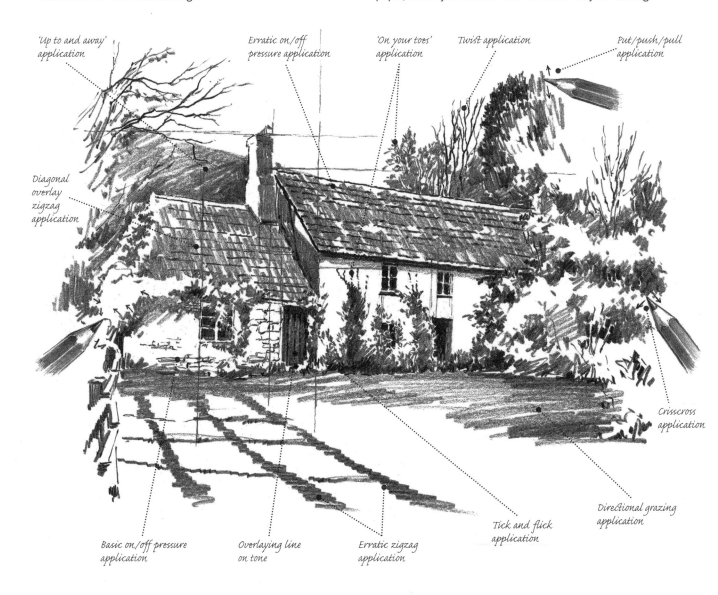

'Up to and away' application

Erratic on/off pressure application

'On your toes' application

Twist application

Put/push/pull application

Diagonal overlay zigzag application

Crisscross application

Directional grazing application

Basic on/off pressure application

Overlaying line on tone

Erratic zigzag application

Tick and flick application

The Completed Watercolour

Saunders Waterford CP (Not) 300gsm (140lb) paper proved to be an ideal surface for this delicate interpretation of the subject. You can see from the two areas that have been enlarged that stroke application is simple and the focus here is on shapes and the results of directional brush strokes.

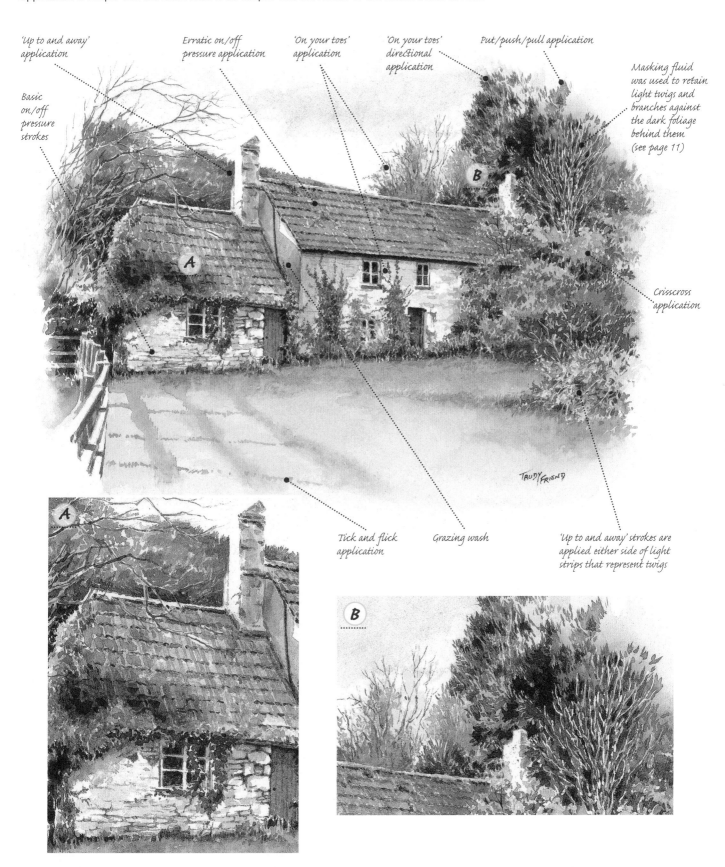

'Up to and away' application

Erratic on/off pressure application

'On your toes' application

'On your toes' directional application

Put/push/pull application

Masking fluid was used to retain light twigs and branches against the dark foliage behind them (see page 11)

Basic on/off pressure strokes

Crisscross application

TRUDY FRIEND

Tick and flick application

Grazing wash

'Up to and away' strokes are applied either side of light strips that represent twigs

Editing Out

As an artist, you have the choice to move elements of a scene to improve the composition or even to remove them altogether. You can also edit out for the purpose of simplicity, eliminating details from a crowded, fussy scene until it contains only what interests you and is important to the picture.

View of the Valley: First Sketch

My first sketch (right), using a photograph as reference, encompasses the whole of the valley from which I have chosen an area to depict, using Derwent Graphitint watersoluble pencils. As I worked I used the sketch to help me formulate in my mind what I liked most about the scene and how I would treat it.

Some of these buildings have been edited out to simplify the background area

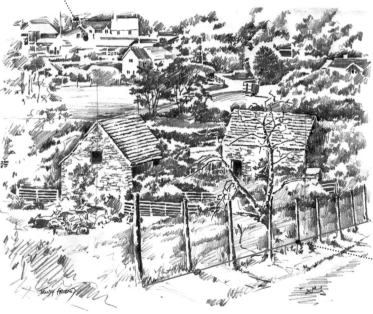

ARTIST'S TECHNIQUES

The skeletons of dead trees provide interesting structure in a landscape, particularly when they are caught by the light, but they need subtle treatment to make them look realistic.

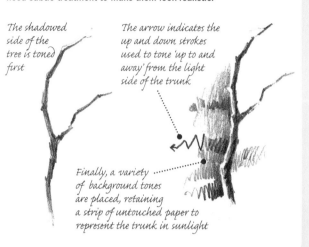

The shadowed side of the tree is toned first

The arrow indicates the up and down strokes used to tone 'up to and away' from the light side of the trunk

Finally, a variety of background tones are placed, retaining a strip of untouched paper to represent the trunk in sunlight

Second Sketch

In my second sketch I chose to edit out part of the background group of buildings and the line of posts in the foreground, after deciding upon the area to be considered for a close-up view. I also changed my viewpoint, eliminating the background hill.

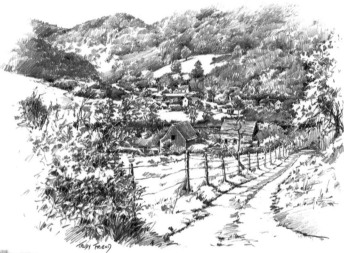

The inclusion of the row of posts would cut off this corner, so these also have been edited out in the final composition

Compositional Considerations

From the original vast expanse of tree-covered hills and buildings nestling in the valley, I chose the two barns in the foreground as the main subject matter for final representation. In view of the line of the river (of which only a small area is visible) and the shape of the track beyond, I decided to use an 'S' shaped composition.

A group of cattle in the foreground and their relationship with the pathway and gap between the buildings leads the eye into the picture. With so many 'busy' areas in the middle ground it is important to retain an area that 'rests the eye', where there is not so much activity. Behind the buildings a more muted approach helps to concentrate the attention upon the main subject matter within the composition.

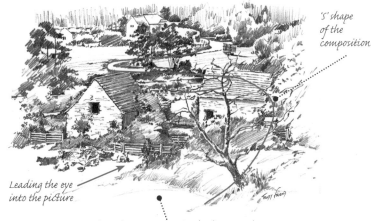

'S' shape of the composition

Leading the eye into the picture

Relatively empty space in the foreground acts as an area that 'rests the eye'

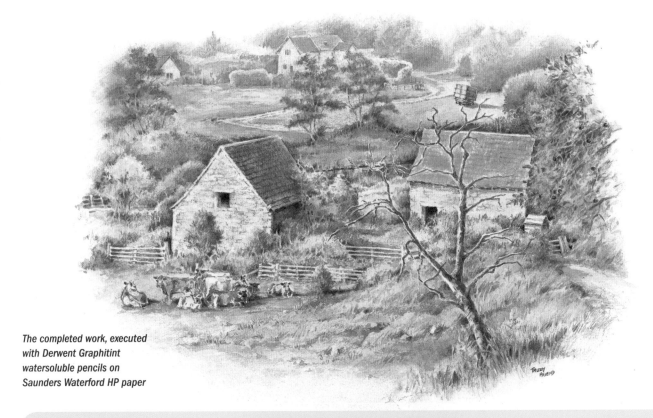

The completed work, executed with Derwent Graphitint watersoluble pencils on Saunders Waterford HP paper

ARTIST'S TECHNIQUES

Both dry-on-dry pigment and pigment blended with water appear in this painting, giving variety of treatment, texture and hue.

Method 1: Drawing directly on to paper and then brushing water over, to blend

Method 2: Taking pigment from colour strip of pencil using wet brush before applying to paper

Meadow

Dry

Dry on dry drawing

Leave slim strips of untouched paper to indicate branches within the foliage masses

With water added

Cool Brown

Dry

Cocoa

Dry

Wet

Varied pressure produces uneven parallel lines to represent tiles

Dry

Wet

With water added

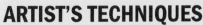

Using Guidelines

However complicated your subject matter may appear to be, if you approach it with a view to lining up shapes rather than thinking about the subject itself you will learn to draw it accurately.

Mastering accurate drawing may be considered to be the first step in developing your observational skills and a logical way of 'training your eye'. It will give you more freedom to draw spontaneously with success – though even then a few guidelines along the way are always helpful. Using photographs for reference (rather than just copying them) is a good starting point while you learn how to recognize and use important shapes, noticing where guidelines relate one component to another. It is a part of learning how to develop your observational skills, not an end in itself.

I have chosen a profile for this demonstration as it may be easier for beginners to see shapes in this context. An animal's head with harness also gives more points of contact to which we can relate. Some of these are marked with red dots – they are placed at certain angles, and from these the guidelines may be drawn. These vertical (drop) and horizontal lines make up a personal grid that forms the scaffold upon which a first investigative sketch or drawing may be built before transferring the outline on to quality paper.

Drawing with Accuracy

First, place a sheet of tracing paper over your photograph or take a photocopy. Look for angles and put dots at the places where you feel a vertical or horizontal line will help you line up another component. Join the dots with guidelines.

Using this as reference, look for shapes between guidelines beyond the image as well as within it. Try to forget the subject at this stage. In order not to get confused by so many lines and to enable your eye to recognize tonal shapes, shade in some of the shadow shapes.

Trace the main image shapes on to good paper (ignoring the guidelines) using tracing paper, a window or a lightbox (see tip, page 74). Choose the medium you wish to work in and build line and tone to complete your drawing.

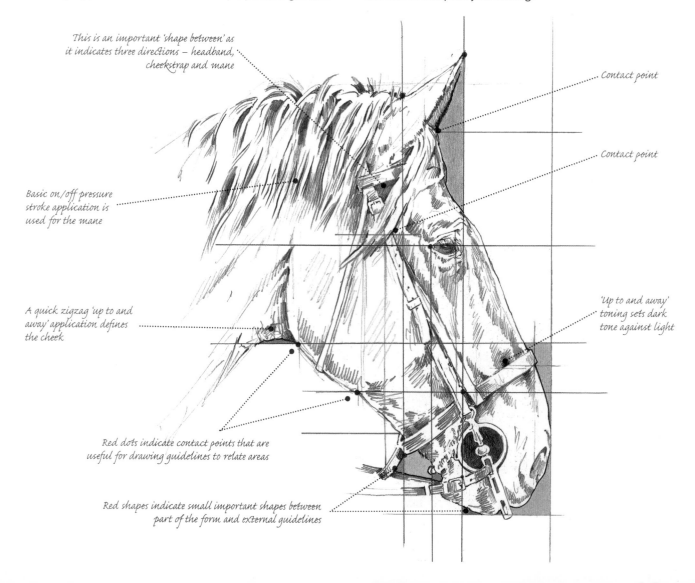

This is an important 'shape between' as it indicates three directions – headband, cheekstrap and mane

Contact point

Contact point

Basic on/off pressure stroke application is used for the mane

A quick zigzag 'up to and away' application defines the cheek

'Up to and away' toning sets dark tone against light

Red dots indicate contact points that are useful for drawing guidelines to relate areas

Red shapes indicate small important shapes between part of the form and external guidelines

The Completed Drawing

Fine charcoal pencil or carbon pencil is suitable for this type of textured drawing as these pencils give a richness of tone. However, it is important to keep a fine point for such delicate work.

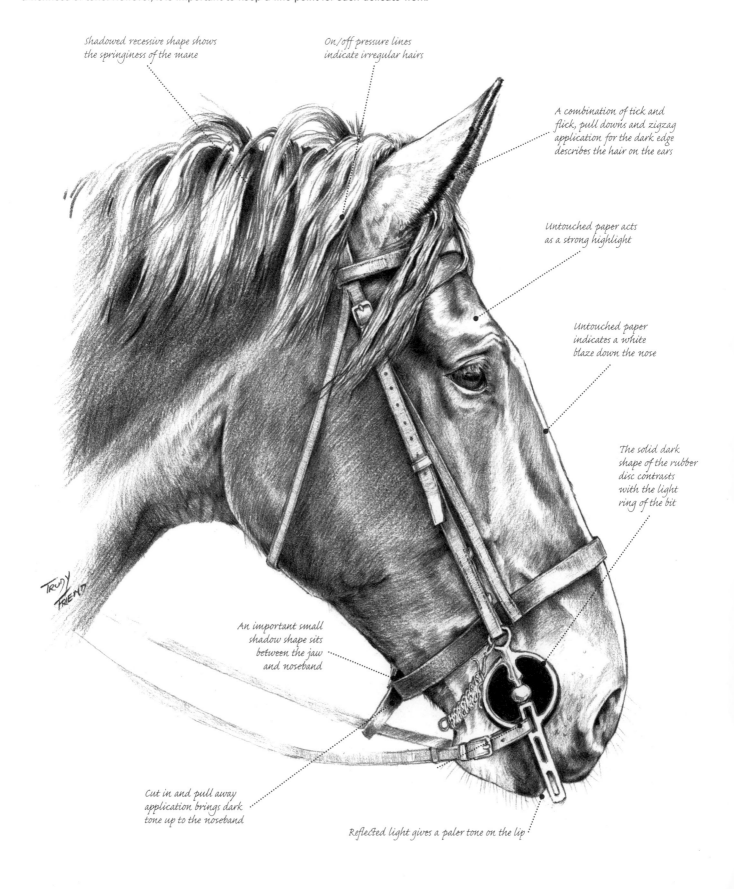

Shadowed recessive shape shows the springiness of the mane

On/off pressure lines indicate irregular hairs

A combination of tick and flick, pull downs and zigzag application for the dark edge describes the hair on the ears

Untouched paper acts as a strong highlight

Untouched paper indicates a white blaze down the nose

The solid dark shape of the rubber disc contrasts with the light ring of the bit

An important small shadow shape sits between the jaw and noseband

Cut in and pull away application brings dark tone up to the noseband

Reflected light gives a paler tone on the lip

Depicting Detail

MEDIA: INKTENSE PENCILS ON 190SM (90LB) BOCKINGFORD PAPER

Detail studies may be shown against untouched paper or a limited background that does no more than support the study. If the image itself is executed in strong tones and colour, you may feel you prefer to leave the background untouched for the study to have maximum impact. If this is the case there needs to be enough interest within the study to satisfy the viewer's eye in terms of angles, shapes, colour, tonal values, texture and so forth. When surface markings are present they need to be painted with regard for the form over which they are seen.

Detail Study: Frog

In this little study of a frog there is so much interest of surface texture that a background is not necessary. For detail studies of animals, it is a good idea to take some photographs to refer to later if need be, as few will stay in front of you long enough for a detail sketch.

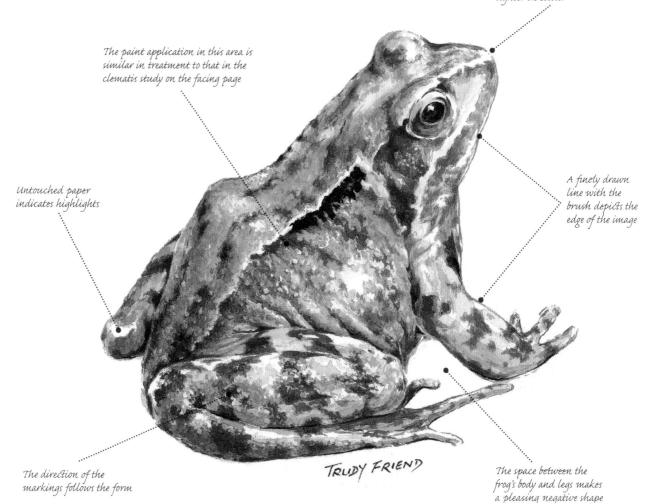

tip

Practise techniques for particular areas of pattern and texture such as skin folds and pattern that follows form prior to starting the final artwork, using different watercolour pencil methods.

A lost line on the nose avoids a darker outline where the skin is lighter in colour

The paint application in this area is similar in treatment to that in the clematis study on the facing page

Untouched paper indicates highlights

A finely drawn line with the brush depicts the edge of the image

The direction of the markings follows the form

TRUDY FRIEND

The space between the frog's body and legs makes a pleasing negative shape

Neutral Hues

When the subject comprises mainly neutral hues, an area of interest such as the cool grey of this owl's beak and the vibrant hue of its eyes will create more of an impact than in a more colourful painting. Again there is so much attention to detail in this study that a plain background may seem preferable to the inclusion of colours and forms that might detract from the image itself.

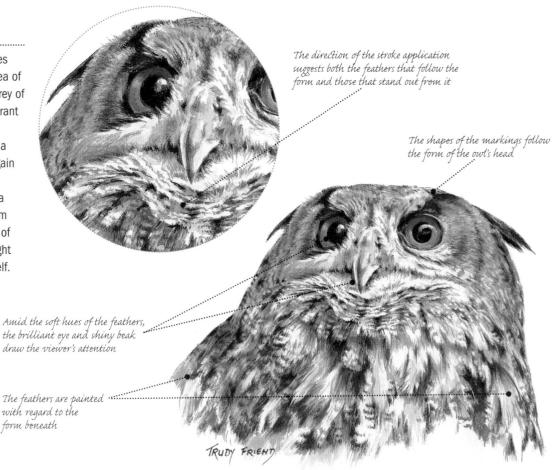

The direction of the stroke application suggests both the feathers that follow the form and those that stand out from it

The shapes of the markings follow the form of the owl's head

Amid the soft hues of the feathers, the brilliant eye and shiny beak draw the viewer's attention

The feathers are painted with regard to the form beneath

TRUDY FRIEND

Translucent Washes

This image has received a number of translucent wash applications, wet on dry, to build tone in the cast shadow areas. With highlights upon petals playing an important part – retaining delicacy of hue and tone – a suggestion of background is an advantage. This supports the image without overpowering it and, with the inclusion of numerous negative dark shadowed recessive shapes, supplies the contrasts required to give impact. The retention of slim untouched paper strips adds a crispness to petal edges.

The representation of texture upon clematis petals to some extent echoes the treatment of a reptile's skin (opposite); the veins have been executed in a similar way to the skin folds.

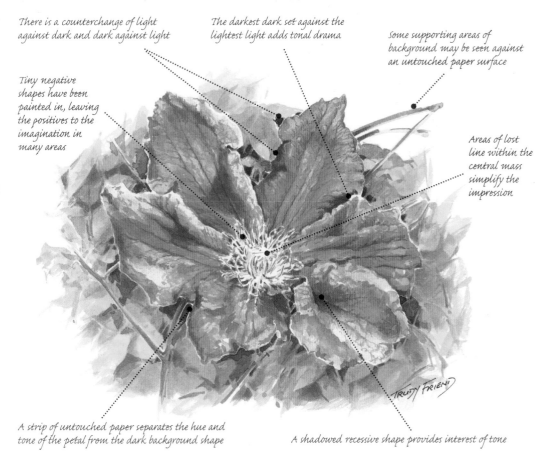

There is a counterchange of light against dark and dark against light

The darkest dark set against the lightest light adds tonal drama

Some supporting areas of background may be seen against an untouched paper surface

Tiny negative shapes have been painted in, leaving the positives to the imagination in many areas

Areas of lost line within the central mass simplify the impression

A strip of untouched paper separates the hue and tone of the petal from the dark background shape

A shadowed recessive shape provides interest of tone

TRUDY FRIEND

Conclusion

In order to progress as an artist, remember that preliminary sketches and planning before starting your final artwork is important. Keeping a sketchbook in which to make visual notes in the form of details and little studies, rather than completed drawings, will help to develop your confidence. In particular, practising pencil and brush exercises in sketchbooks kept primarily for that purpose – cartridge for pencilwork and watercolour paper for brushwork – in the way that I have demonstrated in this book will help you to improve your technique and find your own personal style.

Detailed Studies

You may find that individual objects like the pineapple shown here, executed in pen and wash, will provide you with enough interest to challenge your observational skills as you position the various shapes to show the whole convincingly. In studies such as these you can hone your skills at describing texture and intricate detail.

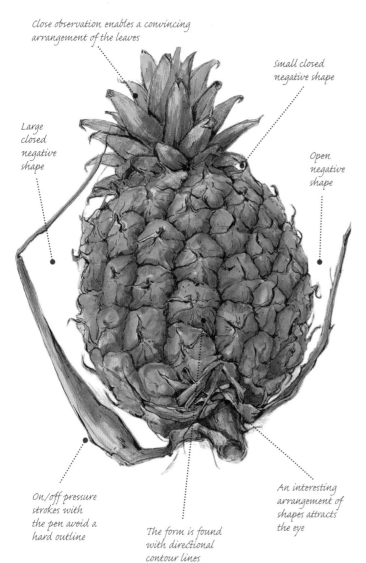

Close observation enables a convincing arrangement of the leaves

Small closed negative shape

Large closed negative shape

Open negative shape

On/off pressure strokes with the pen avoid a hard outline

The form is found with directional contour lines

An interesting arrangement of shapes attracts the eye

Looking for Accuracy

A viewfinder made by cutting an aperture in a piece of card is helpful, not only for planning a composition when working from life but also to place over part of a photographic reference, so that your eye is not confused by taking in too much at any one time.

If you make a small viewfinder and just concentrate upon drawing what you see within that area to start with, you will find it easier to notice shapes and tonal variations as abstract forms. Turning a photographic reference upside down may also help you achieve more accuracy in your representations, as you will cease to see your subject matter, with all the preconceptions you hold about its appearance, and concentrate upon seeing shapes and tones in relation to each other.

Art Cards

Some people find that written reminders or observations help to keep them from straying off the track. One way of using notes is in the form of art cards, which may simply be small card 'offcuts' upon which a few words or sentences are written as ideas come to mind. You may find that writing the following words on separate cards to use for quick reminders will help you, adding references to pages in this book where they are discussed.

- FOLLOW THE FORM
- DARK BACKGROUND
- LOOK FOR ANGLES
- COUNTERCHANGE
- GUIDELINES
- LOST LINE
- THINKING TIME
- GLAZING
- WANDERING LINES
- SHADOW SHAPE
- SHADOW LINE
- SHAPE BETWEEN
- NEGATIVE SHAPE
- SHADOWED RECESSIVE SHAPE
- TONING FOR TONE AND TONING FOR COLOUR

Follow the form

Looking through the book to find these references will help you go over the important considerations in your artwork.

An example of a helpful sentence is: 'Where your thoughts go your pencil marks will follow.' This relates to wandering lines that find form by retaining constant contact through your pencil with the paper's surface.

Simple words such as 'Pause and consider' printed upon a card will remind you not to rush to complete your work and to stop occasionally during execution in order to consider your progress. You can then ask yourself questions such as: 'Have I used enough contrast?' 'Does the composition work, or should I perhaps add in or edit out?'

'Discipline leads to expressiveness' is another helpful art card reminder, as this reinforces the importance of learning the basic skills and practising exercises that will lead you towards the

freedom of expressing yourself in the way you wish through your artwork. Whether you favour a bold approach, vibrant colours, a loose, free style of painting or botanical illustrative work, you will have the freedom to choose.

'What you leave out is just as important as what you put in' is another vital maxim when drawing and painting, reminding you to learn to simplify and to avoid overworking your interpretations.

I would like to conclude this book with a comment made by a student who attended one of my courses, as a response to the course content: 'I discovered the things I wanted to learn were not the most important and that there were other things I needed to learn.' I hope the book will help you to achieve the aspects of your artwork you want to enjoy and also provide an opportunity to discover what you may need to learn in order to attain the level of proficiency you seek.

In my watercolour of a spaniel I have left out brushstrokes from many of the areas where I could have confused the viewer's eye had I put them in unnecessarily. Certain areas of the face and also the shoulders have received minimum attention, while on the ears, where numerous twists and turns of clumps of curly hair add interest, I have noticed negative shapes and highlights in abundance.

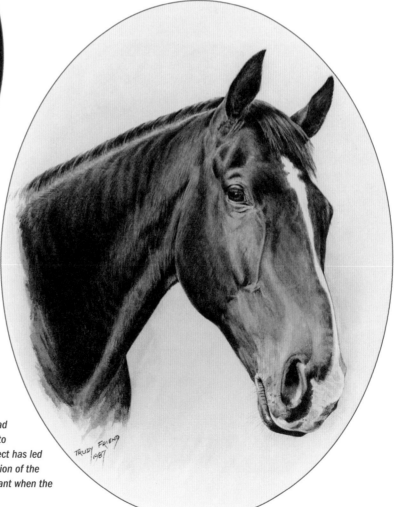

In my watercolour painting of a horse's head you will see how the discipline of learning to understand the bone structure of the subject has led to a realistic interpretation. Close observation of the ears, eye and muzzle is particularly important when the animal is seen from this angle.

Glossary

Chisel edge of pencil: The wider edge of the pencil, used for applying cast shadow areas and shadows when toning.

Constant contact: Maintaining contact as you draw and paint to retain continuity and 'flow'.

Contrasts: Achieve maximum contrast by placing the darkest of your dark tones directly against the untouched white paper (or paint).

Crisscross stroke application: The varied directional movements involved in placing the strokes, to create interest of texture.

Crosshatching: Placing strokes in one direction then overlapping in the opposite direction, to create a solid tonal mass or, if slightly apart, an 'open weave' effect.

Describing form: Follow the form of the object you are depicting by imagining a tiny insect walking over the surface of the object and let your pencil/brush follow the direction the insect would take.

Direction: This may refer to the direction in which an artist encourages the viewer's eye to travel through a composition or to the direction in which your pencil or brush strokes are applied to the paper.

Dry brush: Removing pigment mix from your brush on to scraps of watercolour paper to achieve a dry brush texture on your painting.

Edit in or out: Choosing to include or omit certain components within a composition.

Erratic pressure strokes: Pressing upon and lifting from the paper unevenly to achieve interest of texture.

Fixative: Spraying with Fixative will prevent drawings from smudging.

Grazing: Letting your pencil or brush 'graze' across the paper's surface to create tone (pencil) or a wash of colour (paint).

Guidelines: Vertically or horizontally drawn lines (of varied length) that relate an area or component to another, some distance away, in a composition.

Highlights: Pencil and watercolour techniques rely upon the retention of white paper for the depiction of highlighted areas.

Investigative sketch: Initial sketch or drawing through which we inquire into and examine in detail the subject we have chosen to depict to decide what needs to be edited in or out.

Loading your brush: Lift paint from your palette wells in a way that will help subsequent stroke applications. Roll the brush in the mix and pull away out of the well, to taper the hairs.

Lost lines: When the background (or adjacent image) hue/tone is very similar, causing the two to appear to merge in places, to add interest and a sense of reality to your pictures.

Mediums for watercolour: Additives which alter or enhance characteristics of colour. They may be used to increase gloss, change the rate of drying, improve flow or provide texture.

Monochrome: Painting using one colour only, will help you appreciate the importance of tonal values.

Negative shapes: These may be dark or light. Dark negatives are shadowed recessive shapes, for example, where an animal or object may disappear into the shape. The shapes between foliage masses between which birds may fly to the sky beyond are light negatives.

Neutral hues: Useful for underpainting, and effective in areas that 'rest the eye', providing exciting contrasts when colour is juxtaposed.

On/off pressure: By applying and then lifting pressure upon a pencil or brush, interest of line/shape may be achieved.

On your toes: Small dots, dashes, lines and grazing are achieved by using the tip of the pencil or brush, which is held vertical to the paper's surface.

One stroke images: Using a single brush stroke to produce a recognizable shape.

Put/push/pull: Directing the stroke movement in relation to your subject.

Reflected light: On a spherical or cylindrical shape, leave a light edge on the dark (shadow) side before it meets its dark cast shadow. This depicts light that is reflected back on to the object's shadow side from the light of its support.

Relationships: Relating one form to another with the help of guidelines.

Texture: Creating character of surface, using textured paper, creating texture with a pencil or by 'blotting off' with watercolour.

Tick and flick: Using pencil to make tick movements to create grasses and hair.

Twists and turns: By twisting the pencil between your fingers you will be able to create interest of line.

Underpainting: Building translucent washes, wet on dry in watercolour gives you control over the development of your painting.

Up to and away: 'Cut in' crisply up to the image to be defined, before taking the tone (pencil)/colour (paint) away from the form.

Wandering lines: Constant contact with the paper's surface throughout the application of a line that wanders around the form.

Suppliers

UK

Derwent
The Cumberland Pencil Company
Derwent House
Jubilee Road
Lillyhall Business Park
Workington
Cumbria
CA14 4HS
Tel: 01900 609599
www.pencils.co.uk
For high quality drawing materials

Inveresk
St Cuthbert's Mill
Wells
Somerset
BA5 1AG
Tel: 01749 672015
Fax: +44 (0)1749 678844
Email: sales@inveresk.co.uk
www.inveresk.co.uk
For Saunders Waterford and Bockingford papers

SAA (Society for All Artists)
PO BOX 50
Newark
Notts
NG23 5GY
Tel (UK sales): 0800 980 1123
Tel (Non UK sales): 01949 844050
Fax: +44 (0)1949 844051
Email: info@saa.co.uk
For brushes and sundries

Winsor & Newton
Whitefriars Avenue
Harrow
Middlesex
HA3 5RH
Tel: 020 8424 3200
Fax: 020 8424 3328
www.winsornewton.com
For paints and painting mediums

USA

Art Media
902 SW Yamhill
Portland
Oregon 97205
www.artmediaonline.com
For paints, brushes, paper and other media

Jerry's Artarama
Order Dept.
PO Box 58638J
Raleigh
NC 27658-8638
Tel: 1-800-827-8478
www.jerrysartarama.com
For pencils, paper and other media

Madison Art Shop
17 Engleberg Terrace
Lakewood
New Jersey 08701
Tel: +800 961 1570
Fax: +732 961 1511
www.madisonartshop.com
For drawing and painting supplies

Staedtler, Inc.
21900 Plummer Street
Chatsworth
California 91311
Tel: 1-800-776-5544
Fax: 818.882.3767
Email: info@staedtler-usa.com
www.staedtler.us
For pigment liner pens

Europe

Faber-Castell
Vertrieb GmbH
Nürnberger Strasse 2
D-90546 Stein
Germany
Tel: 0911-9965-0
Fax: 0911-9965-760
Email: Info@graf-von-faber-castell.com
www.faber-castell.com
For Pitt Artist pens

Stabilo
STABILO International GmbH
Schwanweg 1
90562 Heroldsberg
Germany
Tel: +49-911-567 0
Fax: +49-911-567 4444
Email: info@stabilo.com
www.stabilo.com
For pens and writing materials

Acknowledgments

I would like to thank Jane Stroud who, as Editor of *Leisure Painter* magazine at the time, introduced me to David & Charles, as a result of my 'Problems & Solutions' series featured in the magazine.

Thank you to all friends and acquaintances who have provided some of the photographic reference material, without which I could not have produced such a variety of subject matter.

I would also like to thank my husband for his forbearance when, time after time, I had to refrain from being in his company, with the reason ... 'I have to work on my book'.

The 'Problems & Solutions' section of this book originally grew out of a series of articles that Trudy Friend wrote for the *Leisure Painter* magazine. *Leisure Painter* was first published in 1967 and is now the UK's most popular painting magazine, helping beginner and amateur artists to paint in all media. The magazine is available from all good UK newsagents or direct from the publisher on subscription. Write to: *Leisure Painter* magazine, Caxton House, 63/65 High Street, Tenterden, Kent TN30 6BD; or telephone 01580 763315. Further information is available on the website at **www.leisurepainter.co.uk**.

Index